Duchamp and the Aesthetics of Chance

Columbia Themes in Philosophy, Social Criticism, and the Arts

Herbert Molderings

DUCHAMP
and the Aesthetics of Chance

Translated by John Brogden

Art as Experiment

Columbia University Press New York

Columbia University Press
Publishers Since 1893
New York Chichester, West Sussex
Copyright © 2010 Columbia University Press

Originally published as *Kunst als Experiment. Marcel Duchamps "3 Kunststopf-Normalmaße"* by Deutscher Kunstverlag, Munich and Berlin 2006.
All rights reserved

Library of Congress Cataloging-in-Publication Data
Molderings, Herbert.
[Kunst als Experiment. English]
Duchamp and the aesthetics of chance : art as experiment /
Herbert Molderings ; translated by John Brogden.
 p. cm. — (Columbia themes in philosophy, social criticism, and the arts)
Originally published: Kunst als Experiment : Marcel Duchamps "3 Kunststopf-Normalmasse". Munich : Deutscher Kunstverlag, 2006.
Includes bibliographical references and index.
ISBN 978-0-231-14762-0 (cloth : alk. paper) —
ISBN 978-0-231-51974-8 (e-book)
1. Duchamp, Marcel, 1887–1968. 3 standard stoppages. 2. Duchamp, Marcel, 1887–1968—Criticism and interpretation. I. Title. II. Title: Art as experiment.
NB553. D76A15 2010
709.2—dc22 2009043390

Columbia University Press books are printed on permanent and durable acid-free paper.
This book is printed on paper with recycled content.
Printed in the United States of America

c 10 9 8 7 6 5 4 3 2

Designed by Lisa Hamm

Frontispiece: Marcel Duchamp at the finale of the exhibition Marcel Duchamp, même, at the Kestner-Gesellschaft in Hanover, 1965. Umbo. © Phyllis Umbehr, Unterwössen/Courtesy Gallery Kicken, Berlin.

To the memory of the art historian Franz-Joachim Verspohl

CONTENTS

List of Illustrations **ix**
Introduction **xi**

1 The Idea of the Fabrication **1**
2 The 3 *Standard Stoppages* in the Context of the *Large Glass* **7**
 The Pane of Glass as a Materialized Plane Intersecting
 the Visual Pyramid **13**
 Depersonalizing Straight Lines **18**
 The Thread as a Metaphor of the Visual Ray **22**
3 The 3 *Standard Stoppages* as Paintings **33**
 Gravity and Line: The "Rephysicalization" of the Ideal Straight **33**
 Duchamp's Application of the New Standard Measures **44**
 Painting of Chance **49**
 Art as an Experiment **56**
4 1936: Duchamp Transforms the Painting
 Into an Experimental Setup **63**
 On the Title: Roussel's "Method" **75**
 An Excursion Into the World of Shop Signs and Windows **77**
5 Humorous Application of Non-Euclidean Geometry **83**
 A Brief Digression on *Tu m'* **93**
6 The Crisis of the Scientific Concept of Truth **99**
7 Pataphysics, Chance, and the Aesthetics of the Possible **117**
8 Radical Individualism **133**

Notes **145**
Bibliography **193**
Index **211**

ILLUSTRATIONS

Frontispiece. Marcel Duchamp, Hanover, 1965 **ii**
Fig. 1.1 Duchamp, *The Box of 1914* **2**
Fig. 1.2 Duchamp, "The Idea of the Fabrication," note from *The Box of 1914* **3**
Fig. 1.3 Duchamp, *3 Standard Stoppages*, 1913–1914 **5**
Fig. 2.1 Duchamp, *The Bride Stripped Bare by Her Bachelors, Even*, 1915–1923 **9**
Fig. 2.2 Jean du Breuil, Une très belle invention pour pratiquer la perspective **16**
Fig. 2.3 Jean du Breuil, Pour trouver le raccourcissement des figures **17**
Fig. 2.4 Duchamp, *Broyeuse de chocolat II (Chocolate Grinder II)*, 1914 **19**
Fig. 2.5 Duchamp, *Chocolate Grinder II*, reverse **21**
Fig. 2.6 Albrecht Dürer, Two draftsmen plotting points for the drawing of a lute **23**
Fig. 2.7 Ludovico Cigoli's perspective machine **26**
Fig. 2.8 Ludovico Cigoli's perspective machine **26**
Fig. 2.9 Abraham Bosse, visual rays or the pyramid of vision **27**
Fig. 2.10 "Another Invader, Marcel Duchamp" **30**
Fig. 3.1 Duchamp, *3 Standard Stoppages*, 1913–1914 **34**
Fig. 3.2 Note "Wind—for the draft pistons, skill—for the holes, weight—for the standard stoppages" **36**
Fig. 3.3 Jean du Breuil, Une autre belle invention pour pratiquer la perspective **38**
Fig. 3.4 Duchamp, *Piston de courant d'air (draft piston)*, 1914 **38**
Fig. 3.5 Duchamp, "Altar" of the *soigneur de gravité (handler of gravity)*, 1947 **40**

Fig. 3.6 Duchamp, *Réseaux des stoppages* (*Network of Stoppages*), 1914 46

Fig. 3.7 Duchamp, *Réseaux des stoppages* (*Network of Stoppages*), 1914 47

Fig. 3.8 From the exhibition catalogue *by or of Marcel Duchamp or Rrose Sélavy* 48

Fig. 3.9 Duchamp, *Cimetière des uniformes et livrées* (*Cemetery of Uniforms and Liveries*), 1914 49

Fig. 3.10 Duchamp, *3 Standard Stoppages*, 1914 53

Fig. 3.11 Duchamp, "3 décistoppages étalon" (3 standard decistoppages), 1914 55

Fig. 3.12 Hans Arp, *Elementary Construction According to the Laws of Chance*, 1916 57

Fig. 3.13 Étienne-Jules Marey, *Cylinder Engendered by the Displacement of a White Thread Moving Round a Central Axis*, ca. 1887 59

Fig. 3.14 Étienne-Jules Marey, *Marey Agitating a Flexible White Rod*, 1886 60

Fig. 4.1 Costa Achilopulu (?), *Marcel Duchamp and Mary Reynolds*, 1937 65

Fig. 4.2 View of the exhibition Fantastic Art, Dada, Surrealism, 1936 67

Fig. 4.3 View of the exhibition of the Katherine S. Dreier Bequest, 1953 69

Fig. 4.4 Duchamp, *3 Standard Stoppages* in *La Boîte-en-valise* (*The Box in a Valise*), Paris, 1935–1941 71

Fig. 5.1 Duchamp, *Tu m'*, 1918 94

Fig. 6.1 One of sixteen standard meters in the streets of Paris 103

Fig. 6.2 Prototypes of the meter and the kilogram, 1889 103

Fig. 7.1 Note "3 Standard Stoppages étalon = canned chance," 1914 119

Fig. 7.2 Duchamp, *Obligation pour la roulette de Monte-Carlo* (*Monte Carlo Bond*), 1924 126

Fig. 8.1. Man Ray, *Marcel Duchamp*, ca. 1920 132

INTRODUCTION

The individual, as such, stands by his very nature under chance.

—NOVALIS

Whenever art critics and art historians speak about the role of chance in modern art, they invariably cite Marcel Duchamp's *3 Stoppages étalon* (*3 Standard Stoppages*) of 1913–14: three threads, each having a length of one meter and held horizontally were each dropped from a height of one meter onto a piece of canvas and fixed in position by means of varnish.[1] After their first exhibition in 1936, the *3 Standard Stoppages* became a constituent point of reference in the aesthetic theories behind all movements in art that accorded chance an important function in the artistic process, from surrealism ("objet trouvé") to Pop Art and Nouveau Réalisme ("Assemblage") to Fluxus and the New Concrete Art of the 1960s, with its systems of order based on random decisions.[2] While we think we are familiar with this prototype of the aesthetics of chance, not least though its omnipresence as a cited example, we know almost nothing about the actual process of its making or how it ranked in importance within Duchamp's artistic development. Indeed, doubts have even been expressed lately as to whether this work did in fact come into being through chance at all.[3]

Duchamp regarded the *3 Standard Stoppages* as one of his key works. When asked by the museum curator Katharine Kuh which of his works he considered to be the most important, he replied: "As far as date is concerned I'd say the *Three Standard Stoppages* of 1913. That was really when I tapped the mainspring of my future. In itself it was not an important work of art, but for me it opened the way—the way to escape from those traditional methods of expression long associated with art."[4] And in 1963, in conversation with Walter Hopps, the curator of his first retrospective at the Pasadena Art Museum, Duchamp

described the 3 *Standard Stoppages* as his "favorite work."[5] Entirely contradicting the importance Duchamp attached to this work, however, is the fact that he did not exhibit it for twenty-two years. What might be the explanation? What status did the work have in his newly developing approach to art in 1913? What had prompted the painter Marcel Duchamp to perform an experiment with the standard unit of length of one meter? What did this have to do with painting or with art at all? When the 3 *Standard Stoppages* came into the collection of the Museum of Modern Art in New York as a donation from the estate of Katherine S. Dreier in 1953, Duchamp completed a museum questionnaire concerning the work's history, the technique used in its making, and its significance. His answers made reference to numerous fields of thought that were as complex as they were disparate. While declaring, "My first use of 'chance' as a medium" as the "Subject" of the work, the section headed "Significance" was filled in as follows: "Part of reaction against 'retinal' painting (peinture rétinienne). Broyeuse de chocolat—first step toward depersonalizing straight lines by tension of lead wire—a joke about the meter—a humorous application of Riemann's post-Euclidean geometry which was devoid of straight lines. Not first-hand but part!—Cf. Max Stirner—Le moi et sa propriété."[6] Thus, from what Duchamp wrote in this questionnaire, the 3 *Standard Stoppages* signified far more than just an experiment with chance. But how did chance relate to non-Euclidean geometry, or the latter to the philosophy of Max Stirner? These relationships are the subject of this book, as is the question concerning the significance of the 3 *Standard Stoppages* for Duchamp's artistic development during his years of radical change, 1913 and 1914, when he concentrated his entire energy on the production of one single work, the large-format glass painting *The Bride Stripped Bare by Her Bachelors, Even*.

Finding no art-historical explanations for Duchamp's radically new approach, researchers are occasionally accused of seeking answers beyond the realm of art and, in so doing, getting lost in pure speculation.[7] While this criticism may be justified with reference to those unsubstantiated interpretations of his oeuvre as an alchemistically and cabbalistically coded work, it misses the mark entirely

where questions of modern geometry are concerned. Hundreds of notes, preserved by Duchamp more carefully than his Readymades, concern the problems of representation that arise when the principles of Euclidean geometry yield to those of four-dimensional and non-Euclidean geometry. Although it has been admitted that the link between Duchamp's oeuvre and questions of modern geometry and scientific theory is quite justifiable in view of this source material, the general view is that "any direct connection with his works is difficult to establish in most cases."[8] In the following I shall show that the connection in the case of the 3 *Standard Stoppages* could not be more direct and that this work is concerned not with speculations entirely unrelated to art but, on the contrary, with the scientific fundamentals of all post-Renaissance painting.

Central to Duchamp's preoccupation with modern geometry was the constitutive problem of representation since the time of Alberti: the depiction of three-dimensional space on a two-dimensional surface through the use of linear perspective. While cubist painting, during the first decade of the twentieth century, had irrefutably brought home the crisis of the old scopic regime based on perspectivalism, it was around that time, and much to the surprise of most scholars of modern art history, that linear perspective reappeared with a vengeance in the oeuvre of Marcel Duchamp. This was not, as Jean Clair put it, a "project of restoration" expressing a "retrogressive move" on the part of the artist but rather a process of deconstruction of the perspectival notion of the image.[9] In his notes and pictorial experiments for the *Large Glass*, Duchamp breaks down this notion of the image into the metaphors on which it is based—that is, the idea of the image as a window and that of the rays of vision as threads—and reflects upon these metaphors in terms of a more complex, four-dimensional, and non-Euclidean geometry. This book will show that the "fabrication" of the 3 *Standard Stoppages* was an integral part of this theoretical study. Originally, the 3 *Standard Stoppages* did not take the form of a wooden box containing an experimental setup, as they exist today in the collection of the Museum of Modern Art,[10] but that of three paintings on canvas, the making of which was inspired not only by

Introduction xiii

Duchamp's thoughts on chance but also, and just as much, by his reflections on the status of the straight line in non-Euclidean geometry and on the metaphor of the ray of vision as a thread in the classical theory of perspective.

The decade leading up to the First World War saw a profound transformation of the notion of the image that had held good since the Renaissance: the painting as a window to an empirical, observed, or imagined reality had now given way to the painting as an autonomous reality of forms and colors. In this art-aesthetic discourse, Duchamp adopted the most radical stance. Basing his reflections over the scientific fundamentals of visual representation on the new space models of non-Euclidean and four-dimensional geometry, which operated with higher, invisible dimensions, Duchamp arrived at a notion of the image that transcends the limits of painting. The 3 *Standard Stoppages* reached beyond the cubists' still young redefinition of painting as an autonomous composition toward a scientifically underpinned notion of the image as a functional, epistemic object. Whereas hitherto the term "artist" referred purely to the creator of paintings and sculptures, it was now extended—following the inception of the 3 *Standard Stoppages*—to include the invention of experimental setups in which "images" are both the instruments and the results of an experiment. The 3 *Standard Stoppages* established a new style in the art of the twentieth century, one of experimental visual thinking. Within the development of Duchamp's oeuvre, the 3 *Standard Stoppages* was a transitional work that united both the autonomous and the functional notion of the image—extremes that, admittedly, do not reveal themselves clearly until one examines the twenty-year material genesis of this work in all its complexity and detail.

Theoretically, Duchamp's aesthetic of chance was closely bound up with the category of the possible. His new artistic techniques of 1913 and 1914—from the unclassifiable 3 *Standard Stoppages* in their original form as three "canvases" to the equally unclassifiable "ready-made sculptures" of a bottle rack and a bicycle wheel on a kitchen stool—were based on a new kind of aesthetic that centered around the notion of the "possible." Neither "likeness" nor "truth" was its key

aspect, as in all the brands of realism; nor beauty, harmony, or balance, as in the aesthetics of formalism; but rather "the possible" in the sense of what is merely conceivable, the idea that all things can be perceived and conceived differently. Waiving the effect of enchantment through beauty, Duchamp's aesthetics took the form of a mental and visual experiment that relied on shock, surprise, and discovery for its success and, if successful, suddenly opened up the horizon for the viewer. Ignoring the traditional aesthetic discourse on form, Duchamp gave priority to the intellectual gift of invention, to the pleasure of thinking and visualizing what had never been thought before. With the *3 Standard Stoppages* Duchamp established an aesthetic of the possible, an aesthetic in which the boundaries between science and art, artwork and experiment, art and non-art no longer existed. The new approach to the making of art manifest in the *3 Standard Stoppages* ultimately led to the experimentalization of art that has now been a characteristic of contemporary art for the past half a century.

It is a well established fact in Duchamp scholarship that the scientific theories of the mathematician Henri Poincaré were one of Duchamp's most important sources of inspiration. This also applies, and particularly so, in the case of the *3 Standard Stoppages*. In the studies of Craig E. Adcock, we are offered a picture of Duchamp as an artist who has translated Poincaré's "conventionalistic" philosophy of science into the language of fine art.[11] Linda D. Henderson produces an image of Duchamp as an "artist-engineer-scientist," a kind of "anti-Bergsonian" scientific artist who took a stance for rational, scientific thought versus intuition.[12] Duchamp's stance on Poincaré's theories, however, was in no way clear, but full of contradictions. A closer study of the philosophical discourse at the beginning of the twentieth century will show that, in the controversy between Henri Poincaré and the Bergsonian philosopher Édouard Le Roy over the value of science, Duchamp's art sides *against* the rationalism of Henri Poincaré and *with* the nominalistic theory of Édouard Le Roy, according to which all laws, axioms, and standard measures are the arbitrary constructs of scientists. From 1913 onward, the subversion of scientism became the main intent of Duchamp's art, the *3 Standard Stoppages* being the work

that marked the inception of this new aesthetic. From then on, every single artistic work and action by Duchamp was aimed at undermining the primacy of science as the dominant model for explaining the world. The intellectual tools of his new parascientific aesthetic were humor and irony, his model the "Pataphysics" of Alfred Jarry. In Duchamp's weltanschauung, where science was no longer a valid explanatory model of the world or a substitute for religion, where there were no longer any absolute certainties or truths, the only remaining fixed point of reference was the individual himself; hence Duchamp's lifelong fascination for the radically original theses of the German philosopher Max Stirner, whose main work, *The Ego and Its Own*, was published in two separate French translations in 1900. It was through this work that the Parisian milieu of intellectual anarchy at the beginning of the twentieth century found itself in the limelight, especially the group around the magazine *L'Action d'art*, with which Duchamp shared not only radical individualism but also the idea that artistic activity consisted not in the production of works of art but in making a work of art out of life itself.

The present study evolved from the author's series of lectures on the oeuvre of Marcel Duchamp at the Ruhr University of Bochum and the Humboldt University of Berlin. An initial résumé was presented at the symposium Methods of Understanding in Art and Science: The Case of Duchamp and Poincaré, at Harvard University in Cambridge, Mass., in 1999. The book was finished during a one-year research fellowship at the Berlin Institute of Advanced Study in 2002 and 2003. The author's grateful thanks go to the Institute of Advanced Study for having made the final completion of this book possible. Jacqueline Matisse-Monnier and the Association Marcel Duchamp deserve the author's special thanks for having contributed to the translation costs. Without this generous support it would not have been possible to publish this book in English.

Duchamp and the Aesthetics of Chance

1 | THE IDEA OF THE FABRICATION

Duchamp's idea for the fabrication of the *3 Standard Stoppages* is written on a piece of notepaper in the "Box of 1914." The latter was originally a box for photographic plates, measuring 18 x 28 cm, in which Duchamp collected photographic reproductions of the manuscripts of fifteen sketched ideas and a drawing (see fig. 1.1).[1] The note reads as follows: "The Idea of the Fabrication: If a straight horizontal thread one meter long falls from a height of one meter on to a horizontal plane distorting itself *as it pleases* and creates a new shape of the measure of length.—3 patterns obtained in more or less similar conditions: *considered in their relation to one another* they are an *approximate reconstitution* of the measure of length" (see fig. 1.2).[2] On an additional slip of paper pasted to the bottom of the notepaper is written: "The 3 Standard Stoppages are the meter diminished." The first sentence of this "idea of the fabrication" and the note "3 Standard Stoppages: Canned chance. 1914" were published by Duchamp in the box *La Mariée mise à nu par ses Célibataires, même* in 1934. Known as the *Green Box*, it contained ninety-four facsimile notes and reproductions of studies and paintings for the *Large Glass*.[3]

The succinctness of Duchamp's note awakens the impression that in 1913 he suddenly had the idea of changing the form of the revered platinum-iridium standard meter (kept in the Pavillon de Breteuil in Sèvres, near Paris) in an unusual experiment using three pieces of thread and, in so doing, transforming this standard measure, valid in vast parts of the world, into a random variable. His numerous descriptions, given after 1945, of his method of conducting the experiment bear out this impression. In his conversations with the art critic Pierre Cabanne, published in Paris in 1967, Duchamp says:

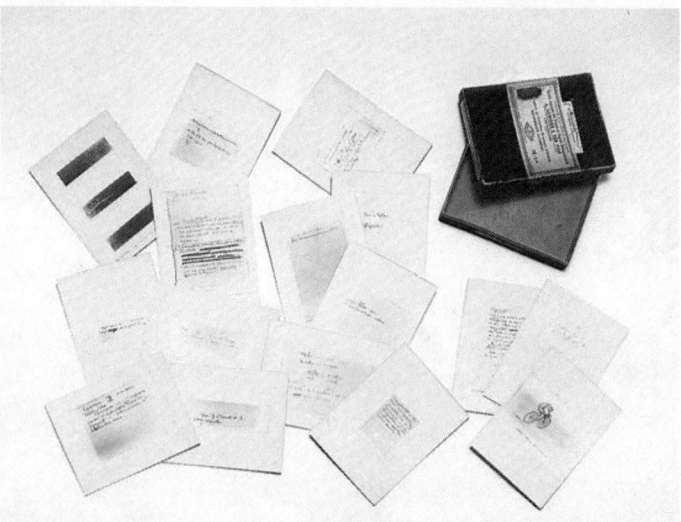

Fig. 1.1 Duchamp, *The Box of 1914*. Cardboard box for glass negatives "A. Lumière & ses Frères" with sixteen photographic reproductions of fifteen manuscript notes and one drawing, mounted on fifteen mat boards (25 x 18.5 cm).

Source: Philadelphia Museum of Art, Gift of Alexina Duchamp, 1991. © Succession Marcel Duchamp/VG Bild-Kunst, Bonn 2008.

> The idea of 'chance',[4] which many people were thinking about at the time, struck me too. The intention consisted above all in forgetting the hand, since, fundamentally, even your hand is chance. Pure chance interested me as a way of going against logical reality: to put something on a canvas, on a bit of paper, to associate the idea of a perpendicular thread a meter long falling from the height of one meter onto a horizontal plane, making its own deformation. This amused me. It's always the idea of 'amusement' which causes me to do things, and repeated three times.... My 'Three Standard Stoppages' is produced by three separate experiments, and the form of each one is slightly different. I keep the line, and I have a deformed meter. It's a 'canned meter', so to speak, canned chance.[5]

Fig. 1.2 Duchamp, "The Idea of the Fabrication," note from *The Box of 1914*.

Source: Philadelphia Museum of Art, Gift of Alexina Duchamp, 1991. © Succession Marcel Duchamp/VG Bild-Kunst, Bonn 2008.

According to Duchamp, this at once pseudoscientific and artistic experiment was performed as follows: From a height of one meter, three white threads, each one meter long and held straight and horizontal, were each dropped onto three narrow canvases. The thin threads were then fixed in position by means of varnish. Thus three lines, each following a different course, appeared on the canvases, lines that were not drawn by hand but, rather, created purely by chance. Moreover, they were lines that made no reference to any figure in the outside world. Indeed, they were totally self-referential, leading a material existence as threads independently of anything existing beyond the image. On each of the three vertically held canvases Duchamp then glued a leather label bearing, in golden, embossed letters, the inscription: "3 STOPPAGES ETALON, 1913–14" (see fig. 1.3). In none of his many descriptions of this experiment does Duchamp say that the canvases are painted in a dark Prussian blue; nor does he mention the fact that the threads are not only fixed with varnish but also stitched through the canvas at both ends and are therefore actually longer than one meter, the surplus ends likewise being fixed with varnish to the rear sides of the three canvases and measuring anything between 5.5 and 12.5 cm;[6] nor does he at any time say that in 1936 he fundamentally altered the appearance of this work. Our first task, therefore, will be to examine and, if possible, resolve the contradiction between the material appearance of the *3 Standard Stoppages* and the "idea of the fabrication" on which it was based.

Fig. 1.3 [opposite] Duchamp, *3 Standard Stoppages*, 1913–1914. Three white threads glued to three painted canvas strips (120 x 13.3 cm), each mounted on a glass panel (125.4 x 18.4 cm).

Source: The Museum of Modern Art, New York, Katherine S. Dreier Bequest, 1953. © Succession Marcel Duchamp/VG Bild-Kunst, Bonn 2008. Digital image © The Museum of Modern Art/Licensed by SCALA/Art Resource, NY.

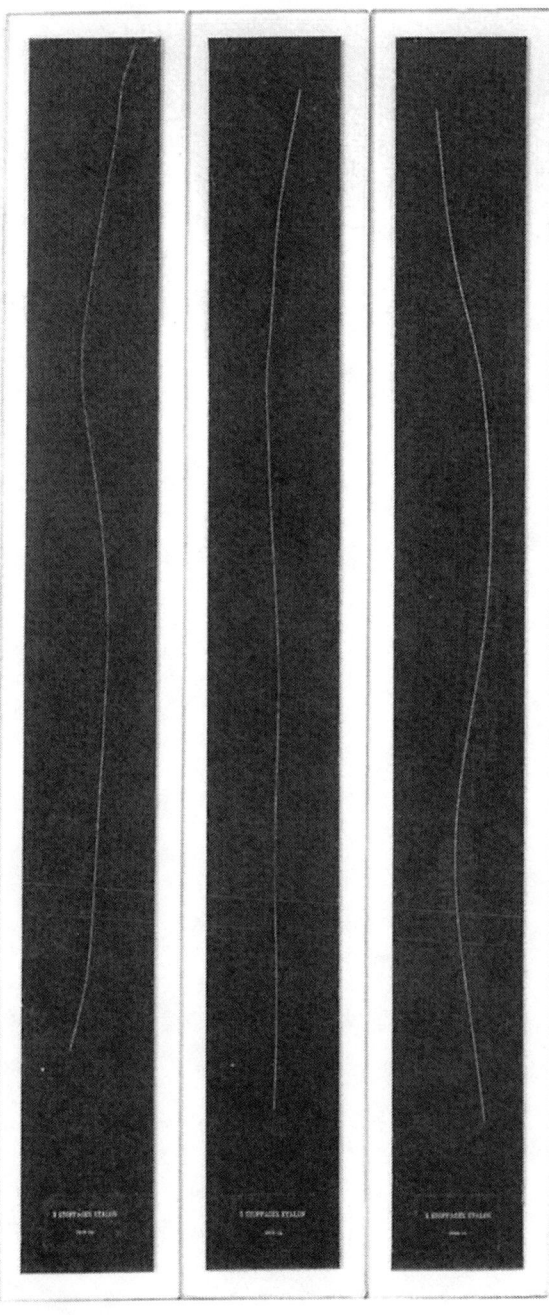

2 | *THE 3 STANDARD STOPPAGES* IN THE CONTEXT OF THE *LARGE GLASS*

Like everything produced by Duchamp between the years of 1913 and 1915, the *3 Standard Stoppages* were a by-product of his preoccupation with his main work, the large-format glass painting *La Mariée mise à nu par ses Célibataires, même* (see fig. 2.1). A strenuous tour of the collections of the public art museums of Basel, Munich, Dresden, Leipzig, Berlin, Prague, and Vienna during a three months' stay in Munich in the summer of 1912 had inspired the then only twenty-five-year-old artist to turn his back on the prevailing avant-garde tendency toward a deliterarization of painting and "to put painting once again in the service of the mind."[1] "Art or anti-art? was the question I asked when I returned from Munich in 1912 and decided to abandon pure painting or painting for its own sake. I thought of introducing elements alien to painting as the only way out of a pictorial and chromatic dead end."[2] Duchamp's intense confrontation over only a few months with many of the most significant masterpieces of Western painting had taught him that "in fact until the last hundred years all painting had been literary or religious; it had all been at the service of the mind."[3] In contemporary painting, on the other hand, the medium itself had become the focal point of interest. "There was no thought of anything beyond the physical side of painting. No notion of freedom was taught. No philosophical outlook was introduced."[4] Looking back at the fruits of his stay in Munich, Duchamp concluded that the painters of the Renaissance and the baroque were not interested in the paint tube itself but rather "in the idea of expressing the divine in one form or another. Without wanting to do the same, I maintain that pure painting as an aim in itself is of no import."[5] The young Duchamp took upon himself the risk of searching for a completely new approach for

the modern painter, an approach far removed from both that of the Cubists and that of pure, abstract painting in the style of Kandinsky, which Duchamp had seen in Munich. This new approach would steer him toward a renewed literarization and intellectualization of painting via, and beyond, his admired models, Odilon Redon and Arnold Böcklin.[6]

And so it was that he took the bold decision to do the same as the great masters of the past and create a large-format painting in tune with the most advanced ideas of his time: *The Bride Stripped Bare by Her Bachelors, Even*. Needing to familiarize himself with these ideas, Duchamp withdrew from the hustle and bustle of the Parisian art scene, ceased to exhibit, enrolled in a course on librarianship at the Sorbonne, and, in November 1913, took on employment with the Bibliothèque Sainte-Geneviève, where in his spare time—and according to him there was plenty of it—he pursued theoretical studies in the fields of geometry, philosophy, science, and perspective.[7] The theme of his large-format painting had already crystallized out of a series of drawings and paintings in Munich and was just as "classical" as Duchamp's aim to "put painting once again in the service of the mind."[8] Prepared over a period of two years with countless literary drafts, sketches, and drawn and partially painted studies, it was to be a complex modern allegory of love. His chosen mode of representation for the erotic relations between the sexes, which were doubtless based on his own experiences and emotions, could not have been more sober and impersonal: mechanical drawing. The entire scenario took the form of a fantasy machine projected onto a glass support, its components and mode of operation remaining undecipherable for the viewer until 1934, when Duchamp published the preparatory notes and studies (in the aforementioned *Green Box*) as a literary counterpart to the painting, a publication that had been planned from the beginning. However, the "commentaries" on the figures and forms depicted in the *Large Glass* were anything but explanatory. No less ambiguous or freely interpretable than the visual forms in the glass painting itself, these commentaries, couched in the metaphorical

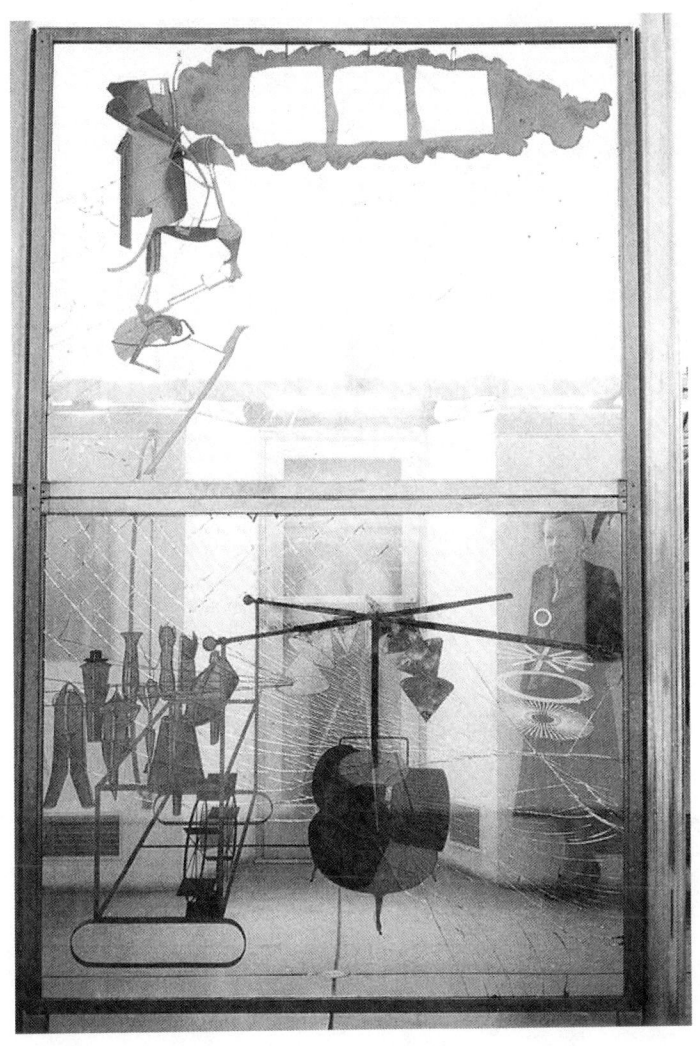

Fig. 2.1 Duchamp, *The Bride Stripped Bare by Her Bachelors, Even*, 1915–1923. Oil, varnish, lead foil, lead wire, and dust on two glass panels (cracked), 277.5 × 175.8 cm.

Source: Philadelphia Museum of Art, Bequest of Katherine S. Dreier. Photo Marcel Jean, 1958. © Succession Marcel Duchamp/VG Bild-Kunst, Bonn 2008.

language of psychologized physics and chemistry, portrayed love as an erotic funfair.

During his preparations for *The Bride Stripped Bare by Her Bachelors, Even*, Duchamp soon realized that it was not possible, in a context akin to eroticized publicity, cinematic frivolity, and the total scientification of human existence, to represent erotic desire with the metaphysical gravity of a Titian or a Böcklin. The intellectual tradition of Rabelais or Jarry seemed to be a more apt and modern line of approach to a complex of experiences in which passions, already dissected into their constituent parts by the incipient science of sexology, were now being pathetically exaggerated by popular contemporary fiction. By contrast, Duchamp's large glass painting was to be a "hilarious picture."[9] Erotic processes were translated into the language of mathematical theorems or physicochemical experiments; the idioms of physics and chemistry were imbued with latent sexual connotations. With such terms as "sex cylinder," "love gasoline," desire-magneto," "emancipated metal," "re-integrated friction," "monotonous fly wheels," "oscillating density," "cinematic blossoming," "electrical stripping," and the like, Duchamp's scientific "poésie en prose" made strange reading indeed.

Duchamp's representation of this "reality which would be possible by slightly distending the laws of physics and chemistry"[10] was based not on the Euclidean, three-dimensional concept of space but rather on the new four-dimensional and non-Euclidean concepts that were among the most talked-about questions of modern scientific thought in the circles of avant-garde artists around 1910. Duchamp had first been confronted by these questions toward the end of 1911 in the "Circle of Puteaux," a group of young cubist painters that met every week in the studios of Duchamp's two elder brothers, the painter Jacques Villon and the sculptor Raymond Duchamp-Villon, in Puteaux, a suburb of Paris, where they discussed the geometrical and theoretical fundamentals of their new style of painting.[11] Albert Gleizes, Jean Metzinger, Fernand Léger, Frank Kupka, Georges Ribemont-Dessaignes, and Guillaume Apollinaire counted among the most important members of the group, as did Maurice Princet, a young actu-

ary who, according to Duchamp, "played at being a man who knew the fourth dimension by heart."[12] Just as linear perspective in art had been based since the Renaissance on the principles of Euclidean geometry, these young painters, led first and foremost by Jean Metzinger, sought in these latest geometrical theories a scientific legitimization for their break with linear perspective. Their development of "multipoint perspective" had led to a new kind of simultaneous picture space that opened up a whole panorama of different facets of the same subject matter. As modern mathematicians no longer limited their thinking to the three dimensions of Euclidean geometry, the cubist painters did likewise and invented visual forms of expression for the new possible dimensions of space. That was the fundamental idea behind their discussions,[13] and no other member of the group took it up as intensively as Marcel Duchamp, for it was ultimately to take him beyond the boundaries of painting.[14] The scale of his fascination with the idea is clearly revealed in Gertrude Stein's account of her first meeting with him. What she noted in particular—according to one of her letters to a friend in New York—was that Duchamp talked "very urgently about the fourth dimension."[15]

Duchamp's mathematical inclinations had already been noticed by art critics in his paintings of 1911 and 1912. "The mathematical mind seems to prevail in Marcel Duchamp," wrote the author Jacques Nayral, one of the members of the Circle of Puteaux, in the foreword of the catalogue of the "Exposicion d'arte cubista" at the Dalmau Gallery in Barcelona in April and May 1912. "Some of his works are purely diagrams, as though he were concerned just with problems and demonstrations. Marcel Duchamp does indeed distinguish himself through an extremely speculative boldness. He tries to generate a double dynamic, a subjective one and an objective one: with his 'Nude Descending a Staircase,' for example."[16] The painter and essayist Georges Ribemont-Dessaignes disclosed in his memoirs that Duchamp's tendencies toward abstract reasoning soon went too far for the painters in Puteaux, not least because his contributions, which were concerned "above all with non-Euclidean geometry

and Lobachevsky's four-dimensional space," were "not at all artistic or creative" ("*nullement plasticiens*").[17] Duchamp's argumentation, writes Ribemont-Dessaignes,

> transcended the creative possibilities of the painters and called in question the accepted notions of the universe; its consequences were so negative that the minimum of stability necessary for the existence of a school that was basically meant to be constructive was destroyed. ... Duchamp's approach incessantly challenged sound human reason; it was considered inordinate, a public danger, for it was actually detrimental to the notion of art.[18]

Duchamp never made a secret about giving his new kind of art a scientific basis: "All painting, beginning with Impressionism, is antiscientific, even Seurat. I was interested in introducing the precise and exact aspect of science, which hadn't often been done, or at least hadn't been talked about very much. *It wasn't for love of science that I did this; on the contrary, it was rather in order to discredit it, mildly, lightly, unimportantly*. But irony was present."[19] This contradiction, that is, his fascination with modern scientific thought, on the one hand, and, on the other, his simultaneous ironization of the claim laid by science to universal truths, was to be the hallmark of his entire oeuvre from 1913 onward.

Taken seriously, the concept of four-dimensional geometry, being a purely mathematical one, could indeed be an intellectual hazard for the visual artist. The fourth dimension as postulated by four-dimensional and n-dimensional geometry is not time, as in the sense of Einstein's theory of relativity, but an additional space axis. Like a conceivable fifth, sixth or nth dimension, this axis gives space a structure that is intelligible not to our senses of perception but only to mathematical thought. And since it was precisely this abstract, mathematical concept of space on which Duchamp based *The Bride Stripped Bare by Her Bachelors, Even*, literary metaphor and visual image, imagination and representation, were no longer combinable in one single painting but realizable only in the form of a new artistic entity of image and words, picture and book.

THE PANE OF GLASS AS A MATERIALIZED PLANE INTERSECTING THE VISUAL PYRAMID

According to his published notes, Duchamp had at the time studied Esprit-Pascal Jouffret's *Traité élémentaire de la géometrie à quatre dimensions et introduction à la géometrie à n dimensions* of 1903,[20] but what was just as important for the development of his new geometrical thought, if not more so, was the study of the theoretical writings of the great French mathematician Henri Poincaré, in which the most important theorems of the new geometries were not only clearly explained but also discussed with reference to their significance for the fundamental questions of science and philosophy. *Science and Hypothesis* (1902), *The Value of Science* (1905) and *Science and Method* (1908) are works that still have an important part to play in debates on scientific theory even today.[21]

It was from the writings of Jouffret and Poincaré that Duchamp learned that Euclidean geometry is just one of many possible geometries and that new scientific thinking presupposed that space had more than three dimensions.[22] By 1913, Duchamp was convinced that four-dimensional geometry must bring about a revolution in painting as great as the Renaissance, when the artists began to base their painting on the principles of Euclidean geometry and optics. The results of Duchamp's studies on four-dimensional space and its visual depiction have survived in a collection of notes that he considered to be still worth publishing much later on in life, only two years before his death. The notes were published at the turn of 1967 under the title *A l'Infinitif*.[23]

In *The Value of Science*, Poincaré had based his definition of the number of dimensions of a continuum on the idea of the "cut." "To divide space," Poincaré writes, "cuts that are called surfaces are necessary; to divide lines, cuts that are called lines are necessary; to divide lines, cuts that are called points are necessary; we can go no further, the point cannot be divided, so the point is not a continuum."[24] Duchamp took Poincaré's definition and developed it in all possible directions in order to find an answer to the question: If three-dimensional space

is a cut through a four-dimensional continuum, how can this four-dimensional space continuum be represented artistically?[25] For his part, Poincaré had in his last large treatise, *Science and Method* of 1908, pointed out the impossibility of visualizing a four-dimensional experience of space, as sensory perception—via geometrical analogies—can assist mathematical thought only as far as the third dimension: "Unhappily our senses cannot carry us very far, and they desert us when we wish to soar beyond the classical three dimensions."[26] Most artists would have seen these words as a warning not to take the matter any further. Not so Duchamp. He had evidently sunk his teeth into another, contrary statement made by Poincaré in the same book: "We must achieve its [i.e., the qualitative geometry of *analysis situs*] complete construction in the higher spaces; then we shall have an instrument *which will enable us really to see in hyperspace and supplement our senses.*"[27] Pages upon pages of notes in *A l'Infinitif* seek an answer to the central question: "What *representation* can one give of a 3-dim'l space in a 4-dim'l continuum?"[28] Duchamp thought he would be able to solve this problem of representation analogously by mentally stepping down a dimension and comparing the structures of the three-dimensional perception of a flat world with the two-dimensional perception of this same world. This was not necessarily something new. In his popular science-fiction novel, *Flatland* of 1884, Edwin Abbot humorously speculated over the structure of perception of two-dimensional beings and over the kind of geometry with which this could be constructed on the basis of their sensory perception.[29] Poincaré used this literary metaphor in *Science and Hypothesis* to explain the peculiarities of Riemann's geometry.[30] "Flat beings" perceive a line in a surface, for example, not as a line but as a wall. In order to locate the line in their space continuum, they must walk around it and measure lengths and angles in relation to other points and lines and integrate them into a mental construct of space. Three-dimensional beings, on the other hand, have an overview of the two-dimensional continuum and therefore see the line simultaneously from all sides. Just as the three-dimensional eye does not see a line in a surface as an impenetrable wall, the four-dimensional eye—Duchamp assumes—will not

see a three-dimensional body as a solid, impenetrable obstacle but as a transparent object visible simultaneously from all sides.

Thus, according to Duchamp, the hypothetical four-dimensional perception of the three-dimensional world is characterized by transparency. "The 4-dim'l native," he writes in a long note on the *Large Glass*, "when perceiving this symmetrical 4-dim'l body will go from one region to the other by *crossing instantaneously* the median space3. One can imagine this instantaneous crossing of a space3 by recalling certain effects with 3-sided mirrors in which the images disappear (behind) new images."[31] It is in the context of such reflections that Duchamp's reasons for replacing opaque canvas with a pane of glass as the support for *The Bride Stripped Bare by Her Bachelors, Even* are to be found. The first draft of this modern sexual allegory was still based on the traditional medium of oil on canvas.[32] "From the 2-dim'l perspective giving the appearance of the 3-dim'l continuum, construct a 3-dim'l (or perhaps a 2-dim'l perspective) of this 4-dim'l continuum. . . . Use transparent glass and mirror for perspective4," Duchamp noted sometime in 1913.[33] In his search for a solution to this problem of representation, he again had to step down a dimension mentally. He began studying the numerous classical treatises on perspective at the Bibliothèque Sainte-Geneviève,[34] that is, the geometrical methods of projecting three-dimensional solids onto a two-dimensional surface. "See Catalogue of Bibliothèque Ste-Geneviève the whole section on Perspective," Duchamp wrote in one of the notes in the *White Box*.[35] The collection of the Bibliothèque Sainte-Geneviève was particularly rich in classical treatises on perspective. All the important works from the years between 1640 and 1680, "the golden age of the perspective treatise in France,"[36] were in this collection.[37]

It was during his studies on perspective that he came across Jean du Breuil's *La Perspective pratique nécessaire à tous les peintres, graveurs, sculpteurs etc.* (1642–1648), which from then on was to be one of his most important and long-lasting sources of artistic inspiration.[38] His study of du Breuil's illustrations of the use of the drawing frame and other tried and tested aids to painting and drawing in perspective brought home to him the significance of the window as the paradigm of the post-Renaissance notion of the image (see fig. 2.2). "We shall

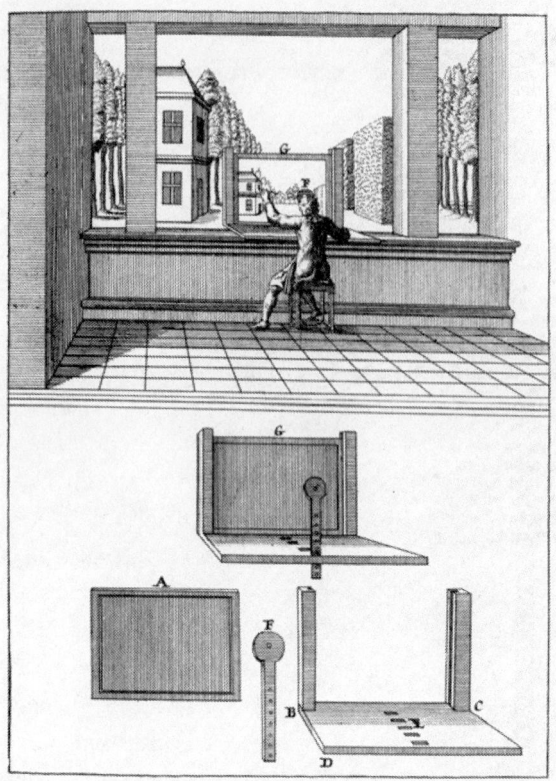

Fig. 2.2 Jean du Breuil, Une très belle invention pour pratiquer la perspective, sans savoir, ni observer les règles.

Source: Breuil, La Perspective pratique, nécessaire à tous les peintres..., vol. 2, Paris 1663.

speak of a fully 'perspectival' view of space," writes Erwin Panofsky with reference to Leon Battista Alberti's treatise Della pittura of 1435,

> not when mere isolated objects... are represented in 'foreshortening', but rather only when the entire picture has been transformed—to cite another Renaissance theoretician—into a 'window', and when we are meant to believe we are looking through this window into space. The material surface upon which the individual figures or objects are drawn or painted or carved is

thus negated, and instead reinterpreted as a mere 'picture plane'. Upon this picture plane is projected the spatial continuum which is seen through it and which is understood to contain all the various individual objects. So far it does not matter whether this projection is determined by an immediate sensory impression or by a more or less 'correct' geometrical construction.[39]

Leonardo da Vinci, too, defined the perspectival representation of space precisely in this sense, namely as a *"parete di vetro"* (wall of glass): "Perspective is nothing else than seeing a place (*sito*) behind a pane of glass, quite transparent, on the surface of which the objects which lie behind the glass are to be drawn. They can be traced in pyramids to the point in the eye and these pyramids are intersected by the glass plane."[40]

Duchamp, at once a Cartesian, mathematical thinker and a visual artist oriented toward the concrete appearance of things, had noted that while the perspectivally executed painting opened a kind of window onto an imaginary reality, it also obscured the viewer's view

Fig. 2.3 Jean du Breuil, Pour trouver le raccourcissement des figures qui doivent paraître droites sur des plats-fonds & voûtes, sans savoir, ni observer les règles de perspective, que naturellement.

Source: Breuil, *La Perspective pratique, nécessaire à tous les peintres*..., vol. 2, Paris 1663.

of the real space of his immediate surroundings. In choosing glass instead of canvas as the projection plane for his fictitious love machine, Duchamp interpreted Leonardo da Vinci's definition quite literally and materialized the virtual plane that intersects the rays of the visual pyramid—that invisible plane inherent in any perspectivally executed painting—in the form of a real "*parete di vetro*."[41]

By rendering the opaque picture plane transparent, Duchamp integrated the imaginary picture space on this plane into the viewer's real space. As the viewer looks at and through the wall of glass, the static, perspectively constructed virtual space on the picture plane merges with the real, three-dimensional spaces in front of and behind the glass, these spaces constantly changing through the coming and going of other viewers. At the same time, the viewer can focus his eyes on his own reflection looking at the work. In this way, the viewers standing on both sides of the glass become real and moving constituent parts of the work. At that point in time, Duchamp was evidently sure of having found a sensory equivalent of four-dimensional perception. The pane of glass, construed as a wafer-thin body or wafer-thin space, corresponds to the "median space3" that is "crossed instantaneously" by the four-dimensional gaze when it "goes from one region to the other."

The fact that Duchamp linked his reflections on four-dimensional perspective with those speculations over "measurements, straight lines, curves, etc."[42] that were preoccupying him during his work on the *Large Glass* brings us straight to the connection between the *3 Standard Stoppages* and the complex spatial concept behind *The Bride Stripped Bare by Her Bachelors, Even*.[43]

DEPERSONALIZING STRAIGHT LINES

Projected in linear perspective onto the lower half of the *Large Glass*, the *Bachelor Machine* centers around a *Broyeuse de chocolat* (*Chocolate Grinder*), a fantasy apparatus comprising three roller drums on a castor-mounted Louis XV occasional table. Before executing it on glass, Duchamp had in the years of 1913 and 1914 depicted it in several

sketches,[44] in two large-format oil studies,[45] and, fully elaborated, in two oil paintings (see fig. 2.4).[46]

Chocolate Grinder I, painted, according to Duchamp, in 1913,[47] was the first painting for which he had renounced the decomposing technique of cubism in favor of a "painting of precision,"[48] an objective form of representation that from then on was to characterize his sketches for the *Large Glass*. On the questionnaire of the Museum of Modern Art Duchamp had answered the question concerning the

Fig. 2.4 Duchamp, *Broyeuse de chocolat II (Chocolate Grinder II)*, 1914. Oil and thread on canvas, 65 x 54 cm.

Source: Philadelphia Museum of Art, The Louise and Walter Arensberg Collection. © Succession Marcel Duchamp/VG Bild-Kunst, Bonn 2008.

"significance" of the 3 *Standard Stoppages* as follows: "Part of reaction against 'retinal' painting (peinture rétinienne). *Broyeuse de chocolat*—first step toward depersonalizing straight lines by tension of lead wire." The "tension of lead wire" referred to his representation of the *Chocolate Grinder* and the *nine malic moulds* on the *Large Glass* by means of lead wire. What links the 3 *Standard Stoppages* with the paintings of the *Chocolate Grinder* is the concept of "depersonalizing straight lines." Since working on these paintings, Duchamp no longer saw the line as an expressive value, as an expression of the "*état d'âme*" of the artist, but rather as a precise, object-defining form. It was now the vocabulary of form of the mechanical draughtsman that guided Duchamp's execution of *The Bride Stripped Bare by Her Bachelors, Even*. The more Duchamp's iconography fed on his sexual unconscious and his personal thoughts and emotions, the more he resorted to the use of impersonal methods of depiction. The *Chocolate Grinder* was meant to operate according to the "adage of spontaneity," Duchamp writes in his notes on the *Large Glass*, and "the bachelor grinds his chocolate himself"—a rather unveiled allusion to the onanistic inclinations of the bride's nine bachelors.[49] The formal problem, as Duchamp saw it in 1913, lay in the need to draw representationally without falling into the trap of academicism. "Mechanical drawing was the answer—a straight line drawn with a ruler instead of the hand, a line directed by the impersonality of the ruler. The young man was revolting against the old-fashioned tools, trying to add something that was never thought of by the fathers. . . . I unlearned to draw. The point was to forget *with my* hand."[50] Whereas in the paintings of the *Broyeuse de chocolat* it was the vocabulary of form of the mechanical drawing that "depersonalized" the straight line, in the 3 *Standard Stoppages* it was chance.

Even greater than the conceptual proximity suggested by the answers given on the MoMA questionnaire was the similarity of the technique and materials used for the 3 *Standard Stoppages* to those used for *Chocolate Grinder II*, which Duchamp completed in February 1914. The materials used for both works were identical: canvas, oil paint, varnish, and sewing thread. Like the lines of the 3 *Standard Stoppages*, the contours and interior details of the *Chocolate Grinder*

are formed by threads stitched through the canvas and fixed to it by means of varnish. Only by passing the threads through the canvas and then back again to the front was Duchamp able to tension the threads sufficiently in order to produce lines that were exactly straight (see fig. 2.5). Although Duchamp described this technique in detail in his dialogues with Pierre Cabanne, hardly any art historian has paid attention to it,[51] and no one has remarked on its affinity to the 3 *Standard Stop-*

Fig. 2.5 Duchamp, *Chocolate Grinder II*, reverse.

Source: Philadelphia Museum of Art, The Louise and Walter Arensberg Collection. © Succession Marcel Duchamp/VG Bild-Kunst, Bonn 2008.

The 3 *Standard Stoppages* in the Context of the *Large Glass* 21

pages. "That first 'Chocolate Grinder' is completely painted," he tells Cabanne, "whereas in the second version, not only is a thread glued with paint and varnish, but it's sewn into the canvas at each intersection."[52] Indeed, the *3 Standard Stoppages* and the painting *Chocolate Grinder II* seem to have been companion pieces within one and the same artistic project. The canvases of both are painted in a very similar dark Prussian blue—in one of Duchamp's early notes on the *Bride Stripped Bare by Her Bachelors, Even*, written when the work was still envisioned as an oil painting on canvas, this color was planned for the entire background.[53] In both cases, the titles have been applied to the fronts of the canvases in the form of small, gold-embossed leather labels, and both works bear inscriptions on their backs in the same style of lettering: "Broyeuse de chocolat 1914 / appartenant à Marcel Duchamp" and "3 Stoppages Étalon appartenant à Marcel Duchamp / 1913–14," respectively. One might say, in other words, that these representations of an imaginary machine and three imaginary standard measures belonged only to the world of the *Large Glass*, the fantasy world of Marcel Duchamp.[54] Duchamp's use of identical colors, materials, and techniques suggests that *3 Standard Stoppages* and *Chocolate Grinder II* were realized at about the same time, that is, in the spring of 1914. This is also borne out by the dating of the note "3 Standard Stops = canned chance" to 1914 in the *Green Box*.[55] The indication of 1913 in the dating "1913–14" very probably refers to the point in time when Duchamp first began to conceptualize the problem that finally led to "the Idea of the Fabrication" for these experimental works.

THE THREAD AS A METAPHOR OF THE VISUAL RAY

Duchamp's *Chocolate Grinder* was the first motif of the *Large Glass* to be drawn in linear perspective.[56] Having received no academic training apart from some brief preparatory courses at a private art school for the admission examination of the École des Beaux Arts, Duchamp was not all that skilled at drawing in perspective. His decision to study the classical treatises on perspective at the Bibliothèque Sainte-Geneviève

had doubtless been prompted not just by theoretical and historical interests but by interests of an altogether practical nature. During his studies he will certainly have come across the famous illustration in Albrecht Dürer's *Underweysung der Messung (Treatise on Measurement)* of 1525 showing a painter and his assistant working with a "perspective machine," the use of which was recommended in most of the treatises on perspective that followed during the sixteenth and seventeenth centuries (see fig. 2.6).[57] This machine consists of a small frame with a door that represents the picture plane. A length of string running from a fixed point on the wall at eye level and representing the ray of vision is joined successively to the various points of the lute that are to be drawn. The points where the ray of vision passes through the picture plane are registered by means of two horizontal threads that can be moved upwards and downwards and by means of two vertical threads that can be moved from side to side. Their points of intersection are transferred successively to the drawing paper fastened to the door until the foreshortened contours of the lute have been essentially depicted.

Fig. 2.6 Albrecht Dürer, Two draftsmen plotting points for the drawing of a lute according to the laws of foreshortening.

Source: Albrecht Dürer, *Underweysung der Messung* (Treatise on measurement), 1525.

Dürer's description of the "perspective machine" so clearly defines the theoretical and imaginary space from which Duchamp's "thread paintings" evolved that it certainly deserves to be quoted in full:

> *You can render anything within reach in correct perspective by means of three threads* and draw it on the table as follows: If you are in a large chamber, hammer a large needle with a wide eye into the wall. It will denote the near point of sight. Then thread it with a strong thread, weighted with a piece of lead. Now place a table as far from the needle as you wish and place a vertical frame on it, parallel to the wall to which the needle is attached, but as high or low as you wish, and on whatever side you wish. This frame should have a door hinged to it which will serve as your tablet for painting. Now nail two threads to the top and middle of the frame. These should be as long, respectively, as the frame's width and length, and they should be left hanging. Next, prepare a long iron pointer with a needle's eye at its other end, and attach it to the long thread which leads through the needle that is attached to the wall. Hand this pointer to another person, while you attend to the threads which are attached to the frame. Now proceed as follows. Place a lute or another object to your liking as far from the frame as you wish, but so that it will not move while you are using it. Have your assistant then move the pointer from point to point on the lute, and as often as he rests in one place and stretches the long thread, move the two threads attached to the frame crosswise and in straight lines to confine the long thread. Then stick their ends with wax to the frame, and ask your assistant to relax the tension of the long thread. Next close the door of the frame and mark the spot where the threads cross the tablet. After this, open the door again and continue with another point, moving from point to point until the entire lute has been scanned and its points have been transferred to the tablet. Then connect all the points on the tablet and you will see the result. And so it is that you may also draw other things.[58]

Thus just three threads, according to this great painter and draughtsman of the Renaissance, hold the entire secret of rendering "anything within reach in correct perspective." What is most significant here, and with particular reference to Duchamp's "thread paintings," is that a length of thread is used to represent the ray of vision.[59]

The Florentine painter Ludovico Cardi da Cigoli (1559–1613), a close friend of Galileo Galilei, developed this principle into a more complex instrument for perspectival drawing featuring an ingenious viewing and measuring system of articulated rods and cords (see figs. 2.7 and 2.8).[60] This system is illustrated no fewer than three times in Jean François Nicéron's treatise *Thaumaturgus opticus* of 1646, which Duchamp expressly mentions in his working notes from the *Large Glass*.[61] The most concise theoretical and pictorial demonstration of the metaphor of the visual ray as a thread is given in another treatise on perspective, likewise kept at the Bibliothèque Sainte-Geneviève, namely Abraham Bosse's *Manière universelle de M. Desargues pour pratiquer la perspective par petit-pied comme le Geometral. Ensemble des places et proportions des fortes et faibles touches, peintes ou couleurs* of 1647.[62] In this book, Abraham Bosse, himself a famous engraver and professor of perspective at the Académie Royale, expounds Girard Desargues's theory of perspective. Desargues was a friend of Descartes and Pascal and probably the "greatest perspectivist and projective geometer of his generation."[63] Interestingly enough, the book's illustrations have had a more sustained influence on the history of art than its theoretical content. Some of the illustrations are almost surrealist in style. They depict three elegantly dressed aristocrats gazing from different points of perspective, each of them raising to one of their eyes four threads attached to the four corners of a rectangle (see fig. 2.9). The commentary accompanying these illustrations reads as follows:

> The following…plates will show you how one can, if need be, use a physically perceptible means in order to help one's imagination to picture visual rays or the pyramid of vision.… Now these rays are so fine that we cannot perceive them without the help of the imagination. If you have not concerned yourself with them hitherto,

Fig. 2.7 Ludovico Cigoli's perspective machine.

Source: Jean-François Nicéron, *La Perspective curieuse* (Paris, 1652), Planche 73.

Fig. 2.8 Ludovico Cigoli's perspective machine.

Source: Jean-François Nicéron, *La Perspective curieuse* (Paris, 1652), Planche 75.

Fig. 2.9 Abraham Bosse: This plate shows how one can use a physically perceptible means in order to help one's imagination to picture visual rays or the pyramid of vision.

Source: Bosse, *Manière universelle de M. Desargues, pour pratiquer la perspective*, 1647.

or if you have not yet accustomed yourself to imagining them, or the idea of familiarizing yourself with them, by no matter what means, may displease you, the following three or four plates seem to me to be quite a simple means. Cut a square shape bcdf from any firm and heavy material and fasten four thin, supple threads to each of its four corners bo, co, do, fo, preferably longer than short, and place it either on the floor or on the wall or on the ceiling, in such a way that it cannot be moved out of place. Now take the four threads between your fingers as shown, always keeping each one so taut that it forms a straight line, and then move your hand to and fro, up and down, and all around the square, as shown by the figures, observing as you do so the order or arrangement formed by the threads together and considering the play of the threads among themselves; and also the various shapes they assume as they move closer together or further apart. Finally... raise to either one of your eyes the fingers in which you are holding, as explained above, the threads attached to the corners of the square, still keeping them straight and taut, at one time when you are standing, at another when you are sitting and again after climbing onto something, in other words, in every situation you could imagine. Holding the assemblage of threads before your eye, look at the square bcdf and you will at the same time see the threads coming from the corners; it will be as if each of these corners is coming toward your eye along one of the threads, or as if your eye is seeing these corners along the threads, the latter going all the way from it to them; and it would be the same for any other point on the square if you cared to fasten a similar thread to it; and it is by these means that the threads will represent the rays we call visual rays and will immediately fire your imagination; and the space they enclose between them represents for you the entire mass of all the visual rays with which your eye sees the square, this being what M.D. [Monsieur Desargues] calls the pyramid of vision.[64]

It was the principle of imagining the rays of vision as lengths of thread or string, a principle common to almost all classical treatises

on perspective, that gave Duchamp the idea—at first glance an absurd one—of using threads in the final version of the *Chocolate Grinder* to depict the contours and interior details of the rollers. By leaving out the dark, chocolate-brown shape underneath the Louis XV table on the first picture of the *Chocolate Grinder* and using threads as a means of drawing the rollers, Duchamp not only negated every functional and expressive element of the subject matter but also transformed the work into a piece of self-reflexive painting. "Remplacer ensuite chaque trait par un fil blanc ou de couleur—collé au vernis à la place des traits au crayon [Finally, replace each line by a white or colored thread—fixed with varnish to where the pencil strokes were]," wrote Duchamp in one of his notes from the *Large Glass*.[65] Those among us with a keen sense of humor will not fail to notice that du Breuil's treatise *La Perspective pratique nécessaire à tous les peintres, graveurs, sculpteurs . . .* , expressly mentions *"brodeurs"* (embroiderers) among the artists and craftsmen it addressed.[66] It was as an embroiderer working on the painting *Chocolate Grinder II* that Duchamp had his photograph taken in 1914. The portrait was submitted a year later for publication in the American magazine *Literary Digest* (see fig. 2.10).

Threads were also used in another perspectival drawing aid, namely the "grid" or "velum" (veil) invented by Leon Battista Alberti (see fig. 3.3).[67] Having described the use of the glass pane in his treatise *La Perspective nécessaire à tous les peintres, graveurs, sculpteurs etc.*, du Breuil then presented the "grid" as "another beautiful invention for practising perspective without knowing anything about it."[68] Here the painter views the subject matter through a frame subdivided into small squares by fine vertical and horizontal threads. With his viewpoint fixed by means of a peephole, the painter transfers the parts of the subject appearing in each square to the correspondingly squared paper in front of him. This drawing frame inspired Duchamp in 1914 to perform an experiment with a square veil for the purpose of determining the forms of the *pistons de courant d'air* (*draft pistons*) on the *Large Glass*—but more about this in the following chapter. The most famous illustration of this device, Dürer's woodcut, *The Designer of the Lying Woman*, from the second, posthumous edition of *Underweysung der*

Fig. 2.10 "Another Invader, Marcel Duchamp."

Source: "The European Art Invasion," *Literary Digest*, 27 November 1915, 126. © Succession Marcel Duchamp/VG Bild-Kunst, Bonn 2008.

Messung,[69] has been exhaustively discussed by Duchamp scholars as the source of inspiration for Duchamp's last large work, the life-sized "perspective machine" *Étant donnés: 1° la chute d'eau 2° le gaz d'éclairage* (1946–1966) at the Philadelphia Museum of Art.[70]

The idea of using threads to represent the lines of the perspectivally executed image in *Chocolate Grinder II* is entirely in keeping with Duchamp's general handling of linear perspective in his construction of *The Bride Stripped Bare by Her Bachelors, Even*. The perspectival projection of three-dimensional space onto a two-dimensional surface can no longer be unquestioningly taken for granted. While he applies it in his sketches, working drawings, and preparatory paintings, such as the *Chocolate Grinder*, he also visualizes its artificial geometricality. Duchamp's relationship to linear perspective is at once practical and

critically broken. Just as he materializes in the *Large Glass* the virtual plane that intersects the visual pyramid as a wall of glass, thus rendering it visible and tangible, so, too, does he materialize the lines of the perspectivally constructed image in the painting *Chocolate Grinder II* and the straight lines of the virtual visual pyramid on the canvases of the *3 Standard Stoppages* as threads.

Negating the spatial illusionism of the "*perspectiva artificialis*"[71] was the main problem of the generation of artists around 1910. The cubists, led by Picasso and Braque, resolved the problem by developing compositional means capable of awakening a sense of solidity and volume without constructing a geometrical picture space. Duchamp approached this problem more from a scientifically analytical angle than from any aspects of synthetic composition. He laid bare the metaphorical principles of the system of representation that since the Renaissance had been based on Euclidean geometry and applied them to the space model of the new and more complex geometries.[72] Indeed, Duchamp's entire oeuvre, from the *3 Standard Stoppages* and the preparatory studies for the *Large Glass* to the "Windows" of 1920 and 1921 (*Fresh Widow* and *La Bagarre d'Austerlitz*)[73] and his last large work, the life-sized "peep show" *Étant donnés* at the Philadelphia Museum of Art,[74] may be understood as the artist's attempt at reconciling the principles of representation based on Euclidean geometry with those of four-dimensional and non-Euclidean geometry. "What was also important [besides the transparency of the support] was perspective. The 'Large Glass' constitutes a rehabilitation of perspective, which had then been completely ignored and disparaged," Duchamp said in one of his dialogues with Cabanne. "For me, perspective became absolutely scientific." It was no longer a "realistic perspective" but rather "a mathematical, scientific perspective" that was based primarily "on calculations... and dimensions."[75]

Besides the "Idea of the Fabrication" for the *3 Standard Stoppages*, the *Box of 1914* also contains the following note on perspective: "Linear perspective is a good means of representing similarities differently, i.e., the equivalent, the (homothetically) similar and the same merge in perspectival symmetry."[76] In other words—to explain Duchamp's

train of thought more clearly—one object can be represented in a variety of ways depending on its distance from, and position in relation to, the viewpoint. Nevertheless, as a note in the *Green Box*—probably originating from the same context of reflections—states, perspective is purely a convention, an external system imposed upon things and their perception. "By perspective (or other conventional means . . .) the lines, the drawing, are *'strained'* [*'forcés'*] and *lose* the nearly of the 'always possible'—with moreover the irony of having *chosen* the body or original object which *inevitably becomes* according to this perspective (or other convention)."[77] That is, the body or object unavoidably takes shape according to the dictates of this external system. With his *3 Standard Stoppages*, Duchamp sought to give the "nearly of the always possible" back to "the lines, the drawing" by materializing the straight lines of Euclidean projective geometry as threads and subjecting them to an experiment in the physical world.

Perhaps it was pure chance—a dropped thread while "sewing" *Chocolate Grinder II*, for instance—that inspired Duchamp to expose an ideal figure, the geometrical straight line, to the effects of gravity and to record the results of its "threefold fall" through real three-dimensional space onto a two-dimensional surface. In the interview with Katherine Kuh, Duchamp remarked on the relationship between chance and planning in his work: "My first accidental experience (that we commonly call chance) happened with the Three Stoppages, and, as I said before, was a great experience. The idea of letting a piece of thread fall on a canvas was accidental, but from this accident came a carefully planned work. Most important was accepting and recognizing this accidental stimulation. Many of my highly organized works were initially suggested by just such chance encounters."[78] Thus, from the chance observation of the deformation undergone by a dropped thread, Duchamp developed an artistic experiment that was outwardly simple but inwardly highly complex: it implied not only the axiom of Euclidean geometry: "A straight line is the shortest distance between two points" but also theorems of the new non-Euclidean geometry as well as ideas on the relativity of that most famous international basic unit of length, first defined by the French Academy of Sciences, the standard meter.

3 | THE 3 *STANDARD STOPPAGES* AS PAINTINGS

GRAVITY AND LINE: THE "REPHYSICALIZATION" OF THE IDEAL STRAIGHT

Today the 3 *Standard Stoppages* at the Museum of Modern Art, with their three wooden templates shaped to the patterns formed by the dropped threads, are displayed like the instruments of some scientific experiment, the three threads themselves having been fixed to long and narrow canvases and mounted on strips of glass like specimens on huge microscope slides (see fig. 3.1). In short, they have all the appearances of results of scientific trials performed with an experimental setup. However, there is much to indicate that the 3 *Standard Stoppages* were originally conceived not as a work of object art, as an "assemblage," but as paintings.

In an essay published in 1999, Rhonda R. Shearer and Stephen J. Gould suggested that, contrary to the "modus operandi" defined in the "idea of the fabrication," Duchamp did not leave the "deformation" of the threads to chance but shaped them deliberately. They drew their conclusion both from the observation that the threads were longer than one meter, their surplus ends being stitched through the canvas, and from the assumption that the threads, when dropped from a height of one meter, were too fine and too light to produce "pathways ... quite regular and appealing in their gradual and limited meandering.... Light string just will not fall into such a regular pattern.... Duchamp, in fact, followed a procedure quite contrary (both in actual action and implied significance with respect to the role of chance) to his stated protocol to make the original object now on display."[1] Shearer and Gould describe the procedure presumably adopted by Duchamp: "Obviously Duchamp made the pathways

Fig. 3.1 Duchamp, *3 Standard Stoppages*, 1913–1914. Wooden box holding three threads glued to three painted canvas strips mounted on three glass panels, three wooden slats, and two wooden meter sticks. Box: 28.2 x 129.2 x 22.7 cm.

Source: The Museum of Modern Art, New York. Katherine S. Dreier Bequest, 1953. © Succession Marcel Duchamp/VG Bild-Kunst, Bonn 2008. Digital image © The Museum of Modern Art/Licensed by SCALA/Art Resource, NY.

purposefully by sewing—that is, he sewed through the obverse, left a meter of string on the recto side, and then sewed back through to the obverse. He could then put tension on the string by holding both of the obverse ends and... produce any pattern of his own choice on the recto side."[2]

Such argumentations based on observations of material behavior are not necessarily conclusive. If one stiffens a sewing thread by drawing it through a block of wax—this is the process used primarily by bookbinders and leather tailors—it is quite possible to obtain similar gentle curves when performing the experiment as described by Duchamp.[3] The fact still remains, however, that Duchamp did not use three threads that were exactly one meter in length but longer threads measuring approximately 106 to 113 cm. In other words, Duchamp had already decided, before the "fabrication" of the 3 *Standard Stoppages*, to stitch the ends of the threads through the canvases and fix them to the reverse sides with varnish. When working on his painting *Chocolate Grinder II*, Duchamp probably found that it would be difficult, if not impossible, to fix the curved threads neatly on the canvases and for this reason first marked the curves formed by the dropped threads on each of the canvases, which he had painted Prussian blue, and then stitched the surplus ends through the canvases, fastened them on the reverse sides and finally fixed the threads with varnish along the marked curves on the front sides. All the same, a definite answer to the question concerning the process used for the production of the 3 *Standard Stoppages*, now at the Museum of Modern Art, cannot be given until such time as their constituent materials have been examined.

It is not only on technical grounds that we may refute Shearer and Gould's assertion that Duchamp did not perform a chance experiment but arranged the threads on the canvases purposefully. Both the theoretical context of this work and its status within the development of Duchamp's painted oeuvre contradict this assertion.

An undisputed fact in Duchamp research, documented by numerous works and notes, is that Duchamp, during 1913 and 1914, used chance as a means of depersonalizing all decisions pertaining to form. In the hypothetical world of the *Large Glass*, it is chance that

determines measure and form; it determines the geometry of the happenings in the domain of the *bride* and in the *bachelor machine*. Its presence is threefold and operates on three different levels: point, line, and surface. "Wind—for the draft pistons / Skill—for the holes / Weight—for the standard stops / to be developed," Duchamp writes in one of his notes in the *Green Box* (see fig. 3.2).[4]

The positions of the *nine shots*—which are actual holes drilled through the upper half of the *Large Glass* below the *flesh-like milky way* and which mark the place where the sexual craving of the *nine malic moulds* enters the world of the *bride*—are "chance hits." Duchamp determined their positions by dipping a matchstick in paint and shooting it nine times at the glass with a toy cannon. Thus they owe their arrangement not to any sense of composition but rather to a "*jeu d'adresse*," a game of skill, in the conception of which Duchamp compared the targeted point with the "vanishing point in perspective."[5] The figure obtained by the nine shots "will be the projection (*through skill*) of the principle points of a 3 dim'l body. With maximum skill, this projection would be reduced to a point (the tar-

Fig. 3.2 Note "Wind—for the draft pistons, skill—for the holes, weight—for the standard stoppages."

Source: From Duchamp, *The Green Box* (Paris, 1934). © Succession Marcel Duchamp/VG Bild-Kunst, Bonn 2008.

get)."[6] The same train of thought is behind a note in the *Box of 1914* that suggests considering the popular fairground "barrel game" as a *"sculpture" of skill*. In this game, players had to throw small metal discs into differently numbered compartments. "A photographic record should be made of 3 successive performances," Duchamp noted at the time.[7]

The contours of the 3 *draft pistons*, which hang in *The Bride Stripped Bare by Her Bachelors, Even* from hooks in front of a cloud—like invisibly inscribed tablets in the style of mediaeval Madonna paintings—and convey the erotic *commands* of the *pendu femelle* to the bachelors, were shaped by the wind (see fig. 3.4) Here, too, Duchamp was concerned with the de-aesthetization of form. The material was a square piece of gauze reminiscent of the veils or nets of the drawing frames—Duchamp also called the 3 *draft pistons* the "3 nets"—that were used during the Renaissance and the baroque period for drawing subject matter in perspective (see fig. 3.3).[8] Duchamp hung the square piece of gauze under an open skylight and captured its deformations caused by the draft in three instantaneous photographs. "I wanted to register the changes in the surface of that square, and use in my Glass *the curves of the lines distorted by the wind*. So I used a gauze which has natural straight lines. When at rest, the gauze was perfectly square—like a chessboard—and the lines perfectly straight—as is the case in graph paper. I took the pictures when the gauze was moving in the draft to obtain the required distortion of the mesh."[9] Thus the changes in the shapes of the 3 *draft pistons* were recorded exactly as Duchamp had suggested in his note on the "barrel game"—by making a "photographic record of 3 successive performances." Enlargements of the three photographs then served as models for drawing the 3 *draft pistons* on the glass.[10]

Chance, operating at the level of the line, intervened in the form of gravity: "Weight—for the standard stops [Le poids—pour les stoppages étalon]," Duchamp writes in the note quoted above. At that time Duchamp had in fact speculated, in numerous notes, over gravity and its role in the perspectival perception of space. A "regime of gravity" was one of the ideas he considered during his preparations for

Fig. 3.3 Jean du Breuil, Une autre belle invention pour pratiquer la perspective sans le sçauvoir.

Source: Breuil, *La Perspective pratique, nécessaire à tous les peintres*..., vol. 2, Paris 1663.

Fig. 3.4 Duchamp, *Piston de courant d'air (draft piston)*, 1914, gelatin silver print, 59.5 × 49.3 cm.

Source: Philadelphia Museum of Art. Gift of Alexina Duchamp, 1991. © Succession Marcel Duchamp/VG Bild-Kunst, Bonn 2008.

the *Large Glass*.[11] "Gravity and 'longitude' in the paintings" stands written in a note discovered posthumously and dated 1912/13 verso, that is, just before Duchamp began to elaborate his "idea of the fabrication" for the *3 Standard Stoppages*.[12]

In 1914, Duchamp sketched the figure of a *handler of gravity* ("*soigneur de gravité*"), also called *juggler of the center of gravity* ("*jongleur de la centre de gravité*"), in the shape of a bistro table with a juggler's ball rolling about on its top.[13] This figure was intended to dance in the *Large Glass* on the line of the horizon and form the link between the domains of the bachelors and the bride. Duchamp's invention of a *soigneur de gravité* was a reaction to the crisis of language that had seized theoretical physics at the turn of the century, when the new insights into the subatomic structure of matter had begun to erode the terminology of classical mechanics and physicists were still not clear about the language needed to describe energetic processes in a subatomic context. "Need I point out," Poincaré wrote in *The Value of Science* in 1905, "that the fall of Lavoisier's principle involves that of Newton's? This latter signifies that the center of gravity of an isolated system moves in a straight line; but if there is no longer a constant mass, there is no longer a center of gravity, we no longer know even what this is."[14] Not only Einstein's Theory of Relativity emerged from this crisis of scientific theory but also Duchamp's experiments with gravity, chance, and the straight line.

In the exhibition Le Surréalisme en 1947 at the Galerie Maeght in Paris, Duchamp related the figure of the *juggler of the center of gravity* directly to the *3 Standard Stoppages*. It had been Breton's idea to erect an "altar" to twelve mythical figures of modernism, including the *soigneur de gravité*, which existed only as a sketch, not having been realized in the *Large Glass*.[15] The interior of the black, cave-like box, in which stood the bistro table balancing the juggler's ball, undeniably bore the mark of the *3 Standard Stoppages*. Hanging on one of the side walls was an enlargement of the note in the *Green Box* containing the "idée de la fabrication," while toward the front of the box three pieces of string, probably one meter long, with the thickness of cords were tautly suspended beneath the ceiling above three dropped, wavy

pieces of string lying directly below them on the floor (see fig. 3.5).[16] The idea of contextualizing the figure of the *handler of gravity* within the *3 Standard Stoppages* definitely did not come from the builders of the "altar," who were Roberto Matta and Frédéric Delanglade, but from Duchamp himself.[17]

When his stepson Paul Matisse asked him in 1963 to explain the enigmatic *3 Standard Stoppages*, which he had heard about but had

Fig. 3.5 Duchamp, "Altar" of the *soigneur de gravité* (*handler of gravity*) in the exhibition Le Surréalisme en 1947, Paris, Galerie Maeght, 1947.

Source: Photo: Willy Maywald. © Succession Marcel Duchamp/VG Bild-Kunst, Bonn 2008.

never seen, Duchamp stressed in his reply letter the significance both of physical space and of gravity for this pseudo-experiment:

> I was not so much concerned with a new straight distance between the 2 ends of a thread deformed by its fall than with the fact that the meter, in becoming deformed by its fall (from the height of one meter), "absorbs" the third dimension and the straight line becomes a curved line without at all losing its title of nobility: the meter. . . . Indirectly, this action invalidates, "irrationally," the concept of the "shortest distance between two points" (the classical definition of the straight line).[18]

Typical of Duchamp's experiments for creating forms for the *Large Glass* at the three levels of point, line, and surface is his strategy of transporting ideal concepts from the world of geometry, the world of pure thought, into the world of physics, at the same time subjecting the axioms, definitions, and ideal figures of geometry—humorously and "irrationally"—to a reality test. Certainly, this strategy was based on the principle of amusement that characterized all Duchamp's artistic experiments from 1913 onward, but it was an amusement inspired by the serious reflections of the most respected French mathematician of the time. In his book *Science and Hypothesis*, Henri Poincaré had stated quite emphatically that geometry is not an experimental science and that, when speaking of a mathematical entity, the word "existence" does not have the same sense as when it is used to refer to a material object:

"A mathematical entity exists, provided its definition implies no contradiction, either in itself, or with the propositions already admitted."[19] Nonetheless, all conclusions in geometry are drawn as if geometric figures behaved in just the same way as solid bodies. How, for instance, can one prove the definition of the equality of two figures. "Two figures are equal," Poincaré writes, "when they can be superposed; to superpose them one must be displaced until it coincides with the other; but how shall it be displaced? If we should ask this, no doubt we should be told *that it must be done without altering the shape*

and as a rigid solid. This vicious circle would then be evident."[20] It was precisely this vicious circle that served Duchamp as the basis for his experiment, for he transformed the geometric figure of the straight line into a solid body, a thread, and made it move in physical space. The result was, as expected, a deformation of the ideal straight.

In the section "On the Nature of Axioms," which concludes the chapter entitled "Non-Euclidean Geometries," Poincaré deals with the question whether the metric system is true and whether it is possible at all to falsify a geometry. Refuting the assumption that the axioms of geometry are experimental verities, Poincaré writes:

> *But we do not experiment on ideal straights or circles*; it can only be done on material objects. On what then could be based experiments which should serve as a foundation of geometry? The answer is easy. We have seen above [Poincaré's discussion of the question of defining the equality of two figures] that we constantly reason as if the geometric figures behaved like solids. What geometry would borrow from experience would therefore be the properties of these bodies. The properties of light and its rectilinear propagation have also given rise to some of the propositions of geometry, and in particular those of projective geometry, so that from this point of view one would be tempted to say that metric geometry is the study of solids, and projective, that of light. But a difficulty remains, and it is insurmountable. If geometry were an experimental science, it would not be an exact science, it would be subject to a continual revision. Nay, it would from this very day be convicted of error, since we know that there is no rigorously rigid solid. The *axioms of geometry therefore are neither synthetic* a priori *judgements nor experimental facts*. They are *conventions*; our choice among all possible conventions is *guided* by experimental facts; but it remains *free* and is limited only by the necessity of avoiding all contradiction. Thus it is that the postulates can remain *rigorously* true even though the experimental laws which have determined their adoption are only approximative. In other words, *the axioms of geometry . . . are merely disguised definitions.*[21]

So why not leave their definitions, since they can never be true anyway, simply to chance? Such was Duchamp's reasoning. Notwithstanding Poincaré's reasoning, Duchamp proceeded to experiment "on the ideal straight." In treating it like a solid body—like a thread—and subjecting it to a test in physical reality, Duchamp was practicing geometry as an experimental science, which, by definition, it is not. The *3 Standard Stoppages* are visualizations of precisely that vicious circle described by Poincaré in which axioms of geometry are treated like experimental facts.[22] This aspect, which is central not only to the "idée de la fabrication" for the *3 Standard Stoppages* but also to Duchamp's other experiments with chance (*3 draft pistons* and *nine shots*), has been ignored by all who claim that Duchamp did not produce the *3 Standard Stoppages* as described in the "idée de la fabrication" but arranged the threads deliberately in keeping with his own sense of form.[23] This theory is untenable inasmuch as Duchamp's pseudo-experiment would, without the passage of the ideal geometric figure of the straight line through real physical space, forgo both its sense and its humor.

Poincaré's *Science and Hypothesis* not only familiarized Duchamp with the notion of conventionality and hence with the relativity of all scientific "*étalons*" but also gave him, very probably, the inspiration for the concrete form in which this notion could be visualized in a humorous way: an experiment with threads. In a four-page section of the chapter entitled "The Classic Mechanics," Poincaré writes about "the school of the thread." This school, the bizarre designation of which could easily have been a figment of the imagination of an Alfred Jarry, "tries to reduce everything to 'the consideration of certain material systems of negligible mass . . . systems of which the ideal type is the *thread*.'"[24] Among Poincaré's descriptions of the experiments typical of the "school of the thread" are a great many that might have inspired Duchamp's special "experiment." One such description, for example, reads: "Or still better, a body is submitted *to the simultaneous action of several identical threads in equal tension*, and the body remains in equilibrium. We have then an experimental verification of the law of the composition of forces."[25] This is entirely the language of the "idea of the fabrication" for the *3 Standard Stoppages*.

The strategy behind the 3 *Standard Stoppages* of conducting absurd experiments in accordance with scientific standards in order to visualize, in an ironic way, the conventionality and relativity of scientific principles was henceforth to be the hallmark of Duchamp's artistic approach. The 3 *Standard Stoppages* became the guiding principle of his artistic thinking. Only in retrospect, years later, did he himself realize how consistent this principle had been throughout his oeuvre. Indeed, he then saw it as his "most important work," for it marked the time "when I tapped the mainspring of my future."[26] It was Duchamp's first work to undermine both the primacy of scientific thought and the elitism of painting. Paradoxically, Duchamp found the support for this approach precisely where it was least expected—in the most advanced scientific philosophy of his time. Was it not so that the dry, rational mathematician Poincaré had himself maintained that we can easily imagine a physical world of non-Euclidean geometry where rays of light are refracted through a medium and do not propagate themselves in a straight line, hence eliciting a different sensory perception of the world?[27] Such were the hypothetical yet logically conceivable phenomena that Duchamp sought to explore and visualize from 1913 onward. Moreover, the fact that Duchamp's logic differed from the logic of the sciences accounted for his genuinely aesthetic way of thinking and acting and, despite the inspiration he drew from his reading of modern scientific literature, ensured that his work never once fell into the category of mere illustrations of scientific problems or theses. In breaching all the rules of all the disciplines and confusing the logic of geometry and physics, science and aesthetics, the 3 *Standard Stoppages* operate according to an alternative, genuinely imaginative logic.

DUCHAMP'S APPLICATION OF THE NEW STANDARD MEASURES

The three curved lines of the 3 *Standard Stoppages*, obtained through the "rephysicalization" of the ideal straight and reendowed through

chance with "the nearly of the 'always possible,'" served as models for the curvatures of the *capillary tubes* on the *Large Glass* that connect the *malic moulds* with the *sieves*, where their sexual yearnings are filtered and transformed (see figs. 2.1 and 3.6).[28] The *illuminating gas* in the *capillary tubes* is converted, "by the phenomenon of stretching in the unit of length," from "solid spangles of frosty gas" into an "explosive liquid" that is propelled, initially through a mechanical system and later through an optical system, toward the *bride*.[29] The allusion to the physiological "phenomenon of stretching in the unit of length"—the sexual arousal of the male, in other words—is more than obvious, not least because the result takes the form of a *"baguette"* ("rod" or "stick"), a slang word for the penis.[30] Duchamp had already drafted this component of the bachelor apparatus before ultimately determining the form of this "phenomenon" with the aid of his thread experiment, though the meter-long thread, after its journey through three-dimensional space, manifested not a *stretching* but rather a *shortening* "in the unit of length." "The Standard Stoppages are the meter diminished," Duchamp writes in the note in the *Box of 1914*.[31]

As the *malic moulds* were to be projected onto the glass by means of a system of strict linear perspective, their lines of connection with the "nearly of the 'always possible'" likewise had to be integrated into this system, a task that was not all that easy for an artist hardly skilled at drawing in perspective. According to Duchamp's own account, work on the "perspectiving of the *9 capillary tubes*" began in the first half of 1914.[32] In accordance with the intended spatial arrangement of the *nine malic moulds*, Duchamp painted in Prussian blue a 1:1 scale plan of the arrangement of the capillary tubes on the canvas of the large-format painting *Jeune homme et jeune fille dans le printemps* (*Young Man and Young Girl in Spring*), after having first made a pencil sketch of the *Large Glass* on the canvas to the scale of 1:2 (see fig. 3.6). In order to make the routes taken by these lines of connection clearly visible, Duchamp painted their adjacent surfaces white. The partial admixtures of red and cerulean blue certainly did not solely serve the purpose of improving visibility and suggest that Duchamp considered this work not just as a working drawing but also as a painting in its own

Fig. 3.6 Duchamp, *Réseaux des stoppages* (*Network of Stoppages*), 1914, oil and pencil on canvas, 147.7 x 197 cm.

Source: The Museum of Modern Art, New York, Abby Aldrich Rockefeller Fund and Gift of Mrs. William Sisler, 1970. © Succession Marcel Duchamp/VG Bild-Kunst, Bonn 2008.

right.[33] The painting entitled *Réseaux des Stoppages* (*Network of Stoppages*) or *Cimetière des uniformes et livrées* (*Cemetery of Uniforms and Liveries*)[34] shows a plan view of what is rendered in oblique perspective on the *Large Glass*. How Duchamp transferred the wavy lines of the *3 Standard Stoppages* to the canvas is not known.[35] As he did not have the wooden templates cut until 1918, he probably transferred the lines to the canvas in 1914 with the aid of tracing paper. Numbers and marks indicating the halfway points along the lines, some of them heightened by a light cerulean blue, doubtless served to facilitate the conversion of the plan view into the perspectival projection of the *nine malic moulds* on the *Large Glass*.[36] Duchamp evidently had difficulty integrating the wavy lines of his playful, non-Euclidean geometry into the linear perspective of the *bachelor machine*. He tried to solve the problem by photographing the painting *Network of Stoppages* from an angle corresponding to the planned perspectival rendering of the *capillary tubes* on the *Large Glass* (see fig. 3.7).[37] But "photography did

Fig. 3.7 Duchamp, *Réseaux des stoppages* (*Network of Stoppages*), 1914, silver gelatin print, 2.1 (2.9) x 9 cm.

Source: Archives Marcel Duchamp, Villiers-sous-Grez. © Succession Marcel Duchamp/VG Bild-Kunst, Bonn 2008.

not prove up to the assignment and a perspective drawing had to be made."[38] If one rotates the painting ninety degrees clockwise and looks at it vertically, the drawing of the "tree of lines" repeats the contours of the arms of the young girl in the overpainted *Young Man and Young Girl in Spring* as she reaches up toward the fruits of a tree (see fig. 3.8).[39] A cryptic, posthumously discovered note probably refers to this correspondence of forms: "The vertical after a certain length becomes 'multibranched.'"[40]

A large-format watercolored pencil drawing (66 x 99.8 cm) of 1914, which is now in the Yale University Art Collection, shows the mirror-inverted representation of the *nine malic moulds* (see fig. 3.9) that Duchamp, in 1915, first transferred to a glass study and then to the *Large Glass* itself.[41] Here the curved lines of the *3 Standard Stoppages*, some of them greatly foreshortened, are integrated into the perspectival, three-dimensional representation of the *malic moulds*. The process of "depersonalization" that characterized the lines representing the *capillary tubes* was also to be implemented for the coloring of the *malic moulds*: an industrial lead oxide paint—known as "red lead" or "minium"—was to be used instead of artist's color.

The *3 Standard Stoppages* as Paintings 47

Fig. 3.8 Double page of the exhibition catalogue *by or of Marcel Duchamp or Rrose Sélavy*, Pasadena Art Museum, 1963.

In 1914 to 1915, Duchamp also considered using the *3 Standard Stoppages* for an application that reached far beyond all geometrical and pseudogeometrical speculations. This was Duchamp's planned project for the invention of a new language. This new language was to consist of "'prime words' ('divisible' only by themselves and by unity)" and abstract words "which have no concrete reference."[42] The *3 Standard Stoppages*, Duchamp speculated, might serve as starting points for the development of "*signes-étalons*" (standard signs) for use as grammatical conjunctions, similar to Chinese ideograms, that cannot be expressed in words formed by the letters of the conventional alphabet.[43] However, Duchamp's deformed, non-Euclidean straights did not enjoy their most intensive application for another four years. This was in 1918, when Duchamp was working on *Tu m'*, his last oil painting (see chapter 5).

One of Duchamp's first drafts for the *Large Glass* features only eight *malic moulds*.[44] A ninth one was added in 1914,[45] for Duchamp had

Fig. 3.9 Duchamp, *Cimetière des uniformes et livrées* (*Cemetery of Uniforms and Liveries*), 1914, Pencil, ink, and watercolor on paper, 66 x 99.8 cm.

Source: Yale University Art Gallery, New Haven, Connecticut, Gift of Katherine S. Dreier to the Collection Société Anonyme. © Succession Marcel Duchamp/VG Bild-Kunst, Bonn 2008.

meanwhile discovered the significance of the number three. "For me the number three is important, but simply from the numerical, not the esoteric, point of view," Duchamp said when asked about the recurrence of this number in the architecture of the *Large Glass*. "One is unity, two is double, duality, and three is the rest. When you've come to the word three, you have three million—it's the same thing as three."[46] In other words: "The three experiments with the falling threads cover the immensity of immeasurable possibilities."[47]

PAINTING OF CHANCE

In fabricating the *3 Standard Stoppages*, Duchamp was concerned not just with recording the "protocol"[48] of an experiment but also, and equally so, with questions of painting. The fact that the threads of the *3 Standard Stoppages* are a few centimeters longer than a meter does not

in any way mean that Duchamp intended from the outset to delude the viewer into believing he had performed a genuine experiment with chance. A more obvious explanation is that Duchamp originally conceived the 3 *Standard Stoppages* neither as an assemblage nor as a work of object art—an art genre that did not even exist at that time—nor as a kind of scientific lab report but as a picture, as a "painting of chance" ("*tableau de hasard*"). When this work was first conceived, Duchamp's way of thinking was still entirely that of a painter. If one considers the 3 *Standard Stoppages* in the light of Poincaré's dictum, "But we do not experiment on ideal straights or circles; it can only be done on material objects," one might argue that Duchamp chose thin sewing threads for the three canvases because it was not his intention to make a material collage but to come as close as possible to the ideal geometrical line of "negligible mass." In his literary sketch for the painting of a car journey (*La Route Jura-Paris*), written at the end of 1912, Duchamp had already taken up the theme of a "pure geometrical line without thickness."[49] That Duchamp was at that time accustomed to working with threads of different thickness is evidenced not only by the painting *Chocolate Grinder II* but also by a note relating to *The Bride Stripped Bare by Her Bachelors, Even* and written at a time when the work was still envisaged as a painting on canvas.[50] "To obtain 'exactitude'—glue to the *finished* canvas threads of different *thickness*—color to accentuate the lines (or intersections)—planes (this thread will be held in place by the varnish)."[51]

Duchamp could just as easily have recorded the results of his experiment with the three dropped threads—as it is described in the *Box of 1914*—with a camera, in much the same way as he had suggested in his note for the "barrel game" and as he actually did when later performing the experiment with the square piece of gauze for the *draft pistons*.[52] However, Duchamp's fabrication of the 3 *Standard Stoppages* was not just an experiment with chance but much more, namely, a pictorial deconstruction of the metaphor of visual rays as threads, a metaphor that has been inherent in perspectival painting ever since the Renaissance. That is why Duchamp made three *paintings* of chance and not three *photographs*.

Several facts indicate that the *3 Standard Stoppages* first took the form of narrow paintings to be viewed vertically rather than horizontally. This vertical arrangement of the three canvases is suggested first and foremost by their leather title labels, which are not properly legible unless the paintings are in an upright position.[53] That Duchamp was in fact toying with the idea of making a "painting of chance" is evidenced by a note for a painting contained in the *Box of 1914* together with his "idea of the fabrication" for the *3 Standard Stoppages*: "Faire un tableau de hasard heureux ou malheureux (veine ou déveine [Make a painting of *happy or unhappy chance* (luck or unluck)]."[54] Duchamp's note probably refers directly to the *3 Standard Stoppages*, though this can no longer be verified.

The *3 Standard Stoppages*, originally conceived as a "tableau de hasard," did not assume their ultimate form until the summer of 1936, when Duchamp was restoring the damaged *Large Glass* at the home of the collector Katherine S. Dreier in West Redding, Connecticut.[55] The three paintings or "tableaux," as Duchamp preferred to call them, had been in this collector's possession since 1918. She had probably purchased them together with the painting *Tu m'*, which she had commissioned Duchamp to paint, or perhaps she had received them as a gift on that occasion.[56] During his work on *Tu m'*, which was his last oil painting, Duchamp used wooden templates cut to the curved lines of the *3 Standard Stoppages* so as to construct a cube according to the rules of non-Euclidean geometry. Duchamp had these three wooden templates cut specially for this purpose. The templates themselves are also depicted in the painting *Tu m'*.[57]

The three "tableaux," with their three threads no thicker than fine lines drawn with a pencil, did not seem at any time to have interested the collector Katherine S. Dreier. While Duchamp was making his preparations for his stay in West Redding, he wrote her a letter requesting her to put these works aside, as he wanted to make them available—though not without first making some changes to them—to Alfred Barr for Fantastic Art Dada Surrealism, an exhibition planned to take place at the Museum of Modern Art at the end of 1936, but Katherine Dreier could not find them at first, evidently because she

had no idea what she was looking for. In more detailed descriptions of the 3 *Standard Stoppages* in several letters, Duchamp always refers to them as "canvases," which can mean either "bare, unpainted canvases" or "paintings on canvas."[58] In his letter of 3 May 1935, he refers to them as "three panels (canvas painted dark blue with a very fine line made by a thread fallen on the canvas)."[59] "Panel" was the term used by Duchamp in other letters to refer to paintings.[60]

In his essay, "L'Esprit Dada dans la peinture," published in 1932, Georges Hugnet unequivocally describes the 3 *Standard Stoppages* as paintings. Marcel Duchamp, he writes, "had painted in 1913 in Paris three pictures entitled *Trois stoppages-étalon*, which attempted to give a new appearance to the measure of the meter."[61] As Hugnet seems to be extraordinarily well informed in this article, not least with reference to the Readymades, which he cannot possibly have seen in the original, we may readily assume that his information came directly from Duchamp.

Further evidence that the 3 *Standard Stoppages* originally took the form of paintings is furnished by the glass-plate negatives of these works, which were found in Duchamp's estate and deposited by Alexina Duchamp in the archives of the Philadelphia Museum of Art, where they are still kept today (see fig. 3.10).[62] The photographs were probably taken in Duchamp's Paris studio at 23, rue Saint-Hippolyte, where he lived and worked from October 1913 until June 1915. The amateurish method of standing the paintings on the floor against a chair suggests that Duchamp took the photographs himself.[63] There is nothing amateurish, however, about the actual photographic technique used. As the negatives, measuring 8.9 x 11.9 cm (slightly smaller than 4" x 5"), reproduce the 3 *Standard Stoppages* exactly to the scale of 1:10, we may assume that Duchamp's purpose in using the photographic process was to obtain an exact scaled reduction of the three curved, one-meter lengths of thread.[64] This could easily be done by repeatedly readjusting the distance between the painting and the lens, refocusing the camera and then checking the length of the thread on the ground glass screen. The resulting negatives were then used for making the three small paperboard-mounted contact prints that

Fig. 3.10 Duchamp, *3 Standard Stoppages*, modern contact prints from original glass plates, 8.9 x 11.9 cm, Paris, 1914.

Source: Philadelphia Museum of Art. Gift of Jacqueline, Paul and Peter Matisse in memory of their mother, Alexina Duchamp. © Succession Marcel Duchamp/VG Bild-Kunst, Bonn 2008.

document—in two exemplars of the *Box of 1914* (Duchamp's personal exemplar and the exemplar belonging to the collector Walter Arensberg)—Duchamp's execution of his "idea of the fabrication" for the *3 Standard Stoppages* (see fig. 3.11).[65] The 1:10 scale reduction is intimated in the hand-written caption under the photographs: "3 décistoppages étalon" (3 Standard decistoppages), formed by analogy with "décimètre" or "décimal."

The contact prints of the *3 Standard Stoppages* made from the glass-plate negatives clearly show that the canvases were originally not only twice the width of the strips of canvas as we know them today but also mounted on stretchers. The strips of canvas today measure 13.3 cm in width. In a letter written to the collector Katherine S. Dreier on 1 January 1936, Duchamp confirms their width as being "about one foot," that is, roughly 30 cm, which tallies more or less with the widths of the canvases shown on the photographs, these being readily calculable as divisors of the known lengths of the threads.[66] In the summer of that same year, Duchamp negated the status of the *3 Standard Stoppages* as paintings by detaching them from their stretchers, reducing their widths by half, and gluing them to three strips of glass 7 mm thick. Before gluing them, Duchamp painted the reverse sides of the canvases white, leaving on each of them two narrow "windows" unpainted. Visible in these windows are the two captions: "Un mètre de fil droit, horizontal, tombé d'un mètre de haut" and "(3 stoppages étalon, appartenant à Marcel Duchamp), 1913–14."[67] Duchamp mounted the *3 Standard Stoppages* on the same glass that he had used for the restoration of the *Large Glass*. His reason for doing so was not just a practical one but also had an iconographical significance. The *refroidisseur à ailettes* (air cooler),[68] that is to say, the horizontal dividing line—the *horizon*—between the *bachelor machine* below and the *bride* above, consisted of three narrow strips of glass placed closely together, one on top of the other. These strips of glass, which had been damaged in transport ten years before, were replaced by Duchamp in 1936 by two strips of greenish glass and one strip of light green, almost clear glass. The same differences in color are featured by the strips of glass on which Duchamp mounted the *3 Standard Stoppages*.[69] In

Fig. 3.11 Duchamp, "3 décistoppages étalon" (3 standard decistoppages), gelatin silver prints, mounted on cardboard (24 x 18 cm), from *The Box of 1914*.

Source: Philadelphia Museum of Art, Gift of Alexina Duchamp, 1991. © Succession Marcel Duchamp/VG Bild-Kunst, Bonn 2008.

Duchamp's notes on *The Bride Stripped Bare by Her Bachelors, Even*, the *horizon* is also called the *garment of the bride*.[70] This garment now had to be invisibly mended—it needed a "stoppage," as it were. Thus, in using the same differently colored panes of glass for the restoration of the *3 Standard Stoppages* and for the invisible mending—the "stoppage"—of the *garment of the bride*, Duchamp had established, quite imperceptibly, a mental link between these two works.

At that time Duchamp was busy not just with the repair of the *Large Glass*; much more important was the fact that he had now entered a phase of his life and work that was less devoted to the production of new works of art than to the reconstitution of his oeuvre from the years between 1905 and 1927. This task was doubtless accompanied by a great many "stoppages" and subsequent "corrections" to his biography. In 1935, Duchamp decided to combine all his most important works in a special kind of catalogue raisonné, the *Box in a Valise*. Evidently Duchamp had not until then realized that the *3 Standard Stoppages* had been the "mainspring" for the Readymades. "I didn't realize at the time exactly what I had stumbled on," Duchamp said in conversation with Katharine Kuh. "When you tap something, you don't always recognize the sound. That's apt to come later. For me the Three Standard Stoppages was a first gesture liberating me from the past."[71]

ART AS AN EXPERIMENT

The *3 Standard Stoppages* are both experimental paintings and paintings of an experiment. The former opened up the horizon to a new concept of painting that completely broke with the traditional notion of "fine art." The extent to which these paintings of chance transcended painting as it was understood in the classical sense becomes clear if we compare them with Hans Arp's *Elementary Construction According to the Laws of Chance* of 1916 (see fig. 3.12). These collages are still very much "compositions," paintings for which the modern definition of a painting as "essentially a flat surface covered with colors assembled

in a certain arrangement" still holds good,[72] except that here it was now chance that determined the arrangement. Chance, for Arp, represented a purely artistic, aesthetic problem, while for Duchamp it went beyond that to become a problem of cognition, for his experiment posed certain epistemic questions: Which geometry is the true geometry? What is the status of the straight line in non-Euclidean projective geometry? What is the nature of geometrical axioms?

While in the 3 *Standard Stoppages* the category of arrangement—in the sense of composition—no longer has an important part to play, it cannot be denied that the three curved threads against the Prussian blue background with the gold-embossed leather labels do in fact

Fig. 3.12 Hans Arp, *Elementary Construction According to the Laws of Chance*, 1916, collage, 40.5 x 32.5 cm.

Source: Kunstmuseum Basel, Kupferstichkabinett, Gift of Marguerite Arp Hagenbach.

manifest a certain elegance. What is decisive for our aesthetic perception of the three curved threads is that they make their appearance as "objective," that is, mechanical and not manual, recordings of three dropped threads. As such, the 3 *Standard Stoppages* come closer to the scientific image and its paradigmatic recording medium, namely photography,[73] than to the chance compositions of a Hans Arp. One of the most impressive forms of experimental scientific photography around 1900 was chronophotography, a technique invented by the physiologist Etienne-Jules Marey for the recording of trajectories of fast moving bodies that elude the naked eye. "In experiments . . . it is of immense importance," wrote Marey in his main work, *Le Mouvement*, published in 1894, "that the graphic record should be automatically registered, in fact, that the phenomenon should give on paper its own record of duration."[74] Duchamp had been familiar with chronophotography since the autumn of 1911, when he had begun to base the compositions of a whole series of paintings of movement on the specific graphic effects that this technique created (*Sad Young Man in a Train, Coffee Mill, Nude Descending a Staircase*).[75] The second chapter of Marey's book, entitled "Space: Its Measurement and Representation by Photography," would have been of particular significance for Duchamp's reflections on the new geometries and the nature of geometrical axioms and "*étalons*."[76] It was this chapter that brought together two lines of development in which the young Duchamp, searching for pictorial forms of expression that would transcend conventional painting, was keenly interested. These were, first, techniques for the automatic recording of forms and, second, the new geometries. In the chapter on "Space," Marey not only demonstrates photographically how it is possible, with the aid of rotating threads, to engender surfaces and volumes—an idea on which are based numerous notes in the *White Box* on the visualization of a four-dimensional continuum—but also discusses the question of whether geometry is an experimental or purely speculative science.[77] Unlike Poincaré, for whom geometry, as already mentioned, was not an experimental science, Marey sought to discover, with the aid of chronophotography, the origins of such geometrical terms as the straight line, plane,

sphere, cylinder, and so on by observing concrete physical phenomena (see fig. 3.13):

> Now, if the geometry of today has become purely a speculative science, it had an experimental origin. It is not likely that the conception of a straight line was evolved from man's brain as a purely abstract expression, but rather that it entered therein, on seeing a stretched thread, for instance, or some other rectilinear object. In the same way the conception of a plane or a circle found its origin from noticing a flat surface or an object of circular form. There are, so to speak, traces of these concrete origins of geometrical figures in the definitions given to solid figures or to those of three dimensions. Such objects are said to be 'engendered' by straight lines or curves, which undergo various displacements. Thus a

Fig. 3.13 Étienne-Jules Marey: *Cylinder Engendered by the Displacement of a White Thread Moving Round a Central Axis*, ca. 1887, chronophotograph.

Source: *Le Mouvement*, 1894.

regular cylindrical surface is engendered by a straight line which moves parallel to another straight line, and yet remains at the same distance from it.[78]

Indeed, it was while he was working on the 3 *Standard Stoppages* that Duchamp made a note of a chronophotographic experiment for determining the shape of the "splashes" of the bachelors on the *Large Glass*. The note went as follows: "Use a radiator and a piece of paper (or something else) moved by the heat above. Photo. 3 performances—probably with a frame in the background giving a better indication of the displacements and deformations." This "frame in the background" was typical of many of the chronophotographs produced by Marey.[79]

The integration of the visual phenomena of chronophotography into his paintings of movement had confronted Duchamp with the scientific notion of the photographic image as a functional instrument. In a biomechanical context, high-speed photography was neither an end in itself nor a means of illustration but rather an instrument of scientific experimentation. Chronophotographs neither reproduced known visible phenomena nor substantiated known theses but rendered visible never-before-seen phenomena that might then be the subject of scientific analysis and reflection. The 3 *Standard Stoppages*

Fig. 3.14 Étienne-Jules Marey, *Marey Agitating a Flexible White Rod*, 1886, chronophotograph.

Source: *Le Mouvement*, 1894.

in the form of the three photographs of the "décistoppages étalon" (fig. 3.11) bear a striking resemblance to certain chronophotographs, for one is reminded of their typical images of white trajectories against black backgrounds and of their typically sequential character.[80] Indeed, the new iconic aspect and function of scientific photography must have made a lasting impression on the young painter Marcel Duchamp at the end of 1911 and the beginning of 1912 (see fig. 3.14).[81]

With his 3 *Standard Stoppages*, Duchamp was the first to introduce the paradigm of the technoscientific image into the realm of artistic creativity. The result was a completely new concept of art, a concept of art as an experiment, a concept according to which painting was no longer either a "*finestra aperta*"—a representation of a perceived or imagined reality—or an autonomous reality in its own right but an experimental method that was at once an image and an instrument.[82] Based on the same principle and developed during the same period, the Readymade, the sister process to the 3 *Standard Stoppages*, was soon to revolutionize the history of twentieth century art.[83]

4 | 1936
Duchamp Transforms the Painting Into an Experimental Setup

In 1936, Duchamp decided to change the 3 *Standard Stoppages* in such a way that their appearance would come as close as possible to that of the Readymades. Indeed, toward the end of his life, Duchamp counted this work among his Readymades and even considered it to be his favorite one.[1] Even the original 3 *Standard Stoppages*, as prototypes of serial imagery, would have been an art-historical sensation in 1913–14. By 1936, however, this was evidently no longer sufficient for Duchamp, or rather it was no longer what he intended, for it was, after all, his declared aim to turn his back completely on the history of painting. Now that Surrealism had elevated the object to a new art form, Duchamp's prewar Readymades had acquired virtually cult status. While Duchamp was on his way by ship to the United States in order to repair the *Large Glass*, the first exhibition of surrealist objects was taking place in Paris.[2] Included in the exhibits, and being shown in public for the very first time, was Duchamp's *Bottlerack*, which for Duchamp had been no more than "a very personal experiment that I had never expected to show to the public,"[3] but for the surrealists it was the foundation work of a new form of artistic expression.[4] Evidently the 3 *Standard Stoppages* were now also intended to go down in history as a testimony to Duchamp's antipainting stance, and for this reason he had to rid them in 1936 of everything that could possibly awaken the slightest association with painting. After detaching the canvases from their stretchers, trimming them to half their width, and gluing them to strips of glass, he housed them together with the wooden templates of 1918 in a wooden box that had built-in compartments for the glass strips and retaining devices for the templates. Duchamp's choice of box was possibly oriented toward the boxes for brass drawing and

measuring instruments commonly used at that time by craftsmen and engineers.[5] The wooden box also reminds one of those—albeit much smaller—boxes in which historical units of length were displayed at the Musée des Arts et Métiers in Paris.[6] The three canvases were thus transformed into a completely new work, one in which glass and wood had predominance over canvas. Whereas the three strips of glass on which are mounted the narrow strips of canvas with the three threads awaken associations with laboratory specimens, the wooden templates evoke the world of the craftsman, of a cabinetmaker, say, or a boat builder. The *3 Standard Stoppages* were henceforth no longer intended to be displayed on a wall but in an instrument box, one that, in the social order of knowledge, would be more at home in a museum of science or technology than in an art museum. They were no longer meant to be viewed vertically either—as their title labels suggest—but horizontally. And so it was not until 1936, twenty years later, when he was able to see how and in what direction contemporary art was developing, that Duchamp negated any connection of the three canvases with painting, the theory of perspective, and the metaphor of the visual ray as a thread. He transformed the *3 Standard Stoppages* into a parascientific experimental setup. Indeed, this work of 1913–14 now found itself, in 1936, in a completely new aesthetic context. As Duchamp still clearly remembered the originally intended form of the *3 Standard Stoppages* as vertical paintings when he spoke about them much later, in 1964, in a slide lecture at the City Art Museum in St. Louis, Missouri, he made a point of emphasizing the contrary: "This is not a painting. The three narrow strips are called Three Standard Stoppages from the French 3 Stoppages étalon. They should be seen horizontally instead of vertically because each strip shows a curved line made of sewing thread, one meter long, after it had been dropped from a height of 1 meter, without controlling the distortion of the thread during the fall."[7]

An equally interesting yet altogether enigmatic testimony to Duchamp's revived preoccupation with the *3 Standard Stoppages* in 1936 are the photographs, taken in the following year, of a surrealist "séance" in which a measuring tape played a prominent role (see fig. 4.1).[8] Duchamp is shown kneeling behind a table in such a way that

Fig. 4.1. Costa Achilopulu (?), *Marcel Duchamp and Mary Reynolds*, 1937, silver gelatin print, 12.7 cm x 15.2 cm.

Source: Philadelphia Museum of Art. Gift of Jacqueline, Paul, and Peter Matisse in memory of their mother, Alexina Duchamp. © Succession Marcel Duchamp/VG Bild-Kunst, Bonn 2008.

only his head is visible. Emerging from his mouth is a measuring tape held by a classically robed Mary Reynolds, who is sitting next to him, between her fingers. As this playful mise-en-scène probably took place in London, the measuring tape is in inches and not in centimetres.[9] Whether meter or yard is of little importance, as both of these standard units of measure are merely conventions. Moreover, in making the tape measure emerge from his mouth like ectoplasm, Duchamp was still operating in the sense of the *3 Standard Stoppages*, these being, after all, a metaphor of autonomy not only of the artist in particular but of the individual in general.[10] The artist creates his own criteria—that is the message both of the *3 Standard Stoppages* and of this photographic "allegory." At this juncture we must remember that Duchamp saw the three standard measures as being linked to him

personally. "3 Stoppages étalon appartenant à Marcel Duchamp" ("3 Standard Stoppages belonging to Marcel Duchamp") is written on the backs of all three canvases. The staging of the "tableau vivant" with Mary Reynolds also denotes Duchamp's ultimate satisfaction with his transformation of the three canvases, which for eighteen years had led a secluded existence in Katherine S. Dreier's warehouse, and his pride in having created a new work that lent physical form, and hence permanence, to the moment of his liberation from painting.[11]

Now transformed into the demonstration objects of a pseudoscientific experiment, the 3 *Standard Stoppages* were shown to the public for the first time in the exhibition Fantastic Art Dada Surrealism at the Museum of Modern Art in December 1936.[12] As Duchamp's *Rotative plaque verre (Optique de précision)* (*Rotary Glass Plates [Precision Optics]*) of 1920 and a photograph of the *Bottlerack* of 1914 were also shown, the exhibition became the first one in the United States to substantiate Duchamp's reputation as a dissident of painting and the pioneer of a new art form: object art. A note in the index of exhibits not only explains the work inaccurately but also contradicts the exhibited material: "Following his interest in the laws of chance as opposed to deliberate artistic composition, the artist dropped three threads a meter long upon the floor [*sic*]. The outlines of the dropped threads are preserved in the strips of wood."[13] Moreover, Alfred Barr could not, or would not, see the 3 *Standard Stoppages* purely as demonstration objects and, significantly, placed them not in the "Objects" section but in that of "Composition by Artificial Accident," adding the comment: "important as probably the earliest."[14] Predominantly featured in this section were, besides the 3 *Standard Stoppages*, Hans Arp's collages "with squares arranged according to the laws of chance" of 1916 and 1917.[15] A surviving photograph shows that Barr put aside the wooden box and hung just the glass-mounted strips of canvas on the wall, arranging them vertically next to one another in the manner of a tripartite painting (see fig. 4.2).[16] Possibly responsible for the perspective of Barr's understanding was Georges Hugnet's contribution to the exhibition catalogue, which described the work in its former state. Repeating an earlier article published in the magazine *Cahiers d'art* in 1932, Hugnet wrote:

Fig. 4.2. View of the exhibition Fantastic Art, Dada, Surrealism, New York, the Museum of Modern Art, December 1936. Displayed on the wall on the right are the 3 *Standard Stoppages*.

Source: From Duchamp, *Marcel Duchamp: The Portable Museum.*

In 1913, in Paris *he had painted three pictures Trois stoppages étalon* (three standard stops) which attempted to give a new appearance to the measure of a meter. This is how they were done: Duchamp took three threads, each a meter long, which he dropped from the height of a meter one after the other on to three black canvases. Scrupulously he traced the contours of the threads with a thin trickle of varnish—a purely accidental design.[17]

The exhibition Fantastic Art Dada Surrealism at the end of 1936 marked the beginning of the history of the American reception of the *3 Standard Stoppages*, a history that reached its first height in the publication of the special "Marcel Duchamp Number" of the magazine *View* in 1945. Contrary to Alfred Barr's perspective, the work was no longer

perceived as a "composition" but as a work of object art. In the article "Marcel Duchamp Anti-Artist," written by the husband-and-wife gallery owners Harriet and Sidney Janis, the *3 Standard Stoppages* were already central to their understanding of Duchamp as the author of an "anti-painting" and "anti-artistic" oeuvre, which they subdivided into the categories of "movement," "machine concept," and "irony," a subcategory of the latter being "chance."

> To Duchamp, the brush, the canvas and the artist's dexterity of hand are anathema. He thinks and works in terms of mechanics, natural forces, the ravages of time, the multiplex accidents of chance. He marshals these forces, so apparently inimical to art, and employs them consciously to produce forms and develop objects, and the results themselves he regards as secondary to the means used in making them.[18]

The assertion that Duchamp regarded the results "as secondary to the means used in making them" certainly did not tally with the genesis of the *3 Standard Stoppages* and the related geometric figures of the *Large Glass*, such as the *draft pistons* and the *nine shots*. This understanding of the work had first been suggested by its new form of presentation as a kind of visual protocol of an experiment. When the *3 Standard Stoppages* were shown in an exhibition of the works of the Duchamp brothers at the Yale University Art Gallery in the same year, the art historian and museum curator George Heard Hamilton interpreted them as an "object" and "perhaps the single most important, as it is certainly the least known, contribution to the formulation of a new esthetic."[19] In 1953, as the executor of Katherine S. Dreier's estate, Duchamp made sure that the *3 Standard Stoppages* were bequeathed to the Museum of Modern Art in New York. For the exhibition of this bequest, Duchamp made one last change, or rather addition, to this work, thus bringing to completion the forty-year history of its genesis. A label written by the director of the museum, Alfred Barr, read as follows: "In this exhibition three stretched threads and two meter sticks, one vertical and one horizontal, have been added at the suggestion of the artist to clarify

his procedure."[20] In accordance with Duchamp's instructions, the three strips of glass-mounted canvas were not hung vertically on the wall like paintings, as had been the case in 1936, but laid on the floor. Their place on the wall was now taken by the three wooden templates, which were arranged horizontally. The two "meter sticks," one arranged vertically, the other horizontally, defined the physical scope of the experiment, in other words, the square base of the cube within which the three one-meter-long threads had been dropped (see fig. 4.3).

Although the note of the "idea of the fabrication" had already appeared as a facsimile in the *Green Box* in Paris in 1934, nobody there had so far ever seen the work itself. Gabrielle Buffet discussed its concept, without touching upon its concrete features, in an essay on Duchamp's art in the *Cahiers d'art* in 1936.[21] Not until 1937, after Katherine Dreier had had a photograph taken of the work, now mounted on strips of glass, did the *3 Standard Stoppages* first appear in the magazine

Fig. 4.3. View of the exhibition of the Katherine S. Dreier Bequest, New York, the Museum of Modern Art, 1953. On the left, in the foreground: *3 Standard Stoppages*, 1913–1914.

Source: From Robert Lebel, *Sur Marcel Duchamp*.

Minotaure, again in vertical arrangement.[22] The work formed part of an uncommented selection of the latest surrealist paintings and objects, as though it had been made just as recently as all the others. In the following year, 1938, Duchamp's coinage "*Hasard en conserve*" ("Canned chance") was included in the *Dictionnaire abrégé du Surréalisme* as one of the definitions of the word "*Hasard*."[23] In 1940, Duchamp incorporated the photograph from *Minotaure* as a pochoir-colored phototype into his catalogue raisonné, the *Box in a Valise* (see fig. 4.4).[24] In Europe, the 3 *Standard Stoppages* themselves did not appear in exhibitions until 1963, and not in the original but as replicas. In 1964, together with most of Duchamp's Readymades, the 3 *Standard Stoppages* were reproduced in a limited edition of eight exemplars by the Milan gallery owner Arturo Schwarz, and since then they have been shown in exhibitions in many cities of Europe (see fig. 3.9).[25] The original was first shown in Europe in the Duchamp retrospective at the Musée national d'art moderne, Centre Georges Pompidou, in 1977.[26]

Thus, in 1913–14, 3 *Standard Stoppages* were not yet a work of object, not the instrumental setup of an experiment as they are presented today at the Museum of Modern Art, but quite simply paintings. At the same time, however, they were the essential part, and also the pictorial result, of a pseudoscientific experiment. The 3 *Standard Stoppages* existed in this contradictory state of still being paintings and no longer being paintings until 1936. From a scientific standpoint, the 3 *Standard Stoppages* are a pseudo-experiment; as an artistic experiment they are the result of speculations on projective geometry, the thread metaphor of the visual ray, and chance as a form-creating factor. What Duchamp actually thought about scientific precision and the scientific need to document an experiment with due accuracy is revealed by a crossed-out yet still decipherable sentence in the original manuscript of the "idea of the fabrication." After the words "3 patterns obtained in more or less similar conditions" Duchamp had originally added, "*not meticulously exact*, for what ought man to understand by a meticulously exact experiment if not a rather futile insistence on repetition?"[27] It is improbable that Duchamp, when performing the experiment, dropped the thread (or threads) just three times and then

Fig. 4.4. Duchamp, *3 Standard Stoppages* in *La Boîte-en-valise* (*The Box in a Valise*), Paris, 1935–1941.

Source: © Succession Marcel Duchamp/VG Bild-Kunst, Bonn 2008.

fixed the three resulting deformations to three canvases with the aid of varnish. On a sketch of the *nine malic moulds*, the whereabouts of which are no longer known, Duchamp had referred to the network of the "9 stoppages semblables," the implication being that there were also stoppages that were not similar.[28] As he needed curved lines that would serve as non-Euclidean "straights" of roughly the same length—indeed the *3 Standard Stoppages* are of equal length to within only a few millimeters despite their deformation after having been dropped—and could therefore be readily used as patterns for the *capillary tubes*, Duchamp would certainly have chosen three suitable results from a relatively large number of "drops."[29] This in no way contradicted the principle of chance formulated by Duchamp in his "idea of the fabrication." Duchamp did only what all experimental scientists do in the final analysis: he selected from random results.

As Duchamp still thought entirely in terms of painting in 1913–14, his *3 Standard Stoppages* were originally intended as a tripartite painting of chance, nothing more. What counted was not the presence of the threads themselves on the canvas but the representation of the result of the experiment: the deformation of an ideal straight, one meter long, under the influence of gravity. And since the *3 Standard Stoppages* were "tableaux" in the sense of "representations," Duchamp would have thought nothing of replacing the possibly thicker thread used for the experiment by fine sewing threads for the sake of a sharper reproduction and, in order that the threads were better able to stay in place on the canvases, stitching them through the canvases at both ends, for which purpose the threads each had to be slightly longer than one meter. The important thing was that each line on the front of the canvas was *exactly* one meter in length.[30] The paintings were not meant to be viewed from the back, and the viewer was not afforded this opportunity until twenty years later, when Duchamp glued the detached and narrowed canvases to strips of glass. In 1913–14, Duchamp was still far removed from the idea of the *3 Standard Stoppages* as a material documentation of an experiment with chance. Only those who confuse the artist with the scientist, the representation of the results of an experiment with the procedure and system of experimentation itself, will cry "fraud"

and "deceit."[31] What obviously counted for Duchamp at that time was not the fact that exactly the same threads appeared on the canvases as those with which the experiments had been performed but merely that this in fact seemed to have been the case.

Evidently Duchamp himself was for a long time not sure about the status of the *3 Standard Stoppages* in his oeuvre. Although they were "tableaux"—paintings—and not drawing instruments, he did in fact use them as instruments when working on the painting *Network of Stoppages* and on his studies for the *nine malic moulds* of the *Large Glass*. This contradiction also finds expression in the three small contact prints of the "décistoppages" in the *Box of 1914*. Duchamp photographed the three narrow paintings in his studio, but cropped the contact prints so much that there was nothing left to indicate that they were paintings, creating the illusion that the photographs were merely meant to document the curvature of the threads resulting from the experiment. Toward the end of 1914, Duchamp noted that he intended to have enlargements made of the *draft pistons* and the "décistoppages" "on very good photo paper.... The photo becoming the picture itself."[32] By this time the status of the *3 Standard Stoppages* as paintings had evidently become so uncertain that he was contemplating having enlargements made of them, these then becoming the actual work, "the picture itself." The only photographs that have survived are two enlargements of the *draft pistons* dated 1915 and measuring approximately 60 by 50 cm.[33] Duchamp's intention to do the same with the *3 Standard Stoppages* would have been thwarted not least by the fact that the production of a photographic enlargement on paper measuring one meter in length was no easy matter at that time. Evidently the photographic documentation to the scale of 1:10 for his compendium of ideas in the *Box of 1914* sufficed in the end.

Although the *3 Standard Stoppages* were among the works that Duchamp took with him to New York when he emigrated to the United States in 1915, he never exhibited them there, unlike, for instance, the two paintings of the *Chocolate Grinder* or even the color reproduction *Pharmacy*. Certainly, they were still paintings, but they already transcended the defining boundaries of painting more than any

cubist collage of newspaper or tablecloth fragments, for the latter was still representational, not to mention the importance the cubists attached to an individual style or to their established ideas of balance and composition. Style, beauty, expression, taste—no such criteria could be applied to the *3 Standard Stoppages*. Consequently, "painting" receded well into the background, yielding entirely to "experiment." We have only to compare, in our mind's eye, the *3 Standard Stoppages* with the *Network of Stoppages* painted with the aid of the new standard units of length to realize how far removed the former was from every kind of "*peinture*." The *3 Standard Stoppages* evidently stemmed from that unclear, undefined sphere of Duchamp's creativity that caused him, in 1913, to note down the question: "Peut-on faire des oeuvres qui ne soient pas d'art? [Can one make works which are not works of 'art'?]").[34] The fate of not being exhibited for two whole decades was shared by the *3 Standard Stoppages* with Duchamp's first two Readymades *avant la lettre*, the *Bicycle Wheel* and the *Bottlerack*. In their case, too, Duchamp did not for a long time know "what [he] had stumbled on."[35] They were private experiments, artistic experimental objects through which he sought "to answer some questions of my own—as a means of solving an artistic problem without the usual means or processes."[36] As they did not even remotely come up to the expectations imposed on art at that time, exhibiting them or even offering them for sale was unthinkable. And precisely because the *3 Standard Stoppages* belonged to the aforementioned undefined sphere of experimental creativity and were neither exhibited nor published for over two decades, Duchamp was able to treat them as "works in progress" that were not to assume their ultimate form until twenty-two years after their original "fabrication."

The *3 Standard Stoppages* had come into being during Duchamp's development of the *Large Glass* and its world of forms.[37] His formulation of the "idea of the fabrication" and its execution were based on exactly the same principle as that of the originally planned book on the *Large Glass*. Duchamp writes in one of his notes:

> Give the text the style of a *proof* by connecting the decisions taken by conventional formulae of inductive reasoning in some

cases, deductive in others. Each decision or event in the picture becomes either an axiom or else a necessary conclusion, according to a *logic of appearance*. This logic of appearance will be expressed only by the *style* (mathematical formulae etc.) [additional marginal note: the principles, laws, or phenom., will be written as in a theorem in geometry books, underlined, etc.] and will not deprive the picture of its character of: *mixture of events plastically imaged*, because each of these events is an *outgrowth* of the general picture. As an outgrowth, the event remains definitely only *apparent* and has no other pretention than a signification of image (against the sensitivity to plastic form).[38]

In a slightly altered variant of this note, Duchamp added a final, clarifying remark: "It can no longer be a matter of plastic beauty."[39] In this fundamental reflection on the style and content of his planned book on the *Large Glass*, Duchamp underlines the principle of objectivity on which the scientific picture is based: "no other pretension than a signification of image." As Duchamp's wording of the "idea of the fabrication"—"If a straight horizontal thread one meter long falls . . ."—is entirely in keeping with the style of "inductive reasoning" described in this note, it follows that, for the pictorial result of the experiment, that is, the three canvases evidencing the fortuitous curvature of three dropped threads, the criteria of "sensitivity to plastic form" and "plastic beauty" no longer have any validity.

ON THE TITLE: ROUSSEL'S "METHOD"

When Duchamp performed the experiment with the threads, he had still not thought of a title. According to the answers he gave in the MoMA questionnaire, his inspiration for the title came from a shop sign: "Saw, on the rue Claude Bernard—, 'Stoppages' sign—title *after* the object was done."[40]

"*Le stoppage*" is the French term for "invisible mending." "*Stoppage*" signs can still be found in France. To the French ear, the title *3 Stoppages*

étalon sounds like *3 Stoppages et talons*, awakening associations with "heel repairs to socks and stockings."[41] Thus Duchamp's playful use of the word "*stoppage*" refers both to the "invisible" method by which he fabricated the three canvases—the invisible stitching of the ends of the meter-long threads through the canvas—and to the (almost) invisible replacement of the curved lines by fine threads. This aspect was a dominant one in the beginning, when the work was still meant to be viewed vertically, but then it gave way to the aspect of gravity and hence also to the material aspect of the threads as threads when the work was later transformed into the visual protocol of an experiment. An "*étalon*" is a standard measure, a fixed physical or chemical unit of measurement. "*Le mètre étalon*," for example, is the French term for the "standard" or "prototype" meter kept in Sèvres near Paris. Duchamp had already used the term "*étalon*" in his notes for the *capillary tubes* before he ever thought of combining it with the term "*stoppage*."[42] The French verb "*stopper*" also means "to stop," referring in this context to the abrupt "stoppage" of the fall of the threads. In this sense, it also awakens associations with the instantaneous photography used by Duchamp at that time to capture the deformations of the *draft pistons*.[43] Indeed, if we imagine the dropped threads as fortuitously captured "images" of an endless number of possible deformations, this form of recording closely resembles that of "chronophotography." Thus the word combination *3 Stoppages étalon* creates, in French, an irritating and humorous variety of associations in which the ideas of invisible mending and abrupt stopping blend with the mental image of the standardizing activities of the scientist.

Duchamp's use of puns in the title was inspired by Raymond Roussel. He had discovered Roussel's technique of combining similarly sounding yet semantically different words at a performance of Roussel's play *Impressions d'Afrique* in June 1912 and then experimented with this technique in his literary sketches for *The Bride Stripped Bare by Her Bachelors, Even*.[44] Later, in 1935, Roussel published an essay explaining his methods of literary invention. Entitled *Comment j'ai écrit certains de mes livres*,[45] the essay reveals that the entire dénouement of *Impressions d'Afrique* was based on the phonetic-semantic

possibilities afforded by the phrase "Les lettres du blanc sur les bandes du vieux billard," which, to the ear, can also be understood to mean: "Les lettres du blanc sur les bandes du vieux pillard."[46] Among the examples given in Roussel's essay with specific reference to his *Impressions d'Afrique* is also the homophonic phrase "étalon à platine," which Roussel reduces to the following components: "1. *Étalon* (mètre étalon) à *platine* (métal. On sait que le mètre étalon est en platine). 2. *étalon* (cheval) à *platine* (langue en argot); d'où le cheval présenté sur la scène des Incomparables."[47] The question of whether Duchamp's invention of the title 3 *Stoppages étalon* harked back specifically to the "*étalon à platine*"—a good two years had elapsed since he saw Roussel's play—or whether only a vague reminiscence of Roussel's literary technique had a part to play in his choice of title must remain a matter of speculation.

AN EXCURSION INTO THE WORLD OF SHOP SIGNS AND WINDOWS

As Duchamp himself stated in the MoMA questionnaire, the title was inspired by a shop sign on the rue Claude Bernard in Paris. Duchamp must have crossed this street every day in 1914, for it was located between his apartment in the rue Saint Hippolyte and his place of work at the Bibliothèque Sainte-Geneviève, not far from the Panthéon. If we consult the Parisian address directories ("Bottin") and the commercial directories ("Annuaires du Commerce Didot-Bottin") of 1913 and 1914, we will find that there were several tailors in the rue Claude Bernard but no "*stoppeurs*." Some tailors did offer a "*stoppage*" service as well, several of them in the rue Claude Bernard.[48] Shops specializing in "*stoppage*," presumably decked out with appropriate shop signs, were to be found in a long neighboring street, the rue Monge, and in a side street that led into it.[49] There was also an "*artiste-stoppeur*" in Paris at that time, in other words, an "artist" versed in the skill of invisible mending,[50] as well as an "Académie artistique des stoppeurs de Paris."[51] As it was a "*stoppage*" sign that gave him the inspiration for the

title of his experimental paintings with the three threads, Duchamp presumably must have felt quite drawn toward this particular kind of "artistic academy."

Duchamp's keen awareness of the language of shop signs was integral to the fascination with street iconography and shop-window aesthetic that characterized his oeuvre in 1913 and 1914. It had been awakened in Duchamp by Guillaume Apollinaire, to whom Duchamp was also indebted for his discovery of Raymond Roussel and with whom he, in the company of Francis Picabia in October 1912, had spent a weekend packed with discussions on the latest developments in poetry and painting at the home of Gabrielle Buffet-Picabia's mother in Étival, in the French Jura.[52] Apollinaire's recitations of his most recent poems—some of which were still unpublished and were to appear a year later in his anthology *Alcools*—initiated Duchamp into the new principles of a poetry influenced by cubist-futurist ideas. Following the return journey to Paris in Picabia's car, Duchamp drafted his first literary sketch, in the style of Raymond Roussel, for his painting of the car journey *La Route Jura-Paris*.[53]

Not only did Apollinaire integrate the language of shop windows and advertising into his poetry, but he also predicted, in his book *Les peintres cubistes. Méditations esthétiques* (*The Cubist Painters: Aesthetic Meditations*) of 1913, that the "minor art of shop windows" would exercise a growing influence on the development of modern painting.[54] We need not doubt that a copy of this book took pride of place in Duchamp's library, not only because the preparations for its publication had been made during their weekend together in Étival but also, and far more importantly, because it contained the first literary recognition of Duchamp's kind of painting to have been written in Paris at all. Referring to the paintings of Juan Gris, Apollinaire writes:

> This art, if it perseveres in the direction it has taken, may end, not with scientific abstraction, but with aesthetic arrangement which, after all, is the highest goal of scientific art. Forms no more suggested by the painter's skill; no more the colours on the canvas, even, as they too are forms so suggested. One could utilize

objects whose capricious arrangement has undeniable meaning. However[,] the impossibility of putting on canvas a man of flesh and blood, a mirror-wardrobe, or the Eiffel tower, will force the painter to return [from *collage*] to the authentic method of painting, or to limit his talents to the minor art of shop-windows—today many window displays are admirably arranged.[55]

No matter how far-sighted Apollinaire's words may seem to be, even today, Duchamp went a step further. His pictorial experiments of 1913–14 represented an unparalleled disregard for the artistic conventions of the time, and his 3 *Standard Stoppages* and his two first Readymades showed that, between the "authentic method of painting" and the "minor art of shop-windows," there was a also third way: a completely new form of aesthetic expression that combined "the highest goal of scientific art" with the "capricious arrangement of objects": "forms no more suggested by the painter's skill" but by chance alone.[56] Apollinaire was unusually well informed about Duchamp's experiments at the beginning of 1913, a circumstance that points to a close friendship and to an equally close exchange of ideas. At the end of January of that same year, Apollinaire dedicated to Duchamp a copy of the catalogue of Robert Delaunay's exhibition *Les Fenêtres* with the following inscription: "For Marcel Duchamp / who opens the windows of chance / his friend Guillaume Apollinaire."[57] Also, the colors on the canvas are no longer to be forms suggested by the painter's skill, but just the work of a "*teinturier* [dyer]"; when he first began to work on *The Bride Stripped Bare by Her Bachelors, Even*, that is to say, when it was still planned as a painting on canvas, Duchamp noted several times the idea of dyeing the canvas instead of painting it.[58] The canvases of the 3 *Standard Stoppages* are painted with such a thin Prussian blue that one might think they had indeed been dyed rather than painted. "One could utilize objects whose capricious arrangement has undeniable meaning"—Duchamp achieved precisely this with his 3 *Standard Stoppages* and his "sculptures toutes faites" (sculptures already made), as the *Bicycle Wheel* and the *Bottlerack* were originally called.[59] In one of his notes, Duchamp even planned to put *The Bride*

Stripped Bare by Her Bachelors, Even behind glass after the fashion of a shop-window display, which for Apollinaire would have been absolutely unthinkable. "Put the entire bride . . . in a transparent case," Duchamp writes in a note.[60] For Duchamp, any perspectivally painted picture was a view through an imaginary pane of glass onto an artistically arranged piece of the world. "The projection in perspective onto the Glass is a perfect example of classical *perspective*, that is to say, the various elements of the Bachelor apparatus were first of all imagined as though they were arranged on the ground behind the Glass rather than distributed on a two-dimensional surface."[61] Considering Duchamp's pictorial experiments and speculations of 1913–14 against the background of Apollinaire's aesthetic meditations in *The Cubist Painters*, one cannot but think that Duchamp did everything to surpass the ideas, bold as they already were, of this most radical of aesthetic theorists in Paris at that time.

Apollinaire's speculative comments at the end of his chapter on Juan Gris do indeed read like a clairvoyant description of Marcel Duchamp's artistic development between the years of 1913 and 1915. "A new style," he writes, "issues from the metal constructions of engineers: the style of the department stores, garages, railroads, air planes. Since art today has a very limited social role, it is only fitting that it should occupy itself with the disinterested and scientific study—even without aesthetic aims—of its immense domain."[62] Viewing the first collages of Picasso, Braque, and Gris, Apollinaire had sensed an objective and more or less impersonal tendency that was to bring about a fundamental change in the development of modern art—a tendency away from painting and toward the development of a new form of artistic expression that was to evolve from the given conditions of a modern culture of science and technology. But it was left to Marcel Duchamp and not to Pablo Picasso, Georges Braque, or Juan Gris to develop a new style from the study of scientific images, chronophotographs, diagrams, and the aesthetic of shop signs and shop windows, and to occupy himself with "the disinterested and scientific study—even without aesthetic aims—of [art's] immense domain" and, as Apollinaire also notes elsewhere, to "attempt the great art of surprise."[63]

Duchamp's works of 1913–14 reflect, in many different ways, the iconography of the shop signs and shop windows of his immediate Parisian surroundings, the streets between the rue Saint Hippolyte, where he had been living since October 1913, and the place du Panthéon, where a month later he began working at the Bibliothèque Sainte Geneviève. In 1914, Duchamp added two tiny marks of green and red paint to the color print of a trivial watercolor landscape and entitled the picture *Pharmacie (Pharmacy)*.[64] The two marks of color awakened associations with the bottles of colored liquid, illuminated from behind by gaslight, that decorated the windows of pharmacists' shops and served as a guide for passers-by after nightfall. On his daily walk to the library, Duchamp passed two such pharmacies, of which both shop windows were—and still are today—decorated with such colored bottles. One of them, the "Pharmacie Lhopitallier," is located directly on the place du Panthéon, while the other stands opposite the corner of rue Berthollet and rue Claude Bernard.

Located at 19, rue Claude Bernard was the main branch of the "Sociéte Française d'incandescence par le gaz (Système Auer)," which sold gas mantles invented and patented by the Austrian chemist Auer von Welsbach. It was "illuminating gas" that Duchamp chose as the metaphor of the erotic fuel that was meant to "fire" the *nine malic moulds* of the *Large Glass*, and it was a "Bec Auer" that was yet to play a central role in Duchamp's last work, the life-size perspective device *Étant donnés: 1° le gaz d'éclairage 2° la chute d'eau* (Given: 1. The Illuminating Gas 2. The Waterfall), which he worked on from 1946 until 1966.[65]

Numerous shops specialized in the making of "uniforms and liver-ies." One such *"maison spéciale,"* in the rue Hippolyte-Lebas, offered "Costumes de livrées, uniformes en tout genre; spécialités pour sapeurs-pompiers, sergents de ville, octroi, gardes de square, gardes-champêtres."[66] One of their shop windows doubtless inspired Duchamp in 1914 to conceive his *nine bachelors* as a *Cemetery of Uniforms and Liveries* (see fig. 3.9). He developed their "malic forms" from a synthesis of abstract drawings of uniforms and tailors' busts and the glassy transparency of gas mantles.[67] "Manchons et becs à gaz" could be purchased in 1913 from a certain Margoulis, 70, rue Claude Bernard.

Finally, we must not forget that Duchamp's idea for the paintings of the *Chocolate Grinder* came to him when looking in the shop window of a *chocolaterie* in Rouen that he had known since his schooldays.

However, the influence of shop windows on Duchamp's imagery was not confined just to his choice of motif and iconography but also extended to questions of material and structure.[68] In a note written in 1913, Duchamp analyzed the new gaze of desire generated by the aesthetic of shop windows. Under the title "The question of the shop window," Duchamp writes:

> To undergo the interrogation of shop windows. The exigency of the shop window. The shop window proof of the existence of the outside world. When one undergoes the examination of the shop window, one also pronounces one's own sentence. In fact, one's choice is 'round trip'. From the demands of the shop windows, from the inevitable response of hiding the coition through a glass pane with one or many objects of the shop window. The penalty consists in cutting the pane and in feeling regret as soon as possession is consummated. Q.E.D.[69]

It was this analysis of Duchamp's personal experience of the modern consumer-capitalist world that strengthened his decision, taken against the background of four-dimensional geometry, not to execute *The Bride Stripped Bare by Her Bachelors, Even* on canvas but on glass. Decades later, in 1945, Duchamp himself assisted with the artistic decoration of the shop windows of two New York bookshops, finally bearing out Apollinaire's prophecy that the modern artist would one day elevate the "minor art of shop-windows" to a new genre of "high art."[70]

5 | HUMOROUS APPLICATION OF NON-EUCLIDEAN GEOMETRY

On the questionnaire from the Museum of Modern Art, Duchamp had answered the question about the significance of the *3 Standard Stoppages* not only with the explanation, "first step toward depersonalizing straight lines," but also with further explanations and source references that could not possibly have been decipherable without a good grounding in mathematics and philosophy: "A joke about the meter—a humorous application of Riemann's post-Euclidean geometry which was devoid of straight lines. Not firsthand but part! Cf. Max Stirner—Le moi et sa propriété."[1] In his slide lecture, "Apropos of Myself," delivered at the City Art Museum of St. Louis, Missouri, in 1964, Duchamp formulated the same idea more understandably and at the same time referred to "pataphysics," a further source that he had not mentioned in the MoMA questionnaire: "This experiment was made in 1913 to imprison and preserve forms obtained through chance, through my chance. At the same time, the unit of length: one meter was changed from a straight line to a curved line without actually losing its identity [as] the meter, and yet casting a pataphysical doubt on the concept of a straight line as being the shortest route from one point to another."[2]

Let us now consider the various elements of this statement. The famous postulate of Euclidean geometry, namely that the shortest distance between two points is a straight line, was first called in question by the German mathematician Bernhard Riemann around the middle of the nineteenth century. From his answers in the questionnaire, Duchamp clearly had no firsthand knowledge of Riemann's geometry.[3] He had evidently familiarized himself with Riemann's ideas through his reading of Jouffret's *Traité élémentaire de géometrie*

à quatre dimensions and Poincaré's *Science and Hypothesis*. In this, his most successful scientific treatise, Poincaré describes in detail how the new geometries of Riemann and Lobachevsky affect the Euclidean concept of space and explains Riemann's geometry with the aid of Abbott's metaphor of the "flat beings":

> Imagine a world uniquely peopled by beings of no thickness (height); and suppose these 'infinitely flat' animals are all in the same plane and cannot get out. Admit besides that this world is sufficiently far from others to be free from their influence. While we are making hypothesis, it costs us no more to endow these beings with reason and believe them capable of creating a geometry. In that case, they will certainly attribute to space only two dimensions. But suppose now that these imaginary animals, while remaining without thickness, have the form of a spherical, and not of a plane, figure, and are all on the same sphere without power to get off. What geometry will they construct? First it is clear they will attribute to space only two dimensions; what will play for them the role of the straight line will be the shortest path from one point to another on the sphere, that is to say, an arc of a great circle; in a word, their geometry will be the spherical geometry.[4]

Thus, with the aid of this simple imagery, Poincaré elucidates the considerably more complicated argumentation used by Riemann to call in question the absoluteness of the Euclidean axiom, "The shortest distance between two points is a straight line." According to Riemann, Poincaré writes, a relatively large number of different geometries exist: "All depends, he says, on the manner in which the length of a curve is defined. Now, there is an infinite number of ways of defining this length, and each of them may be the starting-point of a new geometry."[5] Duchamp, for his part, left the way of defining this length to chance, though *re*defining would be a more precise term, for in the *3 Standard Stoppages* chance could operate only within the limits of the one-meter-square experimental setup as specified in the "Idea of the Fabrication."

But "since several geometries are possible, is it certain ours is the true one?"[6] In other words: "Is Euclidean geometry true?" The question "has no meaning," Poincaré states. "We might as well ask whether the metric system is true and the old weights and measures false; whether Cartesian coordinates are true and polar coordinates false. One geometry cannot be more true than another; it can only be *more convenient*." Poincaré's concluding assertion, "Now, Euclidean geometry is, and will remain, the most convenient,"[7] failed to impress Duchamp, as his way of thinking was that of an artist and not that of a mathematician or physicist accustomed to working according to certain research procedures. What fascinated him, on the other hand, were Poincaré's assertions that Euclid's postulate—"A straight line is the shortest distance between two points"—cannot be proven experimentally[8] and that the principles of geometry are not experimental facts but are based on "conventions" and are therefore "merely disguised definitions,"[9] which meant—such was Duchamp's conclusion—that they can be formulated and visualized entirely differently.

After comparing the different experiences of space in Euclidean, non-Euclidean, and four-dimensional worlds, Poincaré summarizes his views on the relationship between geometry and experience as follows:

> We see that experience plays an indispensable role in the genesis of geometry; but it would be an error thence to conclude that geometry is, even in part, an experimental science.... in reality it is not occupied with natural solids, it has for object certain ideal solids, absolutely rigid, which are only a simplified and very remote image of natural solids. The notion of these ideal solids is drawn from all parts of our mind, and experience is only an occasion which induces us to bring it forth from them. The object of geometry is the study of a particular "group" [of solids and natural phenomena].... Only, from among all the possible groups, we must choose one that will be, so to speak, the *standard* ["*l'étalon*"] to which we shall refer natural phenomena. Experience guides us in this choice without forcing it upon us; it tells us not which is

the true geometry, but which is the most *convenient*. Notice, that I have been able to describe the fantastic worlds above imagined *without ceasing to employ the language of ordinary geometry*. And, in fact, we should not have to change it if transported thither. Beings educated there would doubtless find it more convenient to create a geometry different from ours, and better adapted to their impressions. As for us, in face of the *same* impressions, it is certain that we should find it more convenient not to change our habits.[10]

Marcel Duchamp's art from 1913 onward was a product of the crisis brought about by classical Euclidean geometry's claim to truth against the background of a simultaneous intellectual acknowledgment that a whole multitude of different geometries may in fact exist. While Duchamp did in fact remain in "our world" physically and was not, to use Poincaré's words, transported into "the fantastic worlds above imagined," he preferred to create in his mind's eye a completely different world, "which would be possible by slightly distending the laws of physics and chemistry" and changing his habitual way of working as an artist and painter.[11] The fantastic reality depicted in the glass painting *The Bride Stripped Bare by Her Bachelors, Even* was constructed with a playful geometry derived from fragments of four-dimensional and non-Euclidean geometries and having its origin in the 3 *Standard Stoppages* of 1913–14: three lines that "cast pataphysical doubt" on Euclid's postulate that "a straight line is the shortest distance between two points" and, in so doing, defined three new standard units of length, to which Duchamp henceforth related all spatial phenomena in his world of images and, as we have seen, even the idea of a new kind of language.

But Duchamp's work contains another idea, too, one based on a theory of geometry that at the time was very modern. In *The Value of Science*, Poincaré had shown that Euclidean and non-Euclidean geometry indeed have a common foundation, a kind of higher geometry that, unlike Euclidean geometry, is not a quantitative but, rather, a "qualitative geometry." This geometry is concerned with the spatial properties of a continuum that are

exempt from all idea of measurement. The study of these properties is the object of a science which has been cultivated by many great geometers and in particular by Riemann and Betti and which has received the name of analysis situs.... The theorems of analysis situs [better known today by the term "topology"] have, therefore, this peculiarity, *that they would remain true if the figures were copied by an inexpert draftsman who should grossly change all the proportions and replace the straights by lines more or less sinuous.*[12]

And that is precisely what Duchamp had done in his *3 Standard Stoppages*. It is what he was referring to in the slide lecture mentioned at the beginning of this chapter: "One meter was changed from a straight line to a curved line without actually losing its identity [as] the meter." The line changes its shape, but not its identity as a unit of length.

The topology-based idea of an amorphous space having neither metric nor projective properties had fascinated Duchamp all his life.[13] His notes mention, for example, that the *domain of the bride* in the upper half of the *Large Glass* is characterized by the absence of any "mensuration," while the *domain of the bachelors* in the lower half is defined by metric and projective geometry.[14]

In none of his books did Poincaré deal with this question more thoroughly than in *Dernières Pensées*, which was published posthumously in 1913, the year Duchamp developed his "Idea of the Fabrication" for the *3 Standard Stoppages*.[15] In *Dernières Pensées*, Poincaré differentiated between three kinds of geometry: metric geometry, which is based on the notion of distance; projective geometry, which is based on the notion of the straight line; and qualitative geometry, "analysis situs," in which measure and quantity play a less important role.

> In this discipline two figures are equivalent every time it is possible to have one correspond to the other by means of a continuous deformation, whatever the law governing the deformation may be, provided the continuity is maintained.... Let us imagine a pattern of any kind and the copy of this pattern drawn by a clumsy draftsman. The proportions are distorted, straight lines

drawn by a trembling hand have undergone distressing deviations and result in disproportional curves. From the point of view of metric geometry, and even from that of projective geometry, the two figures are not equivalent; but on the contrary they are equivalent from the point of view of analysis situs.[16]

The same comment goes for the curved lines of the 3 *Standard Stoppages*, for they have likewise developed from straight lines through continuous deformation.[17] On the face of it, these "clumsily" drawn straights seem to be precisely the ideal basic measures of any geometry capable, as Poincaré defined it,

> of reasoning correctly about figures which are poorly constructed. This is not a quip but a truth which deserves reflection. But what is a poorly constructed figure? It is the type which can be drawn by the clumsy draftsman mentioned a short while ago. He distorts the proportions more or less flagrantly; his straight lines are disturbing zigzags; his circles appear as ungraceful humps. But all this does not matter; it will in no way trouble the geometer; this will not prevent him from reasoning correctly.[18]

Not only for an artist like Duchamp, who thought typically in images, but also for the mathematician Poincaré, topology was a higher-ranking geometry than metric or projective geometry, for geometric intuition operated more strongly in topology than in either of the others.[19] Indeed, it was the "véritable domaine de l'intuition géométrique."[20] It was in the chapter of *Dernières Pensées* devoted to topology ("Analysis Situs and the Continuum") that Duchamp read about the fundamental relativity of all geometrical definitions of space, whether Euclidean or non-Euclidean:

> Space is relative; by that I mean not only that it would be possible for us to be transported to another region of space without our noticing it . . . ; not only that all the dimensions of all objects could be increased proportionally without our being able to know

it, provided our measuring instruments underwent the same change; but I also mean that space could be deformed according to some arbitrary law provided our measuring instruments were deformed according to this very same law.[21]

Duchamp's painting of 1914, *Réseaux des Stoppages*, which predicts the spatial arrangement of the *nine capillary tubes* in the *Large Glass*, owes its title to the next passage in Poincaré's train of argument: "Space, when considered independently of our measuring instruments," Poincaré continues,

> has therefore neither metric nor projective properties; it has only topological properties (that is, those studied in analysis situs). It is amorphous, that is, it does not differ from any space which one can derive from it by any continuous deformation whatever. . . . How the functioning of our measuring instruments and in particular how the role of solid bodies provides the mind with the opportunity to determine and to organize this amorphous space more completely, how it permits projective geometry to plot a *network of straight lines* and metric geometry to measure the distances between these points, . . . I have explained at length in other writings.[22]

Replacing Poincaré's Euclidean "network of straight lines" ("réseau de lignes droites") in Duchamp's painting are "networks of stoppages" ("réseaux des stoppages") based on Duchamp's own brand of non-Euclidean geometry.[23] Although this geometry was inspired by Riemann's geometrical theories, it bears no resemblance to it whatsoever, not even in part.

In her study, *The Fourth Dimension and Non-Euclidean Geometry in Modern Art*, Linda Henderson interprets Duchamp's *3 Standard Stoppages* as "the purest expression of Non-Euclidean geometry in early twentieth-century art."[24] This interpretation does not, however, make any allowance for the critical and ironic attitude toward science that is inherent in this work. Duchamp had in no way intended his *Three*

Standard Stoppages to be construed as a serious scientific demonstration of curved space according to Riemann's spherical geometry. Nor are they images that adequately visualize a topologically deformed geometrical figure. If such had been Duchamp's intention, it would have been much easier for him to have followed Hermann von Helmholtz's advice and paint or photograph the world reflected in those decorative shining "gazing globes" commonly found in Bavarian gardens.[25] As "a *humorous* application of Riemann's post-Euclidean geometry" (italics added), the 3 *Standard Stoppages* are rather the image of a figure of thought that takes up certain theorems of non-Euclidean geometry and "bends" and "twists" them into a criticism of mathematically based rationalist thought. Indeed, they are the foundation on which Duchamp developed his new style of experimental visual thinking, a form of artistic imagination that explores absurd constellations of ideas against the background of scientific logic. "We think that we find solutions through this function of rational thought but we do not. The mind is much freer than this type of thought would indicate," Duchamp explained in one of his conversations with Laurence Stephen Gold in 1958.[26]

In their book *Du Cubisme*, published in 1912, Albert Gleizes and Jean Metzinger repudiated the reproach of the conservative press that cubist paintings were nothing but "geometric insanities,"[27] referring in their defense to non-Euclidean geometry and "certain of Riemann's theorems." If we read Gleizes's and Metzinger's defense of cubism in full, we cannot help thinking that Duchamp's 3 *Standard Stoppages* were conceived in direct response thereto. They write:

> This [pictorial] space we have negligently confounded with pure visual space or with Euclidean space. Euclid, in one of his postulates, speaks of the indeformability of figures in movement, so we need not insist upon this point. If we wished to relate the space of the painters to geometry, we should have to refer it to the non-Euclidean mathematicians; we should have to study, at some length, certain of Riemann's theorems.[28]

Euclid's postulate of the indeformability of figures in movement naturally presupposed that this movement took place in one and the same dimension. Duchamp's pseudo-experimental setup contravened this principle because it captured the changes in the ideal straight line after its movement through three-dimensional physical space. In other words: Duchamp's way of thinking is not geometric but pseudogeometric. Unlike the cubist works of Gleizes and Metzinger, the *3 Standard Stoppages* represent not just a calling into question of Euclidean geometry, as Henderson writes,[29] but a calling in question of all axiomatic concepts, even those of non-Euclidean geometry, and of the logic of scientific thought in general. The Parisian painters and critics who at the time sought to legitimize cubism scientifically remained locked in a rationalistic discourse, for they were merely replacing Euclidean geometry by non-Euclidean geometry. The older geometry was now to be succeeded by the convention of a more advanced geometry on which to base the new style of painting, for this new geometry apparently explained our perception of the world "more correctly."[30] Duchamp, on the other hand, broke out of the rational, scientific discourse by integrating certain theorems of non-Euclidean geometry into an experimental setup to produce a new, playful kind of geometry that defied all rational analysis, not least because it was based on standard measures that had been defined by chance. Duchamp was fully aware of the absurd character of this new geometry. While he was experimenting in 1913 and 1914 with the absurd geometry behind his *3 Standard Stoppages*, Duchamp was—as some of his surviving notes prove—also working on an "absurd algebra."[31]

Unlike the non-Euclidean definitions of curves, the *3 Standard Stoppages* are entirely useless for scientific purposes. They are of use only to the artist, for the creation of his own imagined world of forms. Paradoxically, however, the *3 Standard Stoppages* need not avoid the critical eye of the scientist. For if, as Poincaré writes, an "intuition of distance, of direction, of the straight line does not exist,"[32] and space is therefore amorphous and constructed merely through the human being's faculties of reasoning and imagining, then Duchamp

has, through his *3 Standard Stoppages*, made this amorphous state of space visible by leaving the construction of the standard measure of distance entirely to chance. The tripartite painting produced in the initial phase of Duchamp's work on the *3 Standard Stoppages* in 1913 and 1914 was something completely new in the history of art. It was neither a work of representational painting nor a work of pure, self-referential painting, but rather the visualization of a thought experiment, or a "thought figure," to use the term coined by Walter Benjamin. Through his *3 Standard Stoppages*, Duchamp both analyzed and elucidated that invisible foundation of presumptions on which the seemingly so natural "intuition of the straight line" and the axioms of Euclidean geometry are based. What the *3 Standard Stoppages* marked in Duchamp's oeuvre was the beginning not of a phase of scientific art or engineering art but of an ironic, metascientific art. Scientific rationalism and its invisible metaphorical presumptions are their subject matter, not their method.

Although the experiment with the three meter-long threads is pure nonsense from a scientific standpoint, it is in fact a kind of "not-sense" that makes *more* sense inasmuch as it points to the conventionality and relativity of all thought. Thus the *3 Standard Stoppages* may be understood not as a scientific but as an *artistic* "thought figure" that embraces all categories of meaning, including the seemingly unshakable principles of science.

Duchamp once remarked on the interpretation of his work by his first American admirer, Katherine S. Dreier, as follows: "Miss Dreier was correct in stressing the spiritual and poetic aspect of my work; but she lost some of its values by not allowing for the ironic aspects."[33] Since Dreier's interpretation of Duchamp's art in the 1920s, hardly anything has changed in this regard. Most American scholarly literature on Duchamp has to this day either ignored or minimized the humorous, *anti*scientific impetus of his art. One exception is Katharine Kuh, who, following extensive conversations with Duchamp, wrote the following in 1949: "His pseudo-scientific speculations, partially symbolic, partially rational, are always connected tightly with a central idea. Toward modern science and its machinery he developed

a mysterious ambivalence, where his respect was cynically dissipated by humor and doubt."[34]

A BRIEF DIGRESSION ON *TU M'*

Duchamp's *3 Standard Stoppages* enjoyed their most detailed use as constituent elements of the painting *Tu m'* of 1918, which was his last oil painting (see fig. 5.1). As this painting figured in the magazine *Minotaure* in 1935 as an illustration for Breton's essay "Phare de La Mariée,"[35] the art world was already familiar with the features of Duchamp's *3 Standard Stoppages* long before it saw the work itself, indeed, even before the work finally assumed the form in which it is known to us today. Requested by Katherine S. Dreier to paint a long and narrow large-format painting for a free space above a bookshelf in her library, Duchamp decided to paint a kind of modern allegory of painting. The resulting work—a sum of his reflections on metric, projective, and topological geometry—is of such complexity that it has to this day not been completely deciphered.[36] As it would be impossible to analyze it in its entirety in this present book, I propose to deal with it solely—apart from a few general remarks—with reference to the *3 Standard Stoppages*.

In order to be able to use the three sinuous lines of the "meter diminished" for the drawing of geometrical figures on the painting, Duchamp had three wooden templates cut exactly to the shapes formed by the threads. These templates are represented full-scale in the bottom left-hand corner of the painting in staggered, parallel-perspective arrangement (i.e., without foreshortening) one behind the other. Duchamp's use of these wooden templates for the painting of *Tu m'* left traces of paint on them that are still visible today. There are residues of black, violet, and red paint on the drawing edges of the templates. Painted black and red in the painting are not only the drawing edges of two of the templates in the bottom left-hand corner of the painting but also the wavy outer edges (drawn with the same two templates) of the open geometrical solid in the right-hand half of the painting.

Fig. 5.1. Duchamp, *Tu m'*, 1918, oil and pencil on canvas, with bottle brush, three safety pins, and a hexagon nut, 69.8 x 313 cm.

Source: Yale University Art Gallery, Gift from the Estate of Katherine S. Dreier. © Succession Marcel Duchamp/VG Bild-Kunst, Bonn 2008.

The notion of space as a system of dimensions that shift within a four-dimensional continuum is represented here in the form of shadows and real objects. If we follow Duchamp's train of thought and understand the real objects of the Readymades as possible three-dimensional shadows of four-dimensional entities,[37] then these entities are present here in the form of projected two-dimensional shadows of the *Bicycle Wheel* (1913), the *Thonet Hat Rack* (1918), and the *Corkscrew*, the latter a Readymade that has not survived or was perhaps never realized in the first place. A real bottlebrush, placed perpendicularly to the picture plane and, depending on the lighting, casting a real shadow upon or next to the painted shadows, creates an enigmatic and confusing interplay between the real and the painted shadows, thus extending the illusionistic picture space forward, beyond the picture plane, into the real world of the viewer. A real hexagonal nut, which brings to a standstill a stack of lozenge-shaped color samples perspectively projected toward the viewer, and three real safety pins holding together a trompe l'oeil tear in the canvas expose painting as a métier devoted to the illusory arts.

What is most difficult to interpret is the complicated geometrical form in the right-hand half of the painting, which Duchamp drew with the aid of the wooden templates based on the *3 Standard Stoppages*. Both metric and projective geometry are present in the painting; they take the form of two linear-perspective projections, one, the representation of the lozenge-shaped color samples that diminish in size toward a vanishing point on the horizon formed by the top edge of the painting; the other, a pencil of rays formed by colored, rodlike orthogonals on the right, visible only in segments and converging toward a vanishing point on the bottom edge of the painting, their opposite ends terminating at the outer edges of an open cube, the straight lines of which have been replaced by two of the three wavy lines of the *3 Standard Stoppages*.[38] The left-hand face of the cube, white in color and perpendicular to the picture plane, is integrated into the linear-perspectival pencil of rays. Thus Duchamp confronts the viewer with a virtual cube, the image of which has been constructed according to both Euclidean and non-Euclidean principles. Obviously it was

Duchamp's intention to combine Euclidean geometry, on which is based the linear-perspectival construction that integrates the white, left-hand face of the cube, with topological geometry, the theorems of which "would remain true if the figures were copied by an inexpert draftsman who should grossly change all the proportions and replace the straights by lines more or less sinuous."[39]

I have already noted that according to Poincaré—one could almost imagine that Duchamp had Poincaré's books next to him on the table as he worked on this painting—a straight meter and a deformed meter are equivalent from the point of view of analysis situs, the "higher," "qualitative" kind of geometry. This equivalence is represented both in the form of the three "sinuous" templates cut according to the lines formed by the threads of the *3 Standard Stoppages* in the bottom left-hand corner of the painting and, on the right, in the curved lines integrated into the transparent geometrical solid according to the principles of projective geometry. By replacing each of the straight lines by two fortuitously curved lines for the edges of the polyhedron, Duchamp sought at the same time to give back to the latter the "à peu près du 'toujours possible' [the nearly of the 'always possible']" that it had lost through its "strained" integration into the system of linear perspective. Duchamp's choice of red and black for the edges of the polyhedron is evidently not a fortuitous one and doubtless echoes Poincaré's discussion of the possible application of the "calculus of probabilities" to games of chance in the chapter of *The Value of Science* entitled "Rouge et Noir."[40] Six years later, when working on his artistic *Obligation pour la roulette de Monte Carlo*, Duchamp was to attempt to outwit chance by using the martingale system on "rouge/noire" (more about this in a later chapter).

The abbreviated title *Tu m'* invites the viewer to complete its possible meaning: "*Tu m'embêtes*" or "*Tu m'emmerdes*" ("You bore me" or "You get on my nerves").[41] Whether Duchamp means his client, geometry, or painting is open to conjecture, but whatever our interpretation, he had obviously reached the end of his preoccupation with both geometry and oil painting. This farewell to painting is a kind of humorously painted treatise on perspective. Just as in the illustrations

devoted to the "correct projection of shadows" in Jean du Breuil's *La Perspective pratique nécessaire à tous les peintres, graveurs, sculpteurs etc.*,[42] the shadow of the *Hat Rack* is "caught" in the perspectival lines of the Euclidean/non-Euclidean solid in the right-hand half of the painting. Viewed outwardly, *Tu m'* almost has the precision of a Renaissance painting, but its content is based not on any geometry that could claim to be scientifically sound, as in the paintings of a Piero della Francesca or a Leonardo da Vinci, but rather on a playful pseudogeometry that relativizes geometrical representations of space, indeed, exposes the whole arbitrariness of those geometrical models that visualize the way we imagine the world.

6 | THE CRISIS OF THE SCIENTIFIC CONCEPT OF TRUTH

In the philosophical world of France of the last decade of the nineteenth century, Henri Poincaré, the outstanding scientific authority of his time, put forward the theory that not only the axioms of geometry but also most of the principles of physics, such as Newton's laws and the law of conservation of energy, were based on mere "conventions."[1] This theory triggered a heated debate on scientific truth and objectivity, a debate that during the first decade of the twentieth century had assumed—according to the philosopher Abel Rey in his treatise *La Philosophie moderne* of 1911—the character of a "rousing campaign, almost becoming a fashion."[2] "All questions of modern philosophy," Rey writes, "revolve around science."[3] "Thinking science" must, Rey concludes, be the prime aim of all who count themselves among the masters of contemporary philosophy.[4] Essentially, according to Rey, there were two opposing camps of thought: "On the one side we have the rationalist, intellectualist and positivist systems: the dogmatism of science. On the other side we have the pragmatic, fideist systems, or the system of active intuition (like that of Bergson): the dogmatism of action."[5] The forums of this debate were the "Société Française de Philosophie" and the bimonthly *Revue de métaphysique et de morale*.[6] The mathematicians and philosophers Gaston Milhaud (1858–1918) and Édouard Le Roy (1870–1954) and the physicist and philosopher Pierre-Maurice Duhem (1861–1916) were, besides Poincaré, the most important protagonists of this debate.[7] It was above all Édouard Le Roy—a comrade in arms of Bergson—who made his mark through radical antiscientific conclusions drawn from Poincaré's "conventionalist" theories. In several articles published in the *Revue de métaphysique et de morale*, Le Roy had fundamentally criticized

scientific rationalism, carrying Poincaré's "conventionalist" theory to the point of asserting that scientific principles and laws were more or less arbitrary constructs of scientists and could not therefore adequately lay claim to objective truth.[8] The sciences, Le Roy maintained, were able to produce only systems of quantitative relationships, which may well be of practical use but will never be able to grasp the truth of the world. This ability was reserved for metaphysical thought and for emotion, intuition, and faith, in particular. Le Roy's radical critique of science had created such a furor in the circles of French scientists and philosophers, especially in the debates of the Société Française de Philosophie, that in 1902 Poincaré saw himself obliged to take a stand. This he did with his essay "Sur la valeur objective de la science" in the *Revue de métaphysique et de morale*; it was reprinted in his book *La Valeur de la science* of 1905.[9] Poincaré summed up Le Roy's theory, which he considered tainted with skepticism and deeply anti-intellectual, as follows:

> Science consists only of conventions, and to this circumstance solely does it owe its apparent certitude; the facts of science and, *a fortiori*, its laws are the artificial work of the scientist; science therefore can teach us nothing of the truth; it can only serve us as a rule of action. Here we recognize the philosophic theory known under the name of nominalism; all is not false in this theory; its legitimate domain must be left it, but out of this it should not be allowed to go.[10]

It is not known whether Duchamp had read one or other of the essays or any of Le Roy's books,[11] or perhaps Abel Rey's treatise *La Philosophie moderne*, in which the conflict between nominalism and scientism was analyzed in detail. Duchamp certainly acquainted himself with Le Roy's antiscientific theories when reading the chapter "Is Science Artificial" in Poincaré's *The Value of Science*.[12] Indeed, in this dispute between Poincaré and Le Roy, Duchamp clearly sided with Le Roy. Like Le Roy, Duchamp radicalized Poincaré's conventionalist theories toward the nominalist view that scientific laws are merely academic

constructs and generalized Poincaré's observations on the relativity of scientific axioms, principles, and laws to the point of total skepticism.

Poincaré disputed Le Roy's assertion that scientific facts were merely the constructs of scholars by first distinguishing between "crude fact and the scientific fact," saying that any differentiation between true and false could be applied only to the former.[13] The observation, "It is growing dark," is a fact because it is "always verifiable, and for the verification we have recourse either to the witness of our senses, or to the memory of this witness. This is properly what characterizes a fact."[14] However, if the sentence takes the form of a convention, there is no sense in deciding whether it is true or false, "since it could not be true apart from me and is true only because I wish it to be. When, for instance, I say the unit of length is the meter, this is a decree that I promulgate, it is not something ascertained which forces itself upon me. It is the same . . . when it is a question, for example, of Euclid's postulate."[15] Just as Duchamp did when explaining the significance of the 3 *Standard Stoppages* on the MoMA questionnaire, Poincaré here links the question of the standard meter with that of Euclid's postulate. That all units of measure are definitions universally recognized by dint of "conventions" is immediately clear to everyone. Indeed, whole decades of scientific and political endeavor were necessary before a convention could be reached for the standard meter on an international level. And by far not all states have yet recognized the decimal system as an official system of measuring units. The concern of scientific theorists at the time was not whether the standard meter was based on a convention but rather whether this convention had come about *arbitrarily*.

The meter as a unit of length was the brainchild of the French Revolution and the pride of all French intellectuals, then as now. The two-hundredth anniversary celebrations of the French Revolution included an exhibition mounted in honor of the meter at the Musée National des Techniques in Paris.[16] In order to standardize the many different weights and measures that existed throughout the country, the National Assembly had decided in 1791 to introduce a uniform, "Republican" unit of length that would be the same for all. As this unit

of length was to be valid not just for the French but for all peoples and nations, the Académie des Sciences had suggested taking one quarter of the Earth's meridian as the "universal and natural" basis for the new system of measurement.[17] The meter was defined as the unit of length corresponding to "one ten-millionth of the length of the Earth's meridian between the Equator and the North Pole."[18] As early as 1797, the Convention Nationale had *étalons* of the new unit of length displayed on the walls of the most important public buildings in Paris (see fig. 6.1). But it was not until 1799, after an expedition of several years had been commissioned to measure the meridian between Dunkirk and Barcelona, that the actual length of the meter was finally fixed and a prototype meter bar deposited in the Archives Nationales. It was from the definition of the meter that the basic units of measure for determining volume and weight, the liter and the gram, were derived.[19]

The second half of the nineteenth century saw the development of a complex network of scientific and political activity aimed at achieving international validity for the "Republican" standard unit of measure and the decimal system that is based upon it. In 1870 the French government had instituted a Commission Internationale du Mètre in Paris, which led to the signing of a Convention du Mètre by as many as seventeen states by 1875. This convention was the working basis of the Comité International des Poids et Mesures, which oversaw the research work of the Bureau International des Poids et Mesures and prepared the decisions of the highest organ of authority, the Conférence Générale des Poids et Mesures. The latter decided at its first meeting in 1889 to have international prototypes constructed and deposited at the Bureau International des Poids et Mesures in the Pavillon du Breteuil in Sèvres.[20] Thus it is that the most famous international prototype meter, a 102 cm bar consisting of 90 percent platinum and 10 percent iridium and having an X-shaped cross-section, is still kept in a cooled room in that pavilion (see fig. 6.2). However, as the standard meter based on a material prototype cannot exceed a maximum measuring accuracy of 10^{-8}, while an accuracy of 10^{-11} is required for the measurement of wavelengths and for applications

Fig. 6.1. In order to familiarize the people with the metric system, the Convention Nationale displayed sixteen standard meters in marble in the streets of Paris between February 1796 and December 1797. The standard meter shown here is one of the last two surviving exemplars and the last one to be still located in its original place.

Source: Photo: Herbert Molderings.

Fig. 6.2. Prototypes of the meter and the kilogram, 1889, Bureau International des Poids et Mesures, Sèvres, Pavillon du Breteuil.

Source: From exhib. cat. *L'Aventure du mètre*, Musée national des techniques-CNAM, Paris 1989.

in satellite telemetry, the Conférence Générale des Poids et Mesures decided in 1983 to base the meter on another "natural and universal" unit: the speed of light. Since then, the meter has been defined as the length of the path traveled by light in vacuum during a time interval of 1/299,792,458 of a second.[21]

"Experience guides us in this choice [of *étalons*] without forcing it upon us; it tells us not which is the true geometry, but which is the most convenient."[22] If, however, such exact sciences as mathematics and physics are not concerned with the finding of truth but at best with questions of operational or intellectual convenience, how can science continue to justify its claim to superiority over other forms of thought? And what purpose can scientific thought serve at all? Why should the establishment of standard units of measure not simply be left to chance? In transforming the official unit of length, the standard meter, into 3 *Stoppages étalon*, Duchamp radicalized Poincaré's thesis that scientific rules and definitions were merely conventions to the point of concluding that all units of measure are valid, no matter how personal, fortuitous, or arbitrary they might be.

All the rules used by mathematicians and scientists to order empirical data and to generalize them into laws "are not imposed upon us and we might amuse ourselves in inventing others," Duchamp could read in *The Value of Science*,

> but they could not be cast aside without greatly complicating the enunciation of the laws of physics, mechanics and astronomy. We therefore choose these rules, not because they are true, but because they are the most convenient, and we may recapitulate them as follows: The simultaneity of two events, or the order of their succession, the equality of two durations, are to be so defined that the enunciation of the natural laws may be as simple as possible. In other words, all these rules, all these definitions are only the fruit of an unconscious opportunism.[23]

Duchamp's ironic attitude toward science's claim to truth and importance led him to do just that, namely to "amuse" himself "in inventing

other [rules]" and to "complicate the enunciation of the laws of physics, mechanics and astronomy," in 1913–14 when he set about basing his preliminary study for *The Bride Stripped Bare by Her Bachelors, Even* on the most advanced scientific thought. His note, "the whole of this representation is the sketch ... for a reality that would be possible by slightly distending the laws of physics and chemistry,"[24] reads like a direct echo of the passage from Poincaré's book. What the mathematician had suggested merely as an amusing intellectual pastime had been adopted by Duchamp as an approach not only to his *The Bride Stripped Bare by Her Bachelors, Even* but also to all his future artistic experiments.

It was, at the latest, during his endeavor with *The Bride Stripped Bare by Her Bachelors, Even* to put art back in the service of the mind that Duchamp became convinced of the arbitrary, indeed, mythological nature of all scientific thought. "Their [the scientists'] so-called proofs depend on conventions," he said in an interview with the Swiss writer and philosopher Denis de Rougemont in 1945. "Nothing but tautologies! ... Science is purely a mythology, their laws and its subject matter itself are pure myths, they are no more and no less real than the conventions of some game or other."[25] This was entirely the language of Édouard Le Roy, who had defined science as a system of rules that, while enabling one to take action, was no more significant than the rules of any game when it came to determining the true essence of existence. "Rational science," he had written in "Science et Philosophie" in the *Revue de métaphysique et de morale* in 1899, "—the extreme expression of discursive cognition—is just a purely formal word game without any intrinsic significance."[26] From a letter written by Duchamp to the surrealist poet Jehan Mayoux in 1956 it is clear that Duchamp had adopted this view:

> All this twaddle, the existence of God, atheism, determinism, societies, death, etc., are pieces of a chess game called language, and they are amusing only if one does not preoccupy oneself with 'winning or losing this game of chess.'—As a good nominalist, I propose the word *patatautology*, which, after frequent repetition,

will create the concept of what I am trying to explain in this letter by these execrable means: subject, verb, object, etc.[27]

Although Poincaré had in his philosophical writings furnished many an argument in its favor, he did not share this nominalist theory of science at all.[28] To clear up the misunderstandings that had arisen, he replied to Le Roy's theses in his essay "Sur la valeur objective de la science," which was published in the *Revue de Metaphysique et de morale* in 1902. "The rule of tric-trac is indeed a rule of action like science, but does any one think the comparison just and not see the difference?" Poincaré writes, addressing himself directly to Le Roy. "The rules of the game are arbitrary conventions and the contrary convention might have been adopted, *which would have been none the less good*. On the contrary, science is a rule of action which is successful, generally at least, and I add, while the contrary rule would not have succeeded."[29] Thus it is "success," that is, the ability to foresee the recurrence of events under the same conditions, that differentiates the rules of science from those of any game. Poincaré reverts to this point in *La Science et l'hypothèse*. While scientific principles are based on conventions, these conventions are in no way arbitrary: "Are the law of acceleration, the rule of the composition of forces then only arbitrary conventions? Conventions, yes; arbitrary, no; they would be if we lost sight of the experiments which led the creators of the science to adopt them, and which, imperfect as they may be, suffice to justify them. It is well that from time to time our attention is carried back to the experimental origin of these conventions."[30] The recognition that scientific rules and laws were only relative and provisional was for Poincaré not at all synonymous with any notion that they were arbitrary, as it was for Le Roy and Duchamp. For Poincaré they were not the artificial contrivance of some individual but rather the natural outcome of a discourse among scientists that was constantly verified through experimental physics.

"Some people have exaggerated the role of convention in science; they have even gone so far as to say that law, that scientific fact itself, was created by the scientist," Poincaré writes in his introduction to

The Value of Science, defending himself against the skepticist conclusions drawn from his theses. "This is going much too far in the direction of nominalism. No, scientific laws are not artificial creations; we have no reason to regard them as accidental, though it be impossible to prove they are not."[31] But even this statement was not without ambiguity, as indeed were Poincaré's statements in general, his lack of philosophical and verbal precision being the chief reproach leveled at him by critics. One such critic was Gaston Milhaud, who concluded his review of *La Science et l'hypothèse*:

> And in fact, despite all his efforts at justifying the convenience of conventions and definitions, Poincaré will always make us feel that in his eyes they constitute something that is contrary to true objectivity, something that without doubt stands in its place as best it can, but is nevertheless something that opposes it.... Precisely that is how Monsieur Poincaré will always so easily divest the fundamental definitions of science of their *truth*; and that is how he will always lead us—despite his efforts to the contrary—to cast doubt on their objectivity; and that is how, from beginning to end, from the postulates of geometry through to the very core of natural science, he will always allow something to persist, something arbitrary, indeterminate, insufficiently justified, that will always confuse and perturb us in spite of everything.[32]

Even the more benevolent critics were hard put to convince their readers that Poincaré's relativism and conventionalism "in no way meant the ruin of realism."[33] In his book *Science et philosophie*, published in 1912, the year of Poincaré's death, the mathematician Jules Tannery summarized the debate triggered by Poincaré on the truth content of scientific knowledge as follows:

> Some philosophers, whose scientific talent is beyond question, have been pleased to assert that science is but a discourse, a game of definitions, conventions, and formal deductions. Monsieur Poincaré has provided them with some ammunition, of

which they have made full use, but after all is said and done, not everything is wrong in their argumentation, for whenever science establishes itself in a logical form, one must needs begin with definitions; these definitions may seem arbitrary to the beginner, and it is more often than not the case that it is the totality of deductions, the agreement of the conclusions with experimental reality, that justifies these definitions, at least in a provisory way. Without taking back anything of what he has already said, Monsieur Poincaré clearly shows that while science relates to the human being it does not relate to an individual, to the individual scholar, and therefore it is not an artificial work but rather the natural product of an understanding.[34]

The 3 *Standard Stoppages*, on the other hand, are entirely an "artificial work"—arbitrary standards of measure that relate to the "individual, the individual scholar," in this instance to the artist Marcel Duchamp. Neither their experimental origin nor their practical use extends beyond Duchamp's own self. They have a meaning only within his own world of consciousness, his imagination, his art. Duchamp made this perfectly clear when he wrote "3 Stoppages étalon; appartenant à Marcel Duchamp" on the back of the canvases. Concomitant with the act of "depersonalizing straight lines," which is what Duchamp had in mind with this experiment with the three threads, was a new act of "personalizing the standard measure." To understand this fully, we must go back—insofar as the meter was concerned—to the time before 1795, when units of length were not standard or universal but personal. The "Étalon de longueur; appartenant à Marcel Duchamp" is curiously reminiscent of the "Étalons royales de Mesures," which can be viewed at the Musée des Arts et Métiers, Paris, alongside the "Mètre en platine," the "Mètre du Conservatoire" of 1799.[35]

Both Linda D. Henderson and Craig E. Adcock have interpreted the 3 *Standard Stoppages* as "conventionalist artworks," works that translated Poincaré's conventionalist theory of science into the language of art.[36] In actual fact, the 3 *Standard Stoppages* stretch the conventionalist theory to the point of absurdity. In Poincaré's theory, the asser-

tion that scientific principles and laws essentially depend on conventions for their validity does not mean that these principles and laws are in any way arbitrary. On the contrary, these scientific conventions are, first, founded on experiments and experiences and, second, not decreed by any one individual but are agreed upon within a discourse among scientists and constantly checked, extended, and, if need be, redefined against the background of new experimental data.[37] The kind of convenience to which Poincaré refers in connection with the establishing of conventions has little to do with the common notion of convenience. The criteria governing scientific "convenience" were for him formal mathematical "simplicity" and the congruence—as accurate as possible—of the principles and laws with the information obtained through experiments on the behavior of bodies. While Poincaré's conventionalist theory of science called in question the absoluteness of geometrical axioms and scientific principles and laws, it did not negate the fundamental capability of scientific thought to come closer and closer to the "truth." Duchamp, on the other hand, basically doubted the value of science as a means of acquiring knowledge of life and accorded it, as did Le Roy and Bergson, merely a purely technical and practical function.

Poincaré had had used the term "nominalism" to describe Le Roy's theory that scientific principles and laws were more or less arbitrary constructs and no more able to grasp the truth of the world than any kind of game. In 1914, the year in which he produced the *3 Standard Stoppages*, Duchamp wrote the following note: "A kind of pictorial nominalism (check)."[38] What Duchamp meant, in other words, was his intention to apply the notion of nominalism to the visual arts, to painting. This implied two things: first, that art was to serve as a kind of game, without expressing any claim to any truth whatsoever, neither a claim to "la grandeur des formes metaphysiques" (Apollinaire)[39] nor a claim to the ideals of science and technology (futurism) or to the "eternal laws of art" (Gleizes);[40] second, it implied the idea of exposing those geometrical principles on which painting had been based since the Renaissance as arbitrary "artistic" constructs that had no objective value. Duchamp did this by reifying the invisible plane intersecting

the visual pyramid as a pane of glass and by materializing visual rays based on Euclidian optics as threads. There is much that gives reason to assume that the 3 *Standard Stoppages* were, in their original form as "tableaux," Duchamp's first attempt at realizing "pictorial nominalism." Indeed, they confront us with lines that are nominalistic figures inasmuch as they refer to nothing real except themselves, neither to an objective (mimesis) nor to a subjective (expression) state of affairs. Moreover, they are works that in no way conceal their arbitrary and artificial character as the intellectual constructs of an individual.

The historian of philosophy Abel Rey had interpreted the Poincaré–Le Roy controversy as a sign of a deep crisis of the scientific worldview as based on the laws of physics.[41] In 1907, he wrote:

> If the [physical and chemical] sciences, which in history have been essentially emancipators, collapse in this crisis, which reduces them to the status of mere technically useful recipes but deprives them of all significance from the standpoint of knowledge of nature, the result must needs be a complete revolution both in the art of logic and the history of ideas. Physics then loses all educational value; the spirit of positive science it represents becomes false and dangerous.... Knowledge of the real must be sought and given by other means.... One must take another road, one must return to subjective intuition, to a mystical sense of reality, in a word, to the mysterious, all that of which one thought it had been deprived.[42]

Édouard Le Roy, a dedicated Catholic and a contributor to the *Annales de philosophie chrétienne*, worked during the 1910s and 1920s on a theory of "intuitive thought" and sought to revaluate religious belief as the only form of metaphysical knowledge able to counter rational logic.[43] Unlike Le Roy, Duchamp was a skeptic, who after the collapse of the positivist worldview chose not a "return to a mystical sense of reality" in compensation for the loss of absolute certainties but rather the forces of humor and irony as a preventive measure against the "dangerous spirit of positive science." He, too, sought the

experience of mystery, of what defies all rational description, but the experience he was seeking was an aesthetic one, not a religious one.[44] For Duchamp, life devoid both of a scientific, positivist "truth" and of a metaphysical sense was tolerable only if it could be understood as a game. "The realization of the game-like nature of life is of greatest importance," Duchamp once said, explaining his concept of art and life. "We should not strive for absolutes, don't make truth of the rules, recognize that we play the game according to rules as we see them now."[45] Only by treating life as a game, Duchamp was convinced, can we enjoy the possibility of escaping the "laws," the serious side of life and the sciences, in order to gain the freedom of a way of life that is neither bound nor determined by anything.[46]

The *3 Standard Stoppages* of 1913–14 are Duchamp's first openly *anti*scientific work. The combination of the nonsense title, the ironically conceived pseudoscientific experiment and the choice of trivial materials for its realization conveyed not the slightest impression of philosophical seriousness.[47] It was on such a combination of title, concept, and materials that Duchamp's art was based throughout all the years he worked on the *Large Glass* (1913–1923). Thus Linda D. Henderson's interpretation of the *Box of 1914*, the *3 Standard Stoppages*, and the *Large Glass* as works that established Duchamp's new identity as an "artist-engineer-scientist" stems from a fundamental misconception: "Duchamp found in Leonardo and Poincaré models for his activity as an anti-Cubist artist-engineer-scientist," Henderson writes, summing up her investigations into the relationship between Duchamp's work of 1913 through 1915 and the sciences, "and he used their ideas to undermine the increasingly antimathematical, antiscientific stance of the Bergsonian Puteaux Cubists."[48] Duchamp, however, never saw himself as an "artist-engineer-scientist," and the *3 Standard Stoppages* and all his other works of the years from 1913 to 1915 are in no way proscientific stances against the antiscientific stances of the Puteaux cubists. On the contrary, Duchamp took scientific ideas and twisted them in such a way that they themselves called in question the primacy of scientific reason. Duchamp's pseudoscientific experiment of the *3 Standard Stoppages* did not hark back to Poincaré's

conventionalist philosophy just in order to attack Euclidean geometry, as Henderson writes, but rather to ironize all axiomatic concepts, including non-Euclidean geometry, and the logic of scientific thought as a whole.

Duchamp's absolute opposition—as construed by Henderson—to the "antimathematical, antiscientific stance of the Bergsonian Puteaux Cubists" (i.e., Gleizes, Metzinger, Léger, Delaunay, Duchamp's brothers J. Villon and R. Duchamp-Villon, among others) is, moreover, an oversimplification.[49] If we consider, on the one hand, the zeal with which Gleizes and Metzinger sought to legitimize cubism scientifically through references to non-Euclidean geometry and, on the other, how Duchamp's 3 *Standard Stoppages* disputed not only Euclidean geometry's claim to truth and objectivity but also that of non-Euclidean geometry, then it is Duchamp who suddenly appears as the antimathematical and antiscientific thinker and not the Puteaux cubists. The aesthetic quintessence of the *Box of 1914* is summarized by Henderson as follows: "Through his deep interest in science Duchamp declared his allegiance to quantity versus quality, to intelligence over intuition, to the world of Descartes versus that of Bergson."[50] In resorting, after 1913, to the vocabularies of form of "mechanical drawings" and scientific diagrams, Duchamp certainly developed forms of artistic expression that ran counter to the categories of self-expression, intuition, and taste as favored by Gleizes and Metzinger in *Du Cubisme*, but this in no way implied—as Henderson maintains—a complete rejection of subjectivity in art. Duchamp had simply invented new forms of subjectivity; in personalizing one of the most impersonal products of modern thought, the standard meter, Duchamp subjectivized scientific thought and, by the same token, aestheticized it. Nor did he in any way scorn intuition as one of the most important forces of the creative process.[51] As shown in the previous chapter, Duchamp differed from Gleizes and Metzinger in that he developed intuition in the field of, and from the precepts of, geometry itself, and stretched the limits of geometrical intuition beyond the rules of scientific discourse.

We must also relativize the diametrical opposition suggested by Henderson: Bergsonian irrationalism on the one side, Duchampian

prorationalism on the other. Duchamp decidedly criticized, for example, the rationalist use of the term *"esprit"* in Gleizes and Metzinger's book, *Du Cubisme*:

> When they [Gleizes and Metzinger] said there is no reality outside the mind they were using the word mind in its rational sense. I do not feel that this type of thinking was an influence on me. . . . We are not all material or rational. . . . There is more to man than these concepts would imply. In order to explain the part of man that is important but not material or rational I use the word spiritual. It does not imply a religious stand.[52]

Like Bergson and Le Roy, Duchamp took a definite stand against scientific rationalism and positivism in his art after 1913, but it was an inward rather than an outward stand. While the philosophers Bergson and Le Roy pleaded for metaphysics instead of physics, the artist Duchamp opted for a "playful physics."[53] He stretched scientific reasoning, often unnoticeably, beyond the very limits of rationality. In the already quoted letter to Paul Matisse, Duchamp explains that the influence of the third dimension on a meter-long thread falling through space "invalidates *'irrationally'* the concept of the 'shortest distance between two points' (classical definition of the straight line)."[54] The "idea of the fabrication" of the 3 *Standard Stoppages* only seems to observe the discourse framework of scientific argumentation. A more than basic knowledge of geometry and scientific theory is required in order to know that the "checking" of a geometrical postulate by means of a physical experiment is a completely unscientific, "irrational" approach. In this regard, the 3 *Standard Stoppages* are not all that far removed from the "antiscientific stance of the Bergsonian Puteaux Cubists," except that they do not favor the aesthetic categories of taste, harmony, and expression but rather cloak their criticism of science in a pseudoscientific guise.

Whether Duchamp was absolutely opposed to Bergson's philosophy, as Henderson maintains in *Duchamp in Context*, is open to doubt, as this thesis takes no account whatsoever of the numerous points

on which Bergson and Duchamp agree when it comes to the criticism of science and reason.[55] Almost nothing is known, however, about Duchamp's knowledge of Bergson's writings. This has yet to be made the subject of research.[56] Some of Duchamp's notes make direct or indirect reference to Bergson's ideas.[57] He even once confessed to having been directly influenced by Bergson's philosophy: "I agree that in so far as they recognize the primacy of change in life I am influenced by Bergson and Nietzsche. Change and life are synonymous. We must realize this and accept it. Change is what makes life interesting. There is no progress, change is all we know."[58] What we *do* know for certain is that Duchamp shared the Bergsonian views of Le Roy, with whose central theses he had familiarized himself probably not through Le Roy's writings themselves but through his reading of Poincaré's *La Valeur de la science*. Indeed, Duchamp never left any doubts about his criticism of rationalism in art and philosophy. "My work has been an attempt to show that reason is less fruitful than we think," Duchamp said in one of his interviews with Laurence Stephen Gold. "We think we find solutions through this function of rational thought but we do not. The mind is much freer than this type of thought would indicate."[59]

Duchamp's logic is the relativist logic of skepticism. As the notion of "objective truth" could no longer be upheld, not even in the exact sciences, the 3 *Standard Stoppages* were in his eyes just as valid as the international prototype meter, the result of years of painstaking measurements, that was kept at the Bureau International des Poids et Mesures in Sèvres. The artist Duchamp derived no end of pleasure from undermining the "realism" of the scientific view of the world. "It was just the idea that life would be more interesting if you could stretch these things [the laws of physics and chemistry] a little. After all, we have to accept these so-called laws of science because it makes life more convenient, but that doesn't mean anything so far as *validity* is concerned," Duchamp once said, summarizing his epistemologically pessimistic and antiscientific views, entirely in the style of his Bergsonian comrade in arms Édouard Le Roy.

Maybe it's all just an illusion. We are so fond of ourselves, we think we are little gods of the earth—I have my doubts about it, that's all. The word 'law' is against my principles. Science is evidently a closed circuit, but every fifty years or so a new 'law' is discovered that changes everything. I just didn't see why we should have such reverence for science, and so I had to give another sort of pseudo explanation. I'm a pseudo all in all, that's my characteristic. I never could stand the seriousness of life, but when the serious is tinted with humor it makes a nicer color.[60]

It is this pseudo-ness that is always present whenever Duchamp thematizes scientific laws and theories. His experiment with the three threads, too, is a pseudo-experiment; it belongs not in the world of physics but in that of "hypophysics"[61] or pataphysics. As Duchamp himself said, in his lecture "A Propos of Myself," the 3 *Standard Stoppages* cast "a pataphysical doubt on the concept of a straight line as being the shortest route from one point to another."[62]

7 | PATAPHYSICS, CHANCE, AND THE AESTHETICS OF THE POSSIBLE

The seminal work of pataphysics is Alfred Jarry's "neo-scientific novel," *Exploits and Opinions of Doctor Faustroll, Pataphysician*, first published, posthumously, in 1911. "Book Eight," entitled "Ethernité,"[1] and beginning with the chapter "Concerning the Measuring rod, the Watch, and the Tuning Fork," had already appeared as a preprint in the magazine *Vers et Prose* in autumn 1910.[2] In this novel, Jarry defines the new discipline of pataphysics as "the science of imaginary solutions. . . . pataphysics will be, above all, the science of the particular, despite the common opinion that the only science is that of the general. Pataphysics will examine the laws governing exceptions, and will explain the universe supplementary to this one."[3] The science of pataphysics, in other words, is a science of exceptions, dealing only with the particular and establishing the laws that distinguish special phenomena from general phenomena. Pataphysics is thus a logical impossibility or, to put it more positively, a poetical game with nonsense in a scientific guise. It can even sound wonderfully rational at times, provided the rules of scientific discourse are observed. Take, for example, the following excerpt from Jarry's novel: "Contemporary science is founded upon the principle of induction: most people have seen a certain phenomenon precede or follow some other phenomenon most often, and conclude therefrom that it will ever be thus. Apart from other considerations, this is true only in the majority of cases, depends upon the point of view, and is codified only for convenience—if that!"[4] Here, curiously, Alfred Jarry, the poet of the grotesque, paraphrases Poincaré, the mathematician, but not without giving, in the next sentence, a convincing example of that brand of "humorous physics" on which Duchamp was to base, two years after

the publication of *Dr. Faustroll*, the ideas behind his *The Bride Stripped Bare by Her Bachelors, Even*.[5]

> Instead of formulating the law of the fall of a body toward a center, how far more apposite would be the law of the ascension of a vacuum toward a periphery, a vacuum being considered a unit of non-density, a hypothesis far less arbitrary than the choice of a concrete unit of positive density such as *water*? For even this body is a postulate and an average man's point of view, and in order that its qualities, if not its nature, should remain fairly constant, it would be necessary to postulate that the height of human beings should remain more or less constant and mutually equivalent. Universal assent is already a quite miraculous and incomprehensible prejudice. Why should anyone claim that the shape of a watch is round—a manifestly false proposition—since it appears in profile as a narrow rectangular construction, elliptic on three sides; and why the devil should one only have noticed its shape at the moment of looking at the time?[6]

It was these astonishing congruencies in the fields of modern poetical and scientific/philosophical thought that so fascinated Duchamp that he saw himself called upon to redefine the work of the artist, its purpose no longer being to produce paintings for sale or exhibition but to invent and develop a new kind of artistic thinking. "Painting wasn't everything. Certain gestures in life could be as aesthetic as painting," Duchamp explained retrospectively. "I wanted to introduce humor in my work. It wasn't a humor that just provokes laughter. Neither was it black humor, it was really a kind of humor that added something ... serious."[7] He saw himself as an artist in the tradition of Rabelais, Roussel, and Jarry.[8] Their critical approach to their respective times, couched in humor and nonsense, was the model on which Duchamp could treat serious philosophical and scientific questions without subjecting himself to the criteria of philosophical and logical discourse. The sketched ideas gathered together in the *Box of 1914*—the concept of the "diminished meter," the idea of making "a

painting of happy or unhappy chance," the barrel game as a *"sculpture of skill"*—clearly testify to Duchamp's endeavor to create an artistic equivalent of Jarry's literary criticism of science. The note "arrhe est à art ce que merdre est à merde" ("arrhe is to art as shitte is to shit")[9] in the *Box of 1914* made direct reference to the famous expletive— "Merdre!"—spoken by King Ubu on entering the stage in Jarry's play of the same name.

"The idea of 'chance', which many people were thinking about at the time, struck me too," said Duchamp, explaining his concept of the 3 *Stoppages étalon* to Pierre Cabanne. "Pure chance interested me as a way of going against logical reality: to put something on a canvas, on a bit of paper, to associate the idea of a perpendicular thread a meter long falling from the height of one meter onto a horizontal plane, making its own deformation. This amused me" (see fig. 7.1).[10] In scientific treatises at the beginning of the twentieth century there were in fact only a few ideas that were discussed as intensively as the question concerning the part played by chance in natural processes.[11] Whether Duchamp had read any of the copious scientific writings on the subject of chance or had again taken his basic ideas secondhand from Poincaré, as he had done in the case of Riemann's geometry,

Fig. 7.1. Note "3 Standard Stoppages étalon = canned chance," 1914.

Source: From Duchamp, *Green Box* (Paris, 1934). © Succession Marcel Duchamp/VG Bild-Kunst, Bonn 2008.

is not known.[12] Growing allowance for the theory of probability in modern theoretical physics (thermodynamics, kinetic gas theory) had fundamentally shaken the absolute determinism of classical mechanics and, with it, the principle of induction, this being the logical basis on which general statements can be made about particular entities.[13] Poincaré discussed this problem, quite humorlessly, in the chapter "Contingence and Determinism" of his book *The Value of Science*. Here, too, the philosopher and mathematician Poincaré was unable to offer his readers any absolute certainty:

> Experimental laws are only approximate, and if some appear to us as exact, it is because we have artificially transformed them into what I have above called a principle. We have made this transformation freely, and as the caprice which has determined us to make it is something eminently contingent, we have communicated this contingence to the law itself.... I do not at all wish to investigate here the foundations of the principle of induction; I know very well that I should not succeed; it is as difficult to justify this principle as to get on without it. I only wish to show how scientists apply it and are forced to apply it. When the same antecedent recurs, the same consequent must likewise recur; such is the ordinary statement. But reduced to these terms this principle could be of no use. For one to be able to say that the same antecedent recurred, it would be necessary for the circumstances *all* to be reproduced, since no one is absolutely indifferent, and for them to be *exactly* reproduced. And, as that will never happen, the principle can have no application.[14]

Entirely exaggerating Poincaré's argumentation, both Jarry and Duchamp advocated the immediate abandonment of the principle of induction. Duchamp's experiment with the three threads cast a "pataphysical doubt" not only on the Euclidean postulate of the straight line being the shortest distance between two points but also on the determinist view that a certain process taking place under identical conditions will always have the same consequence, such

that a law, that is, a prediction, can be derived from it. While the three equally long threads dropped "in similar conditions" are "in their relation to one another . . . an approximate reconstitution of the unit of length" (Duchamp's wording here seems to echo the cautious, pondering approach of Poincaré),[15] the experiment produces three individual and distinctly different "cases." If one considers the various sequences of events separately, "individually so to speak"—here Poincaré furnishes further food for Duchamp's antiscientific doubts—then one will "recognize that among these sequences there are no two altogether alike."[16] Thus both the principle of induction and the principle of causality are no longer tenable.[17] Not even a probability calculus that integrates the so-called laws of chance into a set of mathematical rules can help to solve this philosophical problem, for it can predict the effects of chance only *on the average* but *not in each case*, as Poincaré demonstrates in great detail in his third large treatise, *Science and Method*.[18] Impressed by the collapse of determinism in contemporary scientific thought, Duchamp at the time noted down the idea of an "ironic causality," which in his case consisted in working out not just one single "necessary" cause-and-effect relationship but "two or several solutions" for the causal relationships between all the different events in the *Large Glass*.[19]

Since in his view no science would be possible without determinism, Poincaré sought to redeem the principle of induction by stating that the sequences of phenomena may be divided up into classes. "It is to the possibility and the legitimacy of such a classification that determinism, in the end, reduces," Poincaré writes in *The Value of Science*. "The principle of induction would be inapplicable if there did not exist in nature a great quantity of bodies like one another, or almost alike, and if we could not infer, for instance, from one bit of phosphorous to another bit of phosphorous."[20] Reading *Science and Method*, Duchamp would certainly have noted the following:

> Suppose that instead of sixty chemical elements there were sixty milliards of them, that they were not some common, the others rare, but that they were uniformly distributed. Then, every time

we picked up a new pebble there would be great probability of its being formed of some unknown substance; all that we knew of other pebbles would be worthless for it; *before each new object we should be as the new-born babe*; like it we could only obey our caprices or our needs. . . . In such a world there would be no science; perhaps thought and even life would be impossible, since evolution could not there develop the preservational instincts. Happily it is not so; like all good fortune to which we are accustomed, this is not appreciated at its true worth.[21]

This was the idea—"before each new object we should be as the newborn babe"—that had been guiding Duchamp's experimental artistic thoughts and actions since 1913. Art should no longer be based on a social convention over what is "aesthetic" or what is "artistic" but should be an activity that makes possible the experience of the incomparable, the rare, the unique. No more rules of form, no styles and manifestos, just works; no groups, movements, or trends, just individuals.[22] Duchamp even expressed the idea that the work itself is superfluous, as it was only the experiment that counted: "Mode: experiments—the result not to be kept—not presenting any interest."[23] It was an idea that was not to be realized in art for another half a century: in the situationism and the Fluxus movement of the 1960s and 1970s.[24]

One of Duchamp's preparatory notes for the *Large Glass* reads like a marginal note on Poincaré's statements on the problem of singularities that basically concerned all scientific thought: "To lose the possibility of recognizing / identifying 2 similar objects—2 colors, 2 laces, 2 hats, 2 forms whatsoever to reach the impossibility of sufficient visual memory, to transfer from one like object to another the memory imprint."[25] What Duchamp had formulated here as an artistic project had already been reflected upon, in the context of linguistic and scientific criticism, by Friedrich Nietzsche in his famous essay, "On Truth and Lies in an Extra-Moral Sense," written in 1873. The parallels between Nietzsche's reflections and Duchamp's note are so striking that it is hard to imagine that Duchamp could have

formulated it without any knowledge of Nietzsche's essay.[26] "Every word," writes Nietzsche,

> immediately becomes a concept, inasmuch as it is not intended to serve as a reminder of the unique and wholly individualized original experience to which it owes its birth, but must at the same time fit innumerable, more or less similar cases—which means, strictly speaking, never equal—in other words, a lot of unequal cases. Every concept originates through our equating what is unequal. No leaf ever wholly equals another, and the concept "leaf" is formed through an arbitrary abstraction from these individual differences, through forgetting the distinctions; and now it gives rise to the idea that in nature there might be something besides the leaves which would be "leaf"—some kind of original form after which all leaves have been woven, marked, copied, colored, curled, and painted, but by unskilled hands, so that no copy turned out to be a correct, reliable, and faithful image of the original form.[27]

Based on this "forgetting the distinctions," according to Nietzsche, is that "reign of abstractions" to which human beings have subjected themselves in the age of modern philosophy and science.[28] "We obtain the concept, as we do the form, by overlooking what is individual and actual; whereas nature is acquainted with no forms and no concepts, and likewise with no species, but only with an X which remains inaccessible and undefinable for us."[29] Everything that distinguishes the human as a rational being

> depends upon this ability to volatilize perceptual metaphors in a schema, and thus to dissolve an image into a concept. For something is possible in the realm of these schemata which could never be achieved with the vivid first impressions: the construction of a pyramidal order according to castes and degrees, the creation of a new world of laws, privileges, subordinations, and clearly marked boundaries—a new world, one which now confronts that other

vivid world of first impressions as more solid, more universal, better known, and more human than the immediately perceived world, and thus as the regulative and imperative world.[30]

The work of the artist differs from that of the scientist and philosopher in that it proceeds in the entirely opposite direction and develops the ability to transform concepts into "perceptual metaphors," which are "individual and without equals" and thus render it impossible for criticism to derive new laws, axioms, and "clearly marked boundaries" from them. The first work in Duchamp's oeuvre in which this ability of the artist is fully developed and makes a virtually paradigmatic appearance is the 3 *Standard Stoppages*. It was this very aspect that prompted Duchamp to describe it, retrospectively, as his most important work. In 1913, Duchamp began to deconstruct, entirely in Nietzsche's sense, the theory of painting that had been valid for five hundred years into the long forgotten, perceptual metaphors on which it is based: the window, the glass pane, and the thread. By giving the ideal straight of Euclidean geometry the form of a thread and subjecting this thread to three incidences of chance, Duchamp succeeded in transporting the Euclidean postulate into the "vivid world of first impressions," in which there are only individual differences, in which reigns, instead of generalizations, conventions and postulates, the principle of the "l'à peu près du 'toujours possible' [the nearly of the 'always possible']."[31]

It was on the unique, the irreproducible, and all things that defied scientific description that Duchamp focused his art from 1913 onward. Consequently, chance increasingly became the central category of his view of art and life. "In fact, the whole world is based on chance, or at least chance is a definition of what happens in the world we live in and know more than any causality," Duchamp said toward the end of his life.[32] Chance, which knows only the exception, only the isolated case, is the central topos both of pataphysics and of the 3 *Standard Stoppages*. Octavio Paz already drew attention to this connection in 1966: "If the ancient notions of solid matter and clear and distinct reason disappear and give place to indetermination, the result is general disorientation. Duchamp's intention is to get rid forever of the 'pos-

sibility of recognizing or identifying any two things as being like each other': the only laws that interest him are the laws of exception, which apply only for one case and for one occasion only."[33] It is on chance that Duchamp bases his "Regime of Coincidence," which, as a department of the "Ministry of Gravity," organizes the glass world of *The Bride Stripped Bare by Her Bachelors, Even*.[34] Although the forms in the *Large Glass* had been produced by a kind of "controlled" chance, there was also an "uncontrolled" intervention of chance when the *Large Glass* was cracked during transport and Duchamp accepted the cracks in the glass as a new, integral part of the work.[35] Toward the end of his life, Duchamp took pleasure in declaring the whole of art history to be a product of chance, maintaining that the works of art in the museums had not survived because they were beautiful and significant but were beautiful and significant because they had "survived through the law of chance."[36] Likewise in the context of his work on *The Bride Stripped Bare by Her Bachelors, Even*, Duchamp performed, in 1913, two musical experiments, inspired by Raymond Roussel, that were also based on the principle of chance.[37] Both experiments were entitled *Musical Erratum*, and each one was written on two sheets of music-paper, the notes having been drawn from a hat in one case and based on a more complex random process in the other.[38] Around 1915 to 1916, Duchamp noted several "Specifications for Readymades": "By planning for a moment to come (on such a day, such a date such a minute) 'to inscribe a readymade'—The readymade can later be looked for. (with all kinds of delay). The important thing is just this matter of timing [*horlogisme*], this snapshot effect, like a speech delivered on no matter what occasion but at such and such an hour. It is a kind of rendezvous."[39] In 1924, Duchamp designed an edition of a gambling bond for a roulette system in Monte Carlo with the promise of a dividend (see fig. 7.2).[40] Duchamp had calculated it with the aid of a probability calculus that sought to eliminate the unpredictability of chance by calculating and observing the laws by which it operates.[41] Confident of its success, Duchamp wrote in the letter accompanying his sales offer to the collector Jacques Doucet: "Don't be too skeptical because this time I believe I have eliminated the word chance."[42] But the expected

Fig. 7.2. Duchamp, *Obligation pour la roulette de Monte-Carlo* (*Monte Carlo Bond*), 1924, photo-collage on colored lithograph (no. 2/30), 31.5 x 19.5 cm.

Source: Private collection. © Succession Marcel Duchamp/VG Bild-Kunst, Bonn 2008.

winnings failed to materialize and what remained of the mathematical "control" of chance were an artwork and a wonderful bon mot: "As you can see," Duchamp wrote at the time to his friend Francis Picabia, "I haven't quit being a painter. I'm drawing on hazard now."[43]

As we know, a further fifteen years or so went by before quantum mechanics brought the experience of the unique and the irreproducible—which Duchamp had begun to develop, albeit in a humorous vein, as early as 1913—into the limelight of modern physics.[44] The physicist Wolfgang Pauli, who together with Heisenberg and Bohr was one of the authoritative theorists of quantum mechanics, describes the changes in the scientific style of thinking thus: "The need for a definition of reproducibility in the law of nature has ... resulted in the loss of the unique in the scientific conceptualization of nature. What we have experienced in quantum mechanics is the occurrence of the essentially unique where it would least be expected, namely in ('non-lawful') individual observation."[45] Quoting Pauli's words, the historian of science Ernst Peter Fischer comments as follows:

> The unique was basically excluded when it came to scientific practice—at least for a very long time. But like all definitions, this restriction of scope could not count upon remaining a valid and unshakeable principle for ever, and so it was that, little by little, the unique, the irreproducible, crept into the field of vision of the sciences. . . . What the sciences are able to define is usually considered 'rational'. A generally valid natural law represents a rational—rationally graspable—aspect of nature. In this regard, the unique has no place in such a law and thus permits the reverse assumption that it is irrational. This may sound logical and simple enough, but it nevertheless implies something like a condemnation, for nobody wishes to have anything to do with irrationality—at least not in scientific circles. Any scientist wishing to make unique and irreproducible phenomena the subject matter of research must first of all learn to understand the term 'irrational' in a positive sense. 'Irrational' should no longer imply 'nonsense' or 'insanity' but simply something for which it is not

possible to establish a general law. The coincidences of life are certainly a part of this, and hence also the life of every individual. The world is full of irrationalities—not least the destiny of each single human being—and it would be a far-reaching mistake on the part of science if it refused to concern itself with them. Here again, it is quantum mechanics that has not only demanded a rethink but also made it possible.[46]

The belated rehabilitation of the unique in the scientific understanding of nature has given some researchers reason to regard Duchamp as being endowed with almost prophetic capabilities.[47] In fact, however, those basic theoretical ideas that some time later were to be rephrased in the context of quantum mechanics had not been conceived by Duchamp himself. He had found them, already formulated, in the writings of such dissimilar authors as Friedrich Nietzsche and Henri Poincaré. Duchamp adopted Poincaré's thoughts on the relativity of space and time, the approximate character of natural laws, the absence of any reason for inducing generalizations from one or more individual cases, the relationship between chance and determinism, and he humorously exaggerated them. In so doing, he succeeded in opening up new horizons of thought, horizons to which experimental and theoretical physics were later to venture in the 1920s. It was of decisive importance for Duchamp, however, to break with the ironic attitude toward science as practiced by Alfred Jarry. Duchamp called such an attitude, which had only ridicule as its aim, "negative irony," and with particular reference to the Dadaists. "Dada was a negation and a protest. I was not particularly interested in it. One's own 'no' merely makes one dependent on what one negates."[48] "I wished to show man the limited space of his reason, but Dada wanted to substitute unreason. The substitution was not a great improvement. By adding 'un' they thought they changed a great deal, but they had not."[49] Duchamp had realized that mere negation does not take one beyond the horizon of what one is criticizing; it simply evades the primacy of scientific logic, replacing it by other criteria, such as "absurdity" or "the "unconscious." Duchamp saw his own attitude as "affirma-

tive irony":[50] "Irony is a playful way of accepting something. Mine is the irony of indifference. It is a 'meta-irony.' "[51] "Irony of indifference" and "meta-irony" are synonyms for an attitude that differs from the negative irony of Dadaism in that it does not seek to destroy what it is calling in question but places it on a par with itself and at the same time shows it in a different light.[52] Duchamp's art is the kind of art that asks questions, not the kind of art that ridicules because it already knows the answers. If Duchamp had adopted the irony of the Dadaists, he would have had to demonstratively destroy the standard meter—the pride of France and the essence of universality[53]—and arrange it as a fortuitous assemblage of fragments on a canvas or in a box.[54] The 3 *Standard Stoppages*, however, does not negate the value of the standard meter but merely points to the possibility of conceiving it in a different way. Replying to the question, "This chance method of measurement, as with the *Stoppages*, puts a severe strain on the laws of physics, doesn't it?" Duchamp said: "If I do propose to strain a little bit the laws of physics and chemistry and so forth, it is because I would like to think them unstable to a degree. Even gravity is a form of coincidence or politeness since it is only by condescension that a weight is heavier when it descends than when it rises."[55]

The logic manifest in the 3 *Standard Stoppages* is not a scientific, rational logic, but rather a logic of the imagination in the tradition of the late symbolist poetry of Laforgue, Jarry, and Mallarmé, albeit with one big difference: the psychic dramas of human existence have been replaced by the basic concepts of the scientific world model. Stéphane Mallarmé's poem "Un coup de dés jamais n'abolira le hasard" ("A throw of the dice will never abolish chance"), which had just been published as a separate small book in 1914 and ended with the now famous line "Toute Pensée émet un Coup de Dés" ("Every Thought is a Throw of the Dice"),[56] was doubtless a part of Duchamp's intellectual ammunition, but I would nevertheless doubt Octavio Paz's claim that, like Mallarmé, Duchamp saw chance as a "manifestation of the absolute."[57] For Duchamp, the intervention of chance was always accompanied by humor, and this largely precluded the metaphysical significance that Mallarmé attached to chance. Theoretically, Duchamp's

aesthetic of chance was closely bound up with the category of the possible. His new artistic techniques of 1913-14—from the unclassifiable *3 Standard Stoppages* in their original form as three "canvases" to the equally unclassifiable "readymade sculptures" of a bottlerack and a bicycle wheel on a kitchen stool[58]—were based on a new kind of aesthetic that centered around the notion of the "possible."[59] "Likeness" and "truth" were not its key aspects, as in all the various brands of realism, were nor beauty, taste, and harmony, as in the aesthetics of formalism, but rather "the possible," in the sense of what is merely conceivable, the idea that all things can be perceived and conceived differently. "Possible. The figuration of a possible, not as the opposite of impossible, nor as related to probable, nor as subordinated to likely," Duchamp wrote in a sibylline note in 1913, "the possible is only a physical 'caustic' [vitriol type] burning up all aesthetics or callistics."[60] Among the hundreds of original notes that Duchamp kept as carefully as his artworks, this handwritten note enjoys a special status. The idea set down in this note must have been deemed so central to his thought that it was not only kept in a specially designed leaflet but also the only one to be published during his lifetime in a separate booklet.[61]

Waiving the effect of enchantment through beauty, Duchamp's aesthetics took the form of a mental experiment that relied on shock, surprise, and discovery for its success and, if successful, suddenly opened up the horizon for the viewer. Ignoring the traditional aesthetic discourse on form, Duchamp gave priority to the intellectual gift of invention, to the pleasure of thinking and visualizing what had never been thought before. In this regard, Duchamp left the traditional terrain of aesthetics, the "science of the beautiful" (which he called "callistics"), and established an aesthetic of the possible, an aesthetic in which the boundaries between science and art, artwork and experiment, art and non-art opened up completely. Duchamp's project of the "figuration of a possible" describes with equal degrees of precision and poetical openness his new experimental way of thinking from 1913 onward. It was no longer completion and perfection that came first and foremost, as had been the case with the classical work of art, but rather—and at all levels of expression—the

idea of becoming, the idea of change, the "passage from one to the other."[62] With his 3 *Standard Stoppages*, Duchamp had taken a path that nobody had trodden before him and along which nobody was ever to accompany him during his lifetime. The introduction of humor along this path afforded him the greatest possible freedom of artistic thought and experimentation.

We encounter the idea of chance in Duchamp's thinking not only in the contexts of art and the philosophy of science but also at an ethical level. Contrary to the mathematical theory of probability, which seeks to establish laws governing an infinite number of chance occurrences, Duchamp identified the "laws of chance"—much discussed around 1910—with the "laws of exception" based on the pataphysics of Alfred Jarry. This led him, in an ethical sense, to a radical isolation of the individual and, in turn, to his last cryptic entry on the questionnaire of the Museum of Modern Art: "Cf. Max Stirner—Le moi et sa propriété" ("Cf. Max Stirner—The Ego and Its Own").[6]

Fig. 8.1 Man Ray, *Marcel Duchamp*, ca. 1920.

Source: Private collection. Photo: Man Ray. © Man Ray Trust Paris/VG Bild-Kunst, Bonn 2009.

8 | RADICAL INDIVIDUALISM

In a world in which only the "law of the exception" has any validity, the individual is the only reality that counts. This combination of tychism and ethics helps us to understand why a work by the German philosopher Max Stirner, *Der Einzige und sein Eigentum* (*The Ego and Its Own*), was so important for Duchamp.[1] Duchamp had read the works of Poincaré at a time when the positivist notion of science as a new religion and a substitute for philosophy was in a deep crisis.[2] Poincaré's writings were doubtless a source of manifold inspiration for Duchamp's art, but with regard to the philosophical claim of science to be able to explain nature and human destiny, Duchamp sided with Poincaré's philosophical critics, first and foremost with Édouard Le Roy. Duchamp wholly shared the skepticist conclusions drawn by Le Roy from Poincaré's theory that scientific principles were based purely on conventions, but he rejected Le Roy's leaning toward fideism, the doctrine that true knowledge depends solely on faith and not on reason. The philosophers to whom Duchamp turned in this crisis of scientific rationalism were Max Stirner,[3] who had already taken nominalism to its extreme half a century before Le Roy, and the Greek skeptics, above all Pyrrhon of Elis.[4]

Stirner's ideas enjoyed an extraordinary presence in artistic and literary circles in Paris during the years leading up to 1914. Two French translations of his *Der Einzige und sein Eigentum* were published concurrently in 1900, one by the publishers of *Revue Blanche*, a magazine that counted Alfred Jarry among its contributors and was the intellectual focal point of poetical anarchy.[5] These translations were followed, four years later, by Albert Lévy's essay *Stirner et Nietzsche* and Victor Basch's *L'Individualisme anarchiste. Max Stirner*, which was the

first comprehensive laudatory treatise on the philosopher as the guiding intellectual force behind aesthetic and aristocratic anarchism.[6] Thereafter, Stirner's ideas were publicized regularly in the political magazine *L'Anarchie* (1905–1914)[7] and in the short-lived (from February to November 1913) arts magazine *L'Action d'art*, the authors of which were in close touch with the cubists of Puteaux.[8] Contrary to the political collectivist anarchism of Kropotkin or Proudhon, the leading lights of the group around *L'Action d'art*, the writers André Colomer and Gérard Lacaze-Duthiers, propagated an intellectual anarchism inspired by Stirner, Nietzsche, and Bergson. Not in mass actions did they seek the impulses for a new and better society but rather in the heroic rebellion of individuals.[9] They countered the "*médiocratie*" of the masses, the tendency toward cultural uniformity and leveling, with the ideal of the "*aristocratie*" of the mind and proudly called themselves "aristocrats."[10]

In a series of articles entitled "De Bergson à Bonnot. Aux Sources de l'Héroisme Individualiste," André Colomer sought to combine Bergson's philosophy of intuition with the radical, individualistic approaches of Stirner and Nietzsche.[11] Equating the artistic act with the intuitive act, Colomer understood art neither in the sense of "l'art pour l'art," nor in the sense of any political or social commitment, but rather as "the development of an individuality that strives for perfection, a personality that seeks the height of harmony, the affirmation of a human being, a soul, that wishes to be nothing but itself."[12] Colomer's column repeatedly expresses the idea that art must first and foremost be a mental attitude and not a métier for the manufacture of commercial products. Although artists acknowledge the world of intuition, Colomer writes, "they see it too narrowly, confine it to a purely theoretical activity, a luxury activity, so to speak," for this activity, he argues, consists solely in the production of art objects.[13] If, on the other hand, an "aristocrat" "writes, sings, paints, sculpts, then he does so not in order to realize any works for which to reap the rewards of his country, or of humanity, or of society, but to realize his own self."[14] Thus, for the perfect individualist—the "aristocrat" in other words—art is not a métier but rather a special mental attitude, a way of life. "His life is his

art," proclaimed Colomer's comrade in arms Gérard Lacaze-Duthiers. "Art is revolt in its highest sense."[15] By 1913, Duchamp's art was evolving more and more from a métier for the manufacture of aesthetic commodities to a method of research, reflection, and experimental visual thought. When Duchamp looked back on those years of radical change, 1913 and 1914, and said, "Ce n'était pas seulement de faire un tableau, c'était faire un geste dans la vie qui était aussi esthétique que le tableau [It was not just to do a painting, it was to make a gesture in life that was just as aesthetic as a painting],"[16] he might well have been echoing the manifesto of the *Action d'art* group, and no less so in his statement made in a television interview in 1966: "Using... art to create a *modus vivendi*, a way of understanding life; that is, for the time being, of trying to make my life into a work of art itself, instead of spending my life creating works of art in the form of paintings or sculptures."[17] As Duchamp's aim was "not just to do a painting" but also "to make a gesture in life," any questions as to whether what he did was art, non-art, or anti-art were secondary; his relationship to the world was, first and foremost, playfully experimental. "Can one make works which are not works of 'art'?" Duchamp queried in a note written in 1913.[18] "I didn't want to be called an artist," he once said, "I wanted to use my possibility to be an individual, and I suppose I have, no?"[19] If he used the term "an-art" to refer to the results of his search beyond art and anti-art, then he undoubtedly did so by analogy with the term "an-archy."[20]

Like the "aristocrats" around the magazine *L'Action d'art*, Duchamp feared and despised the masses. In conversation with Denis de Rougemont in 1945, he said:

> The masses are uneducable. They detest us and would gladly kill us. They are imbeciles who, in conspiring against free and inventive individuals, solidify what they call reality, the 'material' world as we suffer it.... It is the same world that is then observed by science and for which science decrees its supposed laws. But all our efforts of the future will be to invent, as a reaction against what is happening now, silence, slowness and solitude. Today they are hunting us down.[21]

Art, Duchamp was convinced, could be practiced only as a radically individual, esoteric activity, while the general public necessarily watered all art down: "I regret being obliged to be almost anti-democratic in this case."[22] There seem to be so many parallels between the credo of the magazine *L'Action d'art* and Duchamp's newly evolving philosophy and artistic methods that it is difficult to believe in pure coincidence, but no documents have so far come to light evidencing any direct connection between Duchamp and the authors of this magazine.

A possible connecting link may have been Francis Picabia, an enthusiastic reader of Stirner and Nietzsche who openly sympathized with "aristocratic" brands of anarchism.[23] With no other Parisian artist was Duchamp more closely befriended between the years of 1911 and 1914 than with Picabia. It was Picabia who, according to the reminiscences of Gabrielle Buffet-Picabia, had drawn Duchamp's attention to Stirner's *The Ego and Its Own*.[24] But Picabia was not the only possible link. Guillaume Apollinaire likewise had anarchist sympathies.[25] Apollinaire and Picabia were among the signatories of "Pour la liberté de l'art," a petition launched by the magazine *L'Action d'art* in April 1913 in defense of Jacob Epstein's memorial to Oscar Wilde in the Père Lachaise Cemetery.[26] As Duchamp's possible connections with the *Action d'art* group have yet to be the subject of research, we must for the time being rest our case on Gabrielle Buffet's vivid description of the attitude of revolt shared by these artists at that time: Picabia and Duchamp

> emulated one another in their extraordinary adherence to paradoxical, destructive principles, in their blasphemies and inhumanities, which were directed not only against the old myths of art, but against all the foundations of life in general. Guillaume Apollinaire often took part in these forays of demoralization, which were also forays of witticism and clownery. Better than by any rational method, they thus pursued the disintegration of the concept of art, substituting a personal dynamism, individual forces of suggestion and projection, for the codified values of formal Beauty.[27]

No other book was, by reason of its individualistic perspective, to startle both the world of academic philosophy and the early Marxist circles more than *The Ego and Its Own*, published in 1844 by the Hegelian disciple Johann Caspar Schmidt, who wrote under the nom de plume of Max Stirner.[28] Karl Marx felt obliged to write a copious refutation of Stirner's theses (*Die Deutsche Ideologie*) but then finally decided not to publish it. Dismissed as absurd by academic philosophy,[29] Stirner's ideas had been accepted and assimilated only by Nietzsche in the nineteenth century.[30] For Nietzsche, Stirner's radical nominalism must have been "mesmerizing," as Rüdiger Safranski puts it in his recent Nietzsche biography. Safransky continues:

> The consistency with which he pursued nominalist destruction might appear foolish even today, particularly to the philosophical establishment, but it was nothing short of brilliant. Stirner concurred with medieval nominalists who designated general concepts, especially those pertaining to God, as nothing more than breath devoid of reality. He discovered a creative power in the essence of man that creates phantoms, then winds up oppressed by its own creations.[31]

Although Feuerbach had already developed these ideas in his critique of religion, Stirner went one step further by demonstrating that the critics of religion had merely replaced the "other world outside of us," that is, God and God-based morality, by an "other world in us" that no less enchained human liberty than religion.[32] By this he was referring to that philosophically sustained "reign of abstractions" so pointedly criticized in Nietzsche's famous dictum:

> What, then, is truth? A mobile army of metaphors, metonyms, and anthropomorphisms—in short, a sum of human relations which have been enhanced, transposed, and embellished poetically and rhetorically, and which after long use seem firm, canonical, and obligatory to a people: truths are illusions about which one has forgotten that this is what they are; metaphors which are worn out and without sensuous power.[33]

It was in Stirner's and Nietzsche's sense, too, that Duchamp argued when questioned about his fundamental philosophical convictions: "Idealism and reality behind appearances as concepts are products of the mind. We must realize the way the mind works and beware of abstract words. I do not believe that words such as reality and truth have any meaning";[34] "words such as truth, art, veracity, or anything are stupid in themselves."[35]

In his introduction, under the title "I Have Set My Affair on Nothing," Stirner already confronts the reader with the central argument of his treatise, which he then differentiates in the subsequent chapters under the headings of philosophy, ethics, politics, and society:

> What is not supposed to be my concern! First and foremost the good cause, then God's cause. The cause of mankind, of truth, of freedom, of humanity, of justice; further, the cause of my people, my prince, my fatherland; finally, even the cause of Mind and a thousand other causes. Only *my* cause is never to be my concern. *Shame on the egoist who thinks only of himself!*[36]

In his thinking, Stirner replaces the abstract, bodiless ego of idealist philosophy with the real, concrete, physical, mortal ego, the individual, on which he then focuses his reflections. "The divine is God's concern; the human, man's. My concern is neither the divine nor the human, not the true, good, just, free, etc., but solely what is *mine* [*das Meinige*], and it is not a general one, but is—*unique* [*einzig*], as *I am unique*. Nothing is more to me than myself!"[37] "I want to be free, and I want to be free for myself, almost," was Duchamp's way of putting it.[38] Duchamp's own lifelong conviction was in fact so entirely in tune with Stirner's radical individualism that in 1960 he bought the new edition of *The Ego and Its Own* in order to refamiliarize himself with the German philosopher's ideas.[39] In a world in which, according to Duchamp "there is no solution because there is no problem. Problem is the invention of man—it is nonsensical," there can be nothing worth fighting for.[40] Thus Duchamp wholly concurs with the conclusion drawn by Stirner at the end of his treatise:

> To the Christian the world's history is the higher thing, because it is the history of Christ or 'man'; to the egoist only *his* history has value, because he wants to develop only *himself* not the mankind-idea, not God's plan, not the purposes of Providence, not liberty, and the like. He does not look upon himself as a tool of the idea or a vessel of God, he recognizes no calling, he does not fancy that he exists for the further development of mankind and that he must contribute his mite to it, but he lives himself out, careless of how well or ill humanity may fare thereby.... Every higher essence above me, be it God, be it man, weakens the feeling of my uniqueness, and pales only before the sun of this consciousness. If I concern myself for myself, the unique one, then my concern rests on its transitory, mortal creator, who consumes himself, and I may say: I have set my affair on nothing.[41]

Once asked by an interviewer whether there was anything at all in which he believed, Duchamp gave a reply that seemed to echo Stirner's thoughts: "Only the individual matters to me.... I still believe in the individual, and every man for himself, like in a shipwreck."[42]

Thus the 3 *Standard Stoppages* are more than just a parody of the sciences. They are a symbol of Duchamp's radical individualism, in which only the individual counts, in which only his passions, obsessions, and works are of any importance, while society and its norms are meaningless quantities. "This experiment was made . . . to imprison and preserve forms obtained through chance," he explained in his 1964 lecture *À Propos of Myself*, and then, in order to stress his point, he added: "through *my* chance."[43] This connection between chance and radical individualism was again underscored in a conversation with the art critic Calvin Tomkins: "Your chance is not the same as my chance, just as your throw of the dice will rarely be the same as mine."[44]

Only once did Duchamp express himself publicly on the role of the artist in modern society, and this he did with an explicit reference to Stirner's theories.[45] In a short lecture given at the symposium Should the Artist Go to College? which took place at the Hofstra College in

Hempstead, New York, in 1960, Duchamp condensed his antiscientific and solipsistic convictions into the following statement: "Today, the artist is a curious reservoir of para-religious values, absolutely in opposition to the daily functionalism for which science receives the homage of a blind worship. I say blind because I do not believe in the supreme importance of these scientific solutions which do not even touch the personal problems of a human being."[46] He advises the artist to go to college in order "to keep informed and be aware of the so-called material daily progress." For only on the basis of a relatively sound scientific education will he "possess the very tools which permit him to oppose this materialistic state of affairs through a cult of the ego in an aesthetic frame of spiritual values."[47]

This is one of the rare moments when Duchamp speaks of opposition and engagement, though he immediately limits it to a purely individual undertaking, entirely in Stirner's sense and with direct reference to Stirner's book:

> Internal or spiritual values, mentioned above, and of which the artist is so to speak the dispenser, concern only the individual singled out in opposition to the general values which apply to the individual as part of a society. And under the appearance, I am tempted to say, under the disguise of a member of the human race, the individual, in fact, is quite alone and unique. And the characteristics common to all individuals *en masse* have no relationship whatsoever with the solitary explosion of an individual facing himself alone. Max Stirner, in the last century, very clearly established this distinction in his remarkable book, The Ego and His Own, and if a great part of the education applies to the development of these general characteristics, a part, just as important, of college education, develops the deeper faculties of the individual, the self-analysis and the knowledge of our spiritual heritage.... I believe that today, more than ever before, the artist has this para-religious mission, to keep lit the flame of an inner vision of which the work of art seems to be the closest translation for the laymen.[48]

It was in Duchamp's experimental works, beginning with 3 *Standard Stoppages* in 1913–14, that Stirner's and Nietzsche's radical individualism first served as the guiding principle for works of art. As there are no objective natural laws in this world, no such thing as "truth" or "reality," any unit of length determined by chance is no truer and no falser than a scientific standard measure. This conviction could not have conflicted more crassly with Poincaré's view, which harked back to Pythagoras and Plato, that it is precisely in the laws of mathematics that "the internal harmony of the world," which at the same time is "the source of all beauty," manifests itself.[49] And "it is this harmony ... which is the sole objective reality, the only truth we can attain," Poincaré writes, countering Le Roy's theory of the inability of science to find objective truth.[50] And since mathematical analysis is able to express this inner harmony of the world, it cannot be "a vain play of the mind."[51] "If [the world] were ruled by caprice, what could prove to us," he asks rhetorically, "[that] it was not ruled by chance?"[52] In Duchamp's thinking, however, the world *is* ruled by chance, and therefore such notions as law, harmony, and beauty are obsolete, both with regard to nature and with regard to art. The latter becomes a "play of the mind" that obeys the rules not of a rational logic but of an imaginative one.

The mathematically based, Pythagorean concept of beauty, with which Poincaré had armed himself in 1905 against the doubters of the value of science, was for Werner Heisenberg still one of the important criteria for the truth of scientific cognition a good sixty years later.[53] Poincaré had in fact even gone so far as to maintain that anyone deprived of the "feeling of mathematical beauty, of the harmony of numbers and forms, of geometric elegance" will never be truly inventive.[54] According to the criterion of aesthetic truth, the infinite diversity of disparate things in nature can be understood only because these things are attributable to uniform, mathematically representable relationships, and these relationships seem particularly true and convincing to the scientist if they meet the formal criteria of simplicity and clarity, and especially if they are ordered symmetrically. "Simplex sigillum veri" is the Latin motto behind this approach.[55] Philosophically speaking, the criterion of aesthetic truth in the sciences owes

its existence to a tautological process: natural phenomena are first mathematized and then "abstract beauty" is discovered in the resulting mathematical forms as though it were the very essence of the things themselves. In banishing the category of beauty from aesthetics, Duchamp undermined the aesthetic criterion of truth so popular among philosophizing scientists. In Duchamp's aesthetic, such formal criteria as simplicity, clarity, and symmetry yielded to his interest in singularities, in the incomparable, the incommensurable. While modern mathematicians and physicists have, as far as I can see, derived no benefit from this aesthetic, the same cannot be said of the French philosophers of the 1970s. Starting out from Duchamp's works and ideas, François Lyotard developed principles of a philosophy (and politics) of the incommensurable.[56] It was roughly around the same time that Gilles Deleuze, an intimate connoisseur of the ideas behind the *Large Glass*,[57] developed an aleatory philosophy that understood chance not as an element that was alien to the "sense" of the world but as an impulse on which all existence in nature and civilization was based.[58] However, the most astonishing correspondences between modern philosophy and Duchamp's aesthetic are to be found in the writings of Richard Rorty, who, to my knowledge, has never concerned himself to any great extent with Duchamp's works and ideas. Reference to their common philosophical ancestor, Friedrich Nietzsche, may perhaps suffice to explain these enormous similarities. We should try, Rorty suggests in *Contingency, Irony, and Solidarity*, "to get at the point where we no longer worship *anything*, where we treat *nothing* as a quasi divinity, where we treat *everything*—our language, our conscience, our community—as a product of time and chance. To reach this point would be, in Freud's words, to 'treat chance as worthy of determining our fate.'"[59] In 1963, Duchamp put it thus: "I don't think the public is prepared to accept it ... my canned chance. This depending on coincidence is too difficult for them. They think everything as to be done on purpose by complete deliberation and so forth. ... In fact, the whole world is based on chance, or at least chance is a definition of what happens in the world we live in and know more than any causality."[60]

Inherent in Duchamp's ironic deformation of the standard metric unit of length was a rejection both of the classical concept of beauty based on ideal proportions and of the contemporary metaphysical concept of "absolute painting" that claimed to have attained the unchangeable, eternal truth in art. Duchamp's leaning toward a radically relativist and skepticist interpretation of the conventionalist theories of Henri Poincaré directly influenced the development of his aesthetic convictions in 1913 and 1914. Opposed to the concept of self-referential "pure painting" (*"peinture pure"*), Duchamp was interested in "[putting] painting once again in the service of the mind"[61] by "introducing the precise and exact aspect of science" into art.[62] But Duchamp had turned to the sciences at a time when they were in a deep philosophical crisis. All certainties, considered absolute for centuries past, were no longer valid, and if one was to believe Poincaré, methodic reflection made it impossible to formulate such certainties ever again. Duchamp's pictorial experiment, the 3 *Standard Stoppages*, outwardly expressed his realization that, since it was no longer possible, even in the apparently so exact sciences, to speak of objective, natural laws, then all absolute, eternally unchangeable criteria of evaluation and judgment were just as obsolete in art as well. Thus experimentation was henceforth to be the only decisive principle of the artist's work. No longer was art meant to serve a religious, philosophical, scientific, or artistic "truth" but was now to be understood as an open experiment aimed at exploring the world of the imaginable, the depictable and the undepictable.

The 3 *Standard Stoppages* marked the beginning of Duchamp's development, from 1913 onward, of a playful, experimental aesthetic that was already sounding the death knell for the dogmatic aesthetic in twentieth century art at a time when manifesto art and artistic utopianism were still striving toward their zeniths. Today, ever since this new aesthetic became the norm during the 1960s, neither excellent craftsmanship nor formal mastery, neither the choicest materials nor the universality of the subject or theme can guarantee the quality of an artist's actions or works. This does not mean, however, that the demise of the dogmatic concept of art may be equated with

the "end of art," which many an author foresaw with the inception of Duchamp's aesthetic.[63] On the contrary, the Readymades and the *3 Standard Stoppages* in the form in which they finally emerged in 1936 opened a new chapter in the history of art. Manifest in these works was a new approach to the making of art that ultimately led to that experimentalization of art that has now been a characteristic of contemporary art for the past half a century.

"Painting is a science, and should be pursued as an inquiry into the laws of nature," the English painter John Constable declared in a lecture given at the Royal Institution in 1836. "Why, then, may not landscape be considered as a branch of natural philosophy of which pictures are but the experiments?"[64] Filled with the rationalism of the Age of Enlightenment, the idea of subjecting the visual arts to the rules of scientific discourse was, three generations later, to find an ironic critic in Marcel Duchamp, for the latter's art from 1913 onward could indeed come under the question: "Why, then, may not art be considered as a branch of the philosophy of science of which artworks are but the experiments?" Unlike Constable, however, Duchamp did not acknowledge science as the prime source of human knowledge but developed an art form that undermined science's claim to reveal the laws of nature and life, countering it with imaginative processes of poetic and pictorial thought. "Art," Duchamp concluded toward the end of his life, "is the only thing left for people who don't give science the last word."[65] Humor, irony, and play were the outward manifestations of his new philosophical art, which had begun with the *3 Standard Stoppages* in 1913: humorous, ironic play with chance and dimensions, with visibility and invisibility, with words and images, high and low, art and non-art. Whether such play is idle and futile will, in the final analysis, be decided only by the individual, for art is a form of intellectual manifestation in which the individual speaks but to the individual.

NOTES

INTRODUCTION

1. Janecke, *Kunst und Zufall*, 110–14; Gendolla and Kamphusmann: *Die Künste des Zufalls*, 8.
2. Cf. Holeczek and von Mengden, *Zufall als Prinzip*; Morellet, *François Morellet*, exh. cat.
3. Janecke, *Kunst und Zufall*, 112–13; Shearer and Gould, "Hidden in Plain Sight"; Giunti, "R.rO.S.E.Sel.A.Vy."; Gilles: "Duchamp au bouchon," 128.
4. Kuh, "Marcel Duchamp," 81.
5. Duchamp, "Chronology," unpaged.
6. Artist's files, Department of Painting and Sculpture, the Museum of Modern Art, New York; first published by Naumann, *The Mary and William Sisler Collection*, 170–71.
7. Daniels, *Duchamp und die anderen*, 236, 265.
8. Ibid., 236.
9. Clair, *Duchamp et la fin de l'art*, 108.
10. See Umland et al., *Dada in the Collection of the Museum of Modern Art*, 110–15.
11. Adcock, "Conventionalism in Henri Poincaré and Marcel Duchamp," 249–58; Adcock, *Marcel Duchamp's Notes from the Large Glass*; Holton, "Henri Poincaré, Marcel Duchamp, and Innovation in Science and Art," 127–34.
12. Henderson, *Duchamp in Context*, 72–77.

1. THE IDEA OF THE FABRICATION

1. Schwarz, *Complete Works*, 598, cat. no. 285. Besides the box containing the original manuscripts, which Duchamp either sold or gave to the collector Walter Arensberg in 1915, there were another four boxes in

existence, the whereabouts of three of them still known today. One of them remained in his own possession and was donated by his widow Alexina Duchamp to the collection of the Philadelphia Museum of Art (ibid., cat. no. 284, no. 1) in 1991. Duchamp gave the other boxes to his brother Jacques Villon (ibid., cat. no. 285, no. 4, whereabouts no longer known) and to his two friends Raymond Dumouchel (ibid., cat. no. 285, Nr. 3, coll. Dina Vierny, Fondation Maillol, Paris) and Walter Pach (ibid., cat. no. 285, Nr. 2, the Art Institute of Chicago).

2. Translation quoted from Sanouillet and Peterson, *The Writings of Marcel Duchamp*, 22. The original French text reads: "L'Idée de la Fabrication / —Si un fil droit horizontal d'un mètre de / longueur tombe d'un mètre de hauteur sur un / plan horizontal en se déformant *à son gré* et / donne une figure nouvelle de l'unité de / longueur / —3 exemplaires obtenus dans des conditions / à peu près semblables: dans leur considération chacun à chacun sont une reconstitution approchée de l'unité de longueur. / Les 3 Stoppages étalon sont / le mètre diminué." Quoted from the *Box of 1914* at the Philadelphia Museum of Art, The Louise and Walter Arensberg Collection.

3. Marcel Duchamp, *La Mariée mise à nu par ses Célibataires, même* (Paris: Édition Rrose Sélavy, 1934), 320 copies, published by Duchamp himself (Édition Rrose Sélavy). Cf. Duchamp, *The Bride Stripped Bare by Her Bachelors, Even*, a typographic version by Richard Hamilton of Marcel Duchamp's Green Box, trans. George Heard Hamilton, unpaged; and Schwarz, *Complete Works*, 723–24.

4. Duchamp uses the French word "*hasard*" [Trans.].

5. Cabanne, *Dialogues with Marcel Duchamp*, 46–47.

6. See Umland et al., *Dada in the Collection of the Museum of Modern Art*, 115n. 3. Rhonda R. Shearer and Stephen J. Gould first drew attention to the fact that the threads are longer than one meter, thus giving fresh impetus to academic research into this work. See Shearer and Gould, "Hidden in Plain Sight."

2. THE *3 STANDARD STOPPAGES* IN THE CONTEXT OF THE *LARGE GLASS*

1. From an interview with James Johnson Sweeney in 1946. Quoted from Sanouillet and Peterson, *The Writings of Marcel Duchamp*, 125.

2. Duchamp in Drot, *Jeu d'échecs avec Marcel Duchamp*. This was a TV film recorded in late 1963 and now available with English subtitles. The original, less abbreviated French version went as follows: "Art ou anti-art, ça été ma question à mon retour de Munich, en 1912, quand j'ai dû prendre des décisions de vraiment ce qu'on peut appeler abandonner la peinture pure ou la peinture pour elle-même, et introduire des éléments très divers et très étrangers à la peinture mais qui pour moi étaient la seule façon de sortir d'une ornière . . . de peinture, de couleurs." On the theory of "peinture pure," see Apollinaire, *Méditations esthétiques*; and Apollinaire, *Chroniques d'art 1902–1918*, 34.
3. From an interview with James Johnson Sweeney in 1946. Quoted from Sanouillet and Peterson, *The Writings of Marcel Duchamp*, 125.
4. Ibid.
5. Jouffroy, "Conversation avec Marcel Duchamp," 31. On Duchamp's stay in Munich, see Molderings, "Relativism and a Historical Sense," 15–23; and Molderings, "The Munich Sources, 227–36."
6. On Böcklin, see Duchamp, "Ephemerides," 19 June 1912. On the importance of Redon for Duchamp see Pach, *Queer Thing, Painting*, 163.
7. According to a communication from the Ministère de l'Instruction publique et des Beaux-Arts of 18 November 1913 to the chief administrator of the Bibliothèque Sainte-Geneviève, Duchamp commenced work on 1 November 1913 as a replacement for the temporarily disabled conservator Ch. Mortet (Archive of the Bibliothèque Sainte-Geneviève).
8. See Molderings, "The Munich Sources, 227-36."
9. Duchamp, *Notes*, no. 68r, 41; and Sanouillet and Peterson, *The Writings of Marcel Duchamp*, 30.
10. Sanouillet and Peterson, *The Writings of Marcel Duchamp*, 71.
11. See Cabanne, *Dialogues with Marcel Duchamp*, 25–26; and Henderson, *The Fourth Dimension*, 122–30.
12. See Cabanne, *Dialogues with Marcel Duchamp*, 34. On Princet, cf. Décimo, *Maurice Princet*.
13. See Henderson, "A New Facet of Cubism"; and Henderson, *The Fourth Dimension*, 44–103; Antliff and Leighten, *Cubism and Culture*, 64–79.
14. See Molderings, "Ästhetik des Möglichen," 111–19.
15. Quoted from Henderson, *The Fourth Dimension*, 130.

16. Jacques Nayral, "Cubistas" (1912), quoted from Apollinaire, *Méditations esthétiques*, 223.
17. Ribemont-Dessaignes, *Déjà jadis*, 38. Nicolai Lobachevsky (1792–1856) was a mathematician. His 1826 lecture "A Concise Outline of the Foundations of Geometry" is considered to have marked the discovery of non-Euclidean geometry. The confusion of non-Euclidean and four-dimensional geometry with reference to Lobachevsky clearly shows that Ribemont-Dessaignes himself was not familiar with the geometries he mentions in his memoirs.
18. Ribemont-Dessaignes, *Déjà jadis*, 37–38. Ribemont-Dessaignes's memoirs contradict Calvin Tomkins's assertion that "Duchamp took a very minor part in the discussions and arguments at these meetings" (Tomkins, *Duchamp*, 57).
19. Cabanne, *Dialogues with Marcel Duchamp*, 39, italics added.
20. On the significance of Jouffret's treatise for Duchamp, see Sanouillet and Peterson, *The Writings of Marcel Duchamp*, 89; and the seminal study by Adcock, *Marcel Duchamp's Notes from the Large Glass*.
21. On Poincaré's significance for contemporary scientific thought, see Greffe, Heinzmann, and Lorenz, *Henri Poincaré*; and Nabonnand, "Bibliographie des travaux." On the significance of Poincaré's writings for Duchamp, see Adcock, *Marcel Duchamp's Notes from the Large Glass*, 34–39; Adcock, "Conventionalism in Henri Poincaré and Marcel Duchamp," 249–58; Henderson, *The Fourth Dimension*, 177; Molderings, "Ästhetik des Möglichen," 111; Molderings, "Henri Poincaré/Mathematiker—Marcel Duchamp/Künstler," 14–17; Molderings, *Marcel Duchamp*, 37; Molderings, "Objects of Modern Skepticism," 243–65; Molderings, "Vom Tafelbild zur Objektkunst," 211–19; Shearer, "Marcel Duchamp's Impossible Bed."
22. See Henderson, *The Fourth Dimension*, chap. 3: "Marcel Duchamp and the New Geometries," 117–57. See also John Dee, "Ce Façonnement symétrique."
23. Duchamp, *A l'Infinitif* (150 exemplars), also known as the *White Box*. Reprinted in Sanouillet and Peterson, *The Writings of Marcel Duchamp*, 74–101.
24. Poincaré, *The Foundations of Science*, 243. On the definition of the dimension as a cut, see also Poincaré, *Dernières pensées*, 65–66.
25. Sanouillet and Peterson, *The Writings of Marcel Duchamp*, 94 and 98.

26. Poincaré, *The Foundations of Science*, 380
27. Ibid., 381, italics added.
28. Sanouillet and Peterson, *The Writings of Marcel Duchamp*, 90.
29. Duchamp's sources of inspiration also included Gaston de Pawlowski's science fiction novel *Voyage au pays de la quatrième dimension* (Paris 1912). See Adcock, *Marcel Duchamp's Notes From the Large Glass*, 29–35; Cabanne, *Dialogues with Marcel Duchamp*, 52; Décimo, *La Bibliothèque de Marcel Duchamp, peut-être*, 37–82; Henderson, *The Fourth Dimension*, 118–20; Molderings, "The Bicycle Wheel and the Bottle Rack," 158.
30. Poincaré, *The Foundations of Science*, 57. Duchamp mentions these "flat beings" in his conversations with Cabanne (*Dialogues with Marcel Duchamp*, 39), in connection with Gaston de Pawlowski's *Voyage au pays de la quatrième dimension*, although they hardly have an important part to play in de Pawlowski's novel (cf. Henderson, *The Fourth Dimension*, 119–20). Most probably he was familiar with them through his reading of Poincaré's and Jouffret's books. The "flat being" analogy had also been used by Jouffret in his *Traité élémentaire* (186–88). Cf. Adcock, *Marcel Duchamp's Notes From the Large Glass*, 66–67. Whether Duchamp's knowledge of the "flat being" analogy "almost certainly" came from Jouffret (Adcock, ibid., 67) and not from Poincaré, or even from both, cannot be substantiated by any surviving documents.
31. Sanouillet and Peterson, *The Writings of Marcel Duchamp*, 94.
32. Ibid., 39 and 80.
33. Ibid., 99 and 88.
34. On Duchamp's preoccupation with classical perspective, see Jean Clair's seminal study, "*Thaumaturgus opticus*," in Clair, *Marcel Duchamp et la fin de l'art*, 63–133.
35. Sanouillet and Peterson, *The Writings of Marcel Duchamp*, 86.
36. Kemp, *The Science of Art*, 119.
37. The section on perspective in the Catalogue of the Bibliothèque Sainte-Geneviève lists twenty-four treatises, including the most significant writings north of the Alps, by, among others, Jean Pélerin (also called Viator), Johann Faulhaber, Salomon de Caus, Jean du Breuil, Abraham Bosse, Sébastien Le Clerc, Nicéron, John Peckham, Jean Cousin, and Eugène Chevreul. Albrecht Dürer's *Underweysung der Messung* was catalogued under the artist's name.

38. He very probably consulted the library's second, extended edition of 1663.
39. Panofsky, *Perspective as Symbolic Form*, 27. On Alberti's definition of the painting as window, see Alberti, *Opere volgari*, 3:36–37.
40. *The Literary Works of Leonardo da Vinci*, 2 vols., comp. and ed. J. P. Richter, (1883; 1939). The quotation was taken from Osborne, *The Oxford Companion to Art*, 841. The original Italian text reads: "Pariete di vetro. Prospettiva none altro che vedere uno sito djrieto a uno vetro piano epen transsparente sula superfitie del quale sia segniato tutte le chose che sono daesso vetro indirieto le quali si posano chondure perpiramide alpunto dellochio e essi piramide si tagliano sudetto vetro" (da Vinci, *I manoscritti*, fol. 1v).
41. See Clair, *Marcel Duchamp et la fin de l'art*, 66, especially the reference to Abraham Bosse's treatise *Manière Universelle de M. Desargues, pour pratiquer la perspective* (Paris 1648).
42. Quoted from Cabanne, *Dialogues with Marcel Duchamp*, 39–40: "In any case, at the time I had tried to read things by Povolowski, who explained measurements, straight lines, curves, etc. That was working in my head while I worked, although I almost never put any calculations into the 'Large Glass'. Simply, I thought of the idea of a projection, of an invisible fourth dimension, something you couldn't see with your eyes." Duchamp's statement contains two errors. He refers to "Povolowski" but actually means Gaston de Pawlowski, the author of *Voyage au pays de la quatrième dimension*. However, this novel makes no mention of "measurements, straight lines, curves." Duchamp has evidently confused his reading of this novel with that of Poincaré's *Science and Hypothesis*, in which Poincaré explains in part 2, "Space," not only four-dimensional and non-Euclidean geometry but also those questions that arise from the formal equivalence of Euclidean and non-Euclidean geometries, questions concerning, for example, the nature of the axioms and standard measurements, the definition of straight lines, the substitution of curves for straight lines in Riemann's geometry, etc. See Poincaré, *The Foundations of Science*, 55–91.
43. In his dialogues with Cabanne, Duchamp dates the development of a "personal system of measurement and spatial calculation" to "the end of 1912." See *Dialogues with Marcel Duchamp*, 36.
44. Schwarz, *Complete Works*, cat. nos. 257–61, 287, and 288.

45. Ibid., cat. nos. 288 and 299. Both studies are dated 1914 on the back.
46. Ibid., cat. nos. 264 and 291.
47. Concerning the dating of this work, cf. Duchamp, *Marcel Duchamp: The Portable Museum*, 81. Arturo Schwarz dates it to February–March 1913; see Schwarz, *Complete Works*, cat. no. 264.
48. Sanouillet and Peterson, *The Writings of Marcel Duchamp*, 30.
49. Ibid.
50. Quoted by Tomkins, *Ahead of the Game*, 32.
51. Calvin Tomkins is one of the exceptions. Cf. ibid., 31–32.
52. Cabanne, *Dialogues with Marcel Duchamp*, 37.
53. Duchamp, *Duchamp, Notes*, no. 80.
54. The same inscription is to be found on the back of the *Glider* of 1913-14-15, the first component of the *Bachelor Machine* to be depicted on glass. Cf. Schwarz, *Complete Works*, cat. no. 327.
55. Sanouillet and Peterson, *The Writings of Marcel Duchamp*, 33.
56. Cf. Schwarz, *Complete Works*, cat. nos. 264–269, 271, 277. See also Duchamp, *Duchamp, Notes*, no. 1183.
57. On the status of Dürer's invention in the history of perspective see: Kemp, *The Science of Art*, 172.—The connection between measurement and perspective, as actualized by the *3 Standard Stoppages*, goes back as far as the historical beginnings of perspective. The Nuremberg painters in Dürer's day used the term "Messung" as the German equivalent of the Latin term "perspectiva". See Pfeiffer, "Projections Embodied in Technical Drawings: Dürer and His Followers," in Lefêvre, *Picturing Machines*, 275.
58. Albrecht Dürer, *The Painter's Manual*, 393, italics added. The original German text reads: "Durch drei Fäden magst du ein jedes Ding, das du damit erreichen kannst, in ein Gemälde bringen, auf eine Tafel zu verzeichnen. Dem thue also. Bist du in einem Saal, so schlage eine grofse Nadel mit einem weiten Öhr, die dazu gemacht ist, in eine Wand , vor ein Auge. Ziehe dadurch einen starken Faden und hänge unten ein Bleigewicht daran. Danach setze einen Tisch oder eine Tafel so weit von dem Nadelöhr, darinn der Faden ist, als du willst. Darauf stelle einen aufrechten Rahmen fest, zwerchs gegen das Nadelöhr, hoch oder nieder, auf welche Seite du willst. Der Rahmen habe ein Thürlein, das man auf und zu thun kann. Dieses Thürlein sei deine Tafel, darauf du malen willst. Danach nagele zwei Fäden, die ebenso lang sind als der

aufrechte Rahmen lang und breit ist, oben und mitten in den Rahmen und den anderen auf einer Seite auch mitten in den Rahmen, und lasse sie hängen. Danach mache einen eisernen langen Stift, der zuvorderst an der Spitze ein Nadelöhr habe. Darein fädele den langen Faden, der durch das Nadelöhr an der Wand gezogen ist, und fahre mit der Nadel und dem langen Faden durch den Rahmen hinaus, und gib sie einem Anderen in die Hand. Du aber warte der beiden anderen Fäden, die am Rahmen hängen. Nun gebrauche dies also. Lege eine Laute oder was dir sonst gefällt, so fern von dem Rahmen als du willst, nur dass sie unverrückt bleibe, so lange du ihrer bedarfst. Lasse deine Gesellen die Nadel mit dem Faden hinausstrecken auf die nötigsten Punkte der Laute. Und so oft er auf einem still hält und den langen Faden streckt, so schlage allweg die zwei Fäden am Rahmen kreuzweis gestreckt an den langen Faden, klebe sie an beiden Seiten mit Wachs an den Rahmen und heiße deinen Gesellen seinen langen Faden nachlassen. Danach schlage das Thürlein zu und zeichne denselben Punkt, wo die Fäden kreuzweise übereinander gehen auf die Tafel. Danach thue das Thürlein wieder auf und thue mit einem anderen Punkte abermals so, bis dass du die ganze Laute gar an die Tafel punctierst. Dann ziehe alle Punkte, die von der Laute auf der Tafel geworden sind, mit Linien zusammen, so siehst du, was daraus wird. Also magst du andere Dinge auch abzeichnen."

59. According to Filippo Camerota, this idea can be traced back to a treatise on geometry by Francesco di Giorgio Martini. See Camerota, "Renaissance Descriptive Geometry," 181.
60. See Cigoli, *Prospettiva pratica*; and also Kemp, *The Science of Art*, 177–80.
61. "See Catalogue of Bibliothèque Ste Geneviève, the whole section on Perspective: Nicéron (Father Fr., S. J.) Thaumaturgus opticus," in Sanouillet and Peterson, *The Writings of Marcel Duchamp*, 86. French editions of *Thaumaturgus opticus* were published in 1638 and 1652 under the title *La Perspective curieuse ou magie artificielle des effets merveilleux*. In the edition of 1652, Cigoli's apparatus is shown on plates 36–38.
62. On Bosse's life and work, see Valabrègue, *A. Bosse*, 82.
63. Kemp, *The Science of Art*, 120. Concerning Desargues, Bosse, and Du Breuil, see chapter entitled "The French Perspective Wars," 119–31.
64. Bosse, *Manière universelle*, 59–60. The original French text reads: "Les ... planches, que vous allez voir, montrent comme on peut se servir au

besoin d'un moyen sensible pour l'aider l'imagination à se representer ce qu'on nomme rayons visuels et rayonnement de la vue. . . . Or ces rayons sont tellement déliés qu'on ne les sauroit appercevoir sinon de l'imagination. Que si pour n'en avoir point eu besoin, vous n'étiez pas encore accoutumé de les imaginer & que vous avez ennui de vous rendre cela familier par quelque moyen les 3 ou 4 planches qui suivent, en representent un qui me semble assez facile. Ayez une forme de *Carreau* plat bcdf de quelque matière ferme et pesante, attachez y aux quatre coins quatre filets [= filés] souples et déliés, plutôt longs que court bo, co, do, fo, puis les mettez en lieu qu'il ne puisse bouger d'une place, à terre, contre un mur, ou tenant au plancher ; puis prenez ces quatre filets ensemble entre vos doigts comme vous voyez et les faisant tenir chacun tendu toujours en ligne droite, portez votre main çà et là de tous côtés, haut et bas, à l'entour de ce Carreau, comme les figures montrent ; et à mesure que vous proterez ainsi la main d'un et d'autre côté, regardez l'ordre ou l'arrangement que ces filets gardent ensemble, et considerez le jeu qu'ils font entr'eux. Et les diverses formes qu'ils prennent en s'approchant ou s'écartant l'un de l'autre. En suite . . . portez à l'un des vops yeux les doigts dont vous tenez comme ci-devant les filets attachés aux coins d'un carreau tendus en ligne droite une fois si vous le voulez étant debout, une autre fois étant assis, puis s'il vous plait, une autre fois étant monté sur quelque chose, qui est à dire em toute situation que vous sauriez penser. Et tenant ainsi l'assemblage de ces filets à votre œil, regardez ce carreau bddf, d'un même temps et vous en verrez les coins des ces filets, comme si chacun de ces coins venait le long d'un de ces filets à votre œil ou comme si votre œil voyait ces coins par le long de ces filets, allants de lui jusque à eux et de même de chaque autre point du carreau si vous voulez ajuster un semblable filet ; et par ce moyen ces filets representeront les rayons qu'on nomme visuels, et vous en pourront faire incontinent venir l'imagination ; et l'espace qu'ils enferment entr'eux, vous represente la forme de la masse entière de tous les rayons visuels ensemble, par lesquels votre œil voit lors ce carreau, qui est ce que M. D. [Monsieur Desargues] nomme rayonnement de la vue."

65. Duchamp, *Duchamp, Notes*, no. 127/IV. See also, no. 80: "tous les traits qui devraient être donnés pas les fils blancs de la toile [all the lines that should have been made by the white threads on the canvas]."

66. The full title of du Breuil's treatise reads: *La Perspective nécessaire à tous les peintres, graveurs, sculpteurs, architectes, orfèvres, brodeurs, tapissiers, et autres qui se meslent à dessiner par un religieux de la Compagnie de Iésus* (Paris, 1663,).
67. See Alberti, *Opere volgari*, 3:54–55. See also Kemp, *The Science of Art*, 169.
68. Du Breuil, *La Persepctive*, vol. 2 (Paris2 1663), pratique XCIV: "Une autre belle invention pour pratiquer la perspective sans la scauvoir".
69. Cf. Kemp, *The Science of Art*, 171, ill. 329.
70. Clair, *Duchamp et la fin de l'art*, 107; Molderings, "Un Cul-de-lampe," 96; Stauffer, *Marcel Duchamp. Die Schriften*, 31.
71. See Jean Pèlerin Viator, *De artificiali perspectiva* (Toulon, 1509). This book, the first treatise on perspective to be written north of the Alps and the first treatise on perspective to be printed, is likewise kept at the Bibliothèque Sainte-Geneviève.
72. This critically analytical approach contradicts Jean Clair's theory that Duchamp's "rehabilitation of perspective" between 1913 and 1923 was based on a "project of restoration" (*Duchamp et la fin de l'art*, 108).
73. Schwarz, *Complete Works*, nos. 678, 376, 696 and 397. Clair, *Duchamp et la fin de l'art*, 66–70.
74. Molderings, "Un Cul-de-lampe," 96–99.
75. Cabanne, *Dialogues with Marcel Duchamp*, 65.
76. Quoted, in translation, from *The Box of 1914*: "La perspective linéaire est un bon moyen pour représenter diversement des égalités; c.a.d. que l'équivalent, le semblable (homothétique) et l'égal se confondent, en symétrie perspective".
77. Sanouillet and Peterson, *The Writings of Marcel Duchamp*, 36. The original note reads: "Par la perspective (ou tout autre moyen conventionnel, canons . . .) les lignes, le dessin sont '*forcés*', et perdent l'a peu près du 'toujours possible' avec en plus l'ironie d'avoir *choisi* le corps ou l'objet primitif qui *devient inévitablement* selon cette perspective (ou autre convention" (Sanouillet, *Duchamp du signe*, 55).
78. Kuh, "Marcel Duchamp," 92.

3. THE *3 STANDARD STOPPAGES* AS PAINTINGS

1. Shearer and Gould, "Hidden in Plain Sight." Christian Janecke had already put forward a similar argument. According to his own experi-

ments, Janecke maintains that the dropped threads would have had to produce "more strongly defined and more irregular curves" and concludes that "the 'result' obtained by Duchamp was manipulated to a high degree. Duchamp straightened the curves formed by the threads" (Janecke, *Kunst und Zufall*, 112). Gilles, "Duchamp au bouchon," 128, argues similarly.
2. Shearer and Gould, "Hidden in Plain Sight."
3. My own experiments with 50 g bookbinder's thread produced curves very similar to those of the *3 Standard Stoppages*. James McManus carried out similar experiments with threads stiffened with candle wax. I wish to thank James McManus for the information he has given me concerning his experiments and the results he obtained.
4. Sanouillet and Peterson, *The Writings of Marcel Duchamp*, 36. "Le vent—pour les pistons de ct. d'air / l'adresse—pour les trous / Le poids—pour les stoppages étalon / A développer" (Sanouillet, *Duchamp du signe*, 55).
5. The process is sketched and described in detail in one of the notes in the *Green Box*. Cf. Sanouillet and Peterson, *The Writings of Marcel Duchamp*, 35. On the scientific/historical background to this experiment, cf. Henderson, *Duchamp in Context*; and Henderson, "Uncertainty, Chaos, and Chance in Early Twentieth-Century Art," 141–43
6. Sanouillet and Peterson, *The Writings of Marcel Duchamp*, 35.
7. The complete note reads: "The barrel game [Duchamp draws a sketch of it here] is a very beautiful *'sculpture' of skill:* a photographic record should be made of 3 successive performances; and 'all the pieces in the frog's mouth' *should not be preferred* to 'all the pieces outside' or [nor] above all to a good score" (Sanouillet and Peterson, *The Writings of Marcel Duchamp*, 35). A disc thrown into the open mouth of a metal frog enthroned in the middle of the barrel gave the highest score: hence also the name "frog game."
8. Sanouillet and Peterson, *The Writings of Marcel Duchamp*, 36. When describing the *draft pistons*, Duchamp uses precisely those terms—"grille" and "filet"—that are used in the 17th century treatises on perspective with reference to the drawing frame. Cf. Sanouillet, *Duchamp du signe*, 55–57.
9. Duchamp in conversation with Arturo Schwarz. See Schwarz, *Complete Works*, 1:125, italics added. In a similar experiment, the movements of

a sheet of paper in hot air rising from a radiator were to be captured in three instantaneous photographs. Cf. Sanouillet, *Duchamp du signe*, 51.
10. Two of these enlargements have survived. Cf. Schwarz, *Complete Works*, cat. no. 307.
11. Sanouillet and Peterson, *The Writings of Marcel Duchamp*, 33.
12. Duchamp, *Duchamp, Notes*, no. 180. On the relationship between perspective and weight cf. no. 251; and Sanouillet and Peterson, *The Writings of Marcel Duchamp*, 87, 100–101.
13. Duchamp, *Duchamp, Notes*, nos. 149–52. The sketches in the notes 149 and 152 remained unpublished throughout Duchamp's life. A variant of the "handler of gravity" figured in the *Green Box*. This took the form of a freely swinging, spirally shaped metal spring ending in a ball at the top and mounted on a small three-legged table. See Sanouillet and Peterson, *The Writings of Marcel Duchamp*, 65. On the placement and function of the *soigneur de gravité* in the mechanical context of the *Large Glass*, see Suquet, *Le Grand Verre rêvé*, 149; Suquet, *Le Guéridon et la virgule*, 45–48.
14. Poincaré, *The Foundations of Science*, 312.
15. Duchamp and Breton, *Le Surréalisme en 1947*, 136.
16. The lengths of the strings cannot be exactly ascertained from the photograph. The installation was destroyed after the close of the exhibition.
17. The index of exhibits (a double leaflet printed on four sides, not to be confused with the exhibition catalogue cited in note 15) reads, under the heading "Alvéoles," under No. 7, as follows: "Le Soigneur de Gravité, d'après Duchamp, exécuté par Delanglade et les Mattas." Cf. also Suquet, *Éclipses et splendeurs de la virgule*, 32–34. One of the photographs in Jean, *Histoire de la peinture surréaliste*, 342, shows Matta and the architect of the exhibition, Frederick Kiesler, suspending one of the strings of the *3 Standard Stoppages* beneath the ceiling.
18. "C'était moins une nouvelle distance *droite* entre les 2 ends [sic] du fil déformé par la chute que le mètre en se déformant par la chute (d'un mètre) 'absorbe' la troisième dimension et la ligne droite devient ligne courbe sans toutefois perdre son titre de noblesse: le mètre. . . . Indirectement cette action invalide 'irrationellement' le concept du 'plus court chemin d'un point à un autre' (définition classique de la ligne droite)." Quoted from Molderings, "Une Application humouristique."

See also Matisse, "Marcel Duchamp," 158–59. Gottfried Boehm puts forward the theory that Duchamp's *3 Standard Stoppages* are a reflection upon Galileo's law of falling bodies, but even though gravity has a part to play in this experiment, as we have seen, Duchamp did not perform it with any reference to Galileo's law—which would indeed have been scientifically feasible given sufficient analytical accuracy—but rather considered the effect of gravity in terms of a geometrical theorem, namely that of the "ideal straight line." Cf. Boehm, "Zwischen Auge und Hand," 217–18.

19. Poincaré, *Foundations of Science*, 61.
20. Ibid., 61, italics added.
21. Ibid., 64–65, italics added.
22. Duchamp's approach to geometry is far more complex than the term "deformational" as used by Adcock to describe it. Cf. Adcock, *Marcel Duchamp's Notes from the Large Glass*, 57. The extent to which Duchamp was aware of the difference between concrete physical and ideal geometric figures is clearly evidenced by his thoughts on the "physical notion of curvature" in one of his notes. See *Duchamp Notes*, no. 156rv.
23. Cf. Shearer and Gould, "Hidden in Plain Sight." This theory also connects with Janecke's argument, which, while not directly casting doubt on the fact that Duchamp actually conducted the experiment, does speak of a "manipulated result" and the "pseudo-fortuitousness" of the pathways of the threads (*Kunst und Zufall*, 113).
24. Poincaré, *The Foundations of Science*, 104.
25. Ibid., 104–5, italics added.
26. Kuh, "Marcel Duchamp," 81.
27. Cf. Poincaré, *The Foundations of Science*, 75–80.
28. Duchamp also used chance for the coloring of the *sieves*: the dust that had been collecting for months inside their contours was fixed with varnish in New York in 1920.
29. Sanouillet and Peterson, *The Writings of Marcel Duchamp*, 48. The "spécialiste de la capillarité" was again Poincaré. Cf. Henri Poincaré, *Capillarité* (Paris 1893). Cf. also Henderson, *Duchamp in Context*, esp. 138–42.
30. Sanouillet, *Duchamp du signe*, 72; and Sanouillet and Peterson, *The Writings of Marcel Duchamp*, 48.

31. Sanouillet and Peterson, *The Writings of Marcel Duchamp*, 22.
32. See letter to Richard Hamilton, dated 24 August 1963, quoted in Duchamp, "Ephemerides," 24–25 August.
33. This is also borne out by the overall semantics of the painting. Duchamp's overpainting of *Jeune homme et jeune fille dans le printemps* of 1911, the iconography of which is in the tradition of springtime romance, transforms it into the somber representation of a cemetery of love.
34. The painting bore this title when it was first exhibited by Duchamp. Cf. exh. cat. *First Papers of Surrealism* (New York), unpaged—it was erroneously dated to 1913 in this catalogue.
35. With the exception of Bonk (see Duchamp, *Marcel Duchamp: The Portable Museum*, 255), almost all Duchamp scholars maintain that the lines were drawn with the aid of the templates produced from the 3 *Standard Stoppages*. See d'Harnoncourt and McShine, *Marcel Duchamp*, 274; Duchamp, *The Almost Complete Works of Marcel Duchamp*, 49; Mink, *Marcel Duchamp*, 45; Naumann, *The Mary and William Sisler Collection*, 172; Schwarz, *Complete Works*, 607.
36. See letter from Duchamp to Serge Stauffer: "Rather than use the squaring method for drawing the Network in perspective, I intended to photograph it 'in perspective'—but my attempts left much to be desired." Asked why it was necessary to mark the middle of each Stoppage, he replied: "Probably the middle of each Stoppage on the photo helped me to check the validity of the perspective obtained" (quoted, in translation, from Stauffer, *Marcel Duchamp. Die Schriften*, 290). The original French text reads: "Avant d'employer la méthode des carrés pour la mise en perspective des Réseaux, j'avais l'intention de photographier 'en perspective'—mais les essais laissaient à désirer— probablement le milieu de chaque Stoppage sur la photo m'aidait à contrôler la validité de la perspective obtenue??"
37. The preparatory note for the photograph reads: "Photograph in perspective position the 9 units going from the summit of each mold, and reuniting under the sieves" (Duchamp, *Duchamp, Notes*, no. 120). Duchamp evidently made more than just the one surviving photograph shown here. Cf. Duchamp's note in Sanouillet and Peterson, *The Writings of Marcel Duchamp*, 86 (italics added): "*see photos* made for the perspective of the standard stoppages and the red fellows."

38. Quoted from Hamilton in Duchamp, *The Almost Complete Works*, 49; cf. also Bonk in Duchamp, *Marcel Duchamp: The Portable Museum*, 255. According to one of his posthumously discovered notes, Duchamp was considering—evidently before he painted *Network of Stoppages*, as here he mentions eight rather than nine *malic moulds*—another solution to the problem of perspectival projection. "The tubes for stretching the (illuminating) gas in the unit of length: use the 3 standard stoppages = with lead wire [construct] 3 meters resembling the stand stoppages.—The 3 added one to another and reduced to 1/10 by photography, forming 1/10 of a unit of length. / with the three units, placed perspectively with relation to the photographic lens as in the picture one obtains the exact perspective drawing of the 8 or 24 capillary tubes connecting the malic moulds to the sieves" (Duchamp, *Duchamp, Notes*, no. 120). Thus, according to this note, Duchamp intended to fabricate the lines of the 3 *Standard Stoppages* by shaping them from lead wire, arranging them according to the perspectival view of the *malic moulds* and photographing them in such a way that the result was an image of the *capillary tubes* to the scale of 1:10. The description of the project suggests that Duchamp intended to incorporate this photograph in his 1:10 scale drawing of the *Large Glass*. The photographic project was evidently as abortive as the one for the painting *Network of Stoppages*.
39. In the catalogue that Duchamp himself designed for his retrospective exhibition in Pasadena in 1963, the painting is shown in vertical format. Cf. Duchamp, "Chronology."
40. Duchamp, *Duchamp, Notes*, no. 182: "La vertical après une certaine longueur devient 'à plusieurs branches.'"
41. Schwarz, *Complete Works*, cat. nos. 305 and 328; Herbert, Apter, and Kenney, *The Société Anonyme*, cat. 236 and 239.
42. Sanouillet and Peterson, *The Writings of Marcel Duchamp*, 31. Cf. also Duchamp, *Duchamp, Notes*, no. 185rv.
43. Sanouillet and Peterson, *The Writings of Marcel Duchamp*, 32.
44. Ibid., 48–49 and 51–53.
45. In a letter written to Richard Hamiltion on 24 August 1963, Duchamp dates the addition of the ninth figure to "around Dec[ember 19] 13 or Jan[uary] Feb[ruary 19]14." Quoted from Duchamp, "Ephemerides," 24–25 August.

46. Cabanne, *Dialogues with Marcel Duchamp*, 47.—In the entry under the heading "References" on the questionnaire of the Museum of Modern Art Duchamp had declared the trinity of "unity, duality, infinite multitude" as one of "unity, opposition and series": "no three important / 1—a unit / 2—an opposition / 3—a series."
47. "Les 3 expériences du fil qui tombe couvrent l'immensité des possiblités immésurables" (Duchamp in letter to Paul Matisse, 1963, quoted in Molderings, "Une Application humouristique," 159).
48. Shearer and Gould, "Hidden in Plain Sight."
49. Sanouillet/Peterson, *The Writings of Marcel Duchamp*, 27.
50. Cf. Duchamp's statement in Schwarz, *Complete Works*, 117n.
51. "Pour obtenir une 'exactitude', coller sur la toile finie des fils de différentes *grosseurs*. *Couleur* pour accentuer les lignes (ou intersections)—plans (ce fil sera maintenu par le vernis)" (Sanouillet and Peterson, *The Writings of Marcel Duchamp*, 113).
52. According to a note concerning the photos of the *draft pistons*, dated to May 1915, these photos must have been taken in May or June 1915. Ibid., 36.
53. This is how they were presented at their first showing at the Museum of Modern Art, New York, in 1936 and 1937 and when first published in the magazine *Minotaure*, no. 10 (Winter 1937): 34. On the other hand, Duchamp arranged the photographs of the 3 *décistoppages* in the *Box of 1914* horizontally.
54. Sanouillet and Peterson, *The Writings of Marcel Duchamp*, 23.
55. Richard Hamilton had already drawn attention to the changes later made to the 3 *Standard Stoppages* as early as 1965: "Three canvases were put on long stretchers and painted Prussian Blue. Each thread was dropped on a canvas and varnish was dripped on the thread to bond it to the canvas. . . . *The canvases were later cut from the stretchers and glued down on the strips of plate glass*" (Duchamp, *Not Seen and/or Less Seen*, cat. no. 55, my italics). However, the changes to the 3 *Standard Stoppages* did not become a subject of Duchamp research until Ecke Bonk verified them in 1989 through the correspondence between Duchamp and Katherine S. Dreier and discussed them in detail (Duchamp, *Marcel Duchamp: The Portable Museum*, 218–19). However, Bonk discusses neither the form of the 3 *Standard Stoppages* nor their status in Duchamp's oeuvre before these changes.

56. In Duchamp, *Marcel Duchamp: The Portable Museum*, 218, we read that "Duchamp made a gift of them to her after finishing *Tu m'*." There are no sources, however, that can corroborate this assertion.
57. "When I made the panel *Tu m'*, I made from the Stoppages-étalon 3 wooden rulers which have the same profile as the threads on the canvas" (Duchamp to Katherine S. Dreier, 20 May 1935, in *Selected Correspondence*, 202). How rudimentary knowledge of the artistic form of the *3 Standard Stoppages* still was as late as 1960 is borne out by the fact that Lawrence D. Steefel Jr., in his Duchamp dissertation, referred not to the threads on the canvases as the original work of art but to the wooden templates. Duchamp had, he writes, made the wooden templates in order "to develop another version of the Étalons. Duchamp used them to draw a line on a canvas strip which was mounted on a glass panel" (Steefel, *The Position of Duchamp's Glass*, 178–79; see also 49–50). Here Steefel speaks not of a thread on canvas but of a drawn line, which suggests that he had probably never seen the work in the original. At that time the work was "dans la cave du Museum of Modern Art (!!)," as Duchamp wrote ironically to Paul Matisse in 1963. See Molderings: "Une Application humouristique," 159.
58. Duchamp, *Selected Correspondence*, 202 (20 May 1935), 206 (7 December 1935), 207 (1 January 1936).
59. Ibid., 199.
60. Cf. Duchamp to Katherine S. Dreier, 20 May 1935, in which he refers to the painting *Tu m'* as a "panel." Ibid., 202.
61. Hugnet, "L'Esprit Dada dans la peinture (I)," 65. The original French text reads: "Il avait peint trois tableaux intitulés: *Trois stoppages-étalon*, faits à Paris en 1913, de doter d'une nouvelle figure le mètre."
62. In the background, against the wall on the right-hand side, one can make out the back of the painting *Chocolate Grinder II*, this being recognizable by the stitched-through, varnish-fixed threads forming the contours of the rollers. First published in Duchamp, *Marcel Duchamp: The Portable Museum*, 218. Here the right and left sides of the photographs are slightly cropped, making the character of the "canvases" as paintings difficult to perceive.
63. Duchamp also photographed the painting *Chocolate Grinder II* of 1914 in the same way and in the same place. See illustration in Duchamp, *Marcel Duchamp: The Portable Museum*, 221. Whether and to what

extent Duchamp himself practiced photography in 1913 and 1914 is not certain. For the taking, developing, and printing of the photographs for the *Box of 1914* he undoubtedly collaborated with a photographer. This is revealed by the following note in the *Green Box*: "As a '*Commentary*' on the section of the Slopes—*have a photograph made* of: *to have the apprentice in the sun*" (Sanouillet and Peterson, *The Writings of Marcel Duchamp*, 51, my italics). In another note, referring to the transfer of the *draft pistons* to the *Large Glass*, Duchamp writes: "With the negative of the enlargement: have prepared with silver bromide—the large plate glass and make a print directly on the back. (*ask a photographer for information*—)" (ibid., 38, my italics). Found in Duchamp's estate was a box from the photographic firm of Lumière & ses fils (13.5 x 18.5 cm) containing thirteen negatives (12.8 x 7.8 cm), which had been used to make the prints in the *Box of 1914*. See Duchamp, *Marcel Duchamp dans les collections du Centre Georges Pompidou*, cat. no. 9b.

64. Duchamp wanted to use the same method of size reduction to the scale of 1:10 when photographing the *capillary tubes* fabricated from bent lead wire. See note 38.

65. Duchamp, *Marcel Duchamp dans les collections du Centre Georges Pompidou*, cat. no. 9a; and Schwarz, *Complete Works*, cat. no. 285: "Arensberg Box" and "No. 1 Duchamp Box" (Philadelphia Museum of Art). It is not known why Duchamp did not have prints of the "décistoppages" made for all five exemplars of the *Box of 1914*.

66. Cf. Duchamp, *Selected Correspondence*, 207.

67. See illustration in Schwarz, *Complete Works*, 594. The captions neither run straight nor are they positioned centrally but follow the curvature of the respective threads. Visible in the "windows" are parts of a red line that clearly repeats the line formed by the thread on the front side of the canvas and disappears from view at each end of its "window" underneath the white paint. In places, this red line is out of alignment with the line formed by the thread by between 1 and 2 mm.

68. Sanouillet and Peterson, *The Writings of Marcel Duchamp*, 39.

69. See Ulf Linde, "MARiée CELibataire," 48; see also Henderson, *Duchamp in Context*, 63.

70. Sanouillet and Peterson, *The Writings of Marcel Duchamp*, 66–67.

71. Kuh, "Marcel Duchamp," 81.

72. Maurice Denis, "Définition du Néo-Traditionnisme" (1898), 33.

73. On photography as the paradigm of the *Large Glass*, see Rosalind E. Krauss, "Notes on the Index: Part 1," 202–6.
74. Marey, *Movement*, 3.
75. Cf. Frizot, *Étienne-Jules Marey*, 285–89; Molderings, "Film, Fotografie und ihr Einfluſs," 251–61; and Rowell, "Kupka, Duchamp and Marey," 49.
76. On Duchamp's valuable use of this book, cf. Molderings, "Film, Fotografie und ihr Einfluſs," 253–56.
77. Marey, *Movement*, 24–32. See also Frizot, *Étienne-Jules Marey*, 94–96.
78. Ibid., 24. See also 26–27, figures 15–24.
79. "Se servir du radiateur et d'un papier (ou autre chose) remué par la chaleur au-dessus. Photo. 3 performances—avec probablement un cadre de fond donnant une indication meilleure des déplacements et déformations" (Sanouillet, *Duchamp du signe*, 51). Translated by John Brogden. The translation in Sanouillet and Peterson, *The Writings of Marcel Duchamp*, 35, is not entirely correct.
80. See Marey, *Movement*, esp. figs. 95 and 121.
81. On the significance of scientific photography for Duchamp's new artistic techniques, see Adcock, *Marcel Duchamp's Notes from the Large Glass*, 7; Clair, *Duchamp et la photographie*; Didi-Hubermann and Mannoni, *Mouvements de l'air*, esp. 272–75; Henderson, *Duchamp in Context*, 115; Krauss, "Notes on the Index: Part 1," 196–209.
82. In 1913, the year in which Duchamp produced the 3 *Standard Stoppages*, Fernand Léger defined the essence of the new concept of painting as "conceptual realism," as "l'ordonnance simultanée des trois grandes quantités plastiques: les Lignes, les Formes et les Couleurs" (Léger, *Fonctions de la peinture*, 26 and 28).
83. On the function of the Readymade as an "instrument of research," see Molderings, "Ästhetik des Möglichen"; and Molderings, "It Is Not the Objects That Count."

4. 1936

1. "The one [Readymade] I love most . . . are the three meters of thread falling down" (Roberts, "I Propose," 62).
2. Exposition Surréaliste d'Objets, exh. cat., Paris, Galerie Charles Ratton, 22–29 May 1936.

3. In 1965, when asked about the Readymades, Duchamp replied: "Actually they were a very personal experiment that I had never expected to show to the public" ("Artist Marcel Duchamp Visits U-Classes").
4. On the significance of the Readymades for the surrealists see entry under "Objet" in the *Dictionnaire abrégé du Surréalisme*, 18.
5. Cf. Ramírez, *Duchamp*, 36, figs. 16 and 17.
6. See Musée des Arts et Métiers, Paris, Inv. no. 3234-1. Even though there is no documentary evidence, it is highly probable that Duchamp visited the museum of science and technology during his stay in Munich in the summer of 1912. One of the museum's rooms was devoted to the historical development of standard units of measure. Exhibits included "several standard meters in glass and metal as well as a replica of the prototype meter." See *Deutsches Museum*, 53.
7. d'Harnoncourt and McShine, *Marcel Duchamp*, 273.
8. Five different photographs have survived. One of them, which is in the Mary Reynolds Collection at the Art Institute of Chicago, was mistakenly ascribed to Man Ray. See Edwards, *Surrealism and Its Affinities*, plate VIII; and "Mary Reynolds and the Spirit of Surrealism," fig. 4, 105. One of the photographs in Duchamp's estate indicates "Costa" as the photographer and "London" as the location. As Paul B. Franklin pointed out in a recently published article, the photographer was probably a certain Costa Achilopolu, who belonged to Mary Reynolds's wider circle of friends in London. See Franklin, "A Whodunit."
9. Franklin, "A Whodunit," 159.
10. Duchamp was familiar with the phenomenon of ectoplasm. On 25 December 1922, he wrote to his brother Gaston Villon from New York: "I know a photographer here who takes pictures of ectoplasm on a male medium: I promised I would go along to his sessions, but then I was too lazy to do it, but I would have found it most amuzing" (*Selected Correspondence*, 128, translation partially changed by the author). On a variant of the photograph shown here, the measuring tape does not come out of Duchamp's mouth, and his head is shown in profile, not in front view. Sheldon Nodelman, "The Decollation of Saint Marcel," analyzes in detail the significance of this photograph in a recently published article, basing his argumentation on the photograph's evocation of Salome and the beheading of John the Baptist and not omitting to see in the measuring tape a reference to the *3 Standard Stoppages*.

Even though some of his arguments in the context of Duchamp's biography are altogether convincing, Nodelman's interpretation suffers inasmuch as it fails to establish any connection between the artist-martyr theme and the complex ideas behind the 3 *Standard Stoppages*. Moreover, the image of the bodiless head tradition stands for more than beheadings. One has only to think of Auguste Rodin's famous sculpture *La Pensée* (The thought) of circa 1895 at the Musée d'Orsay in Paris.

11. A further sign of Duchamp's revived preoccupation with the idea of a deformed meter is the negotiating role he played some time during the second half of the 1930s in Walter Arensberg's acquisition of the painting *Metric System* (circa 1933) by the rather mediocre surrealist painter Pierre Roy. Cf. Duchamp, *Selected Correspondence*, 304; and *The Louise and Walter Arensberg Collection, 20th Century Section*, Philadelphia Museum of Art, 1954, ill. 183.
12. Barr, *Fantastic Art Dada Surrealism*, 261, cat. no. 223. The work was not depicted in the catalogue.
13. Ibid., 261.
14. *A Brief Guide to the Exhibition of Fantastic Art Dada Surrealism*, The Museum of Modern Art, New York, 1936, unpaged (cat. no. 15).
15. Barr, *Fantastic Art Dada Surrealism*, 264, cat. nos. 267–68.
16. The templates were shown on the opposite wall. See Katherine S. Dreier to Marcel Duchamp, 2 December 1936, in Umland et al., *Dada in the Collection of The Museum of Modern Art*, 115n. 12.
17. Ibid., 22, italics added. Hugnet's catalogue text was also printed separately under the title "Dada and Surrealism" in the *Bulletin of the Museum of Modern Art* 4, no. 2–3. (1936). This description is a word-for-word translation of the corresponding passage in Georges Hugnet's article "L'Esprit Dada dans la peinture (I)" of 1932. See chapter 3, note 61.
18. Janis and Janis, "Marcel Duchamp, Anti-Artist," 18.
19. Hamilton, "Duchamp Duchamp-Villon Villon," 2. Curiously, in the index of exhibits, the work is quite wrongly described as "string on artificial leather [?] on glass." See entry under "Marcel Duchamp, No. 29," 5.
20. Quoted in Schwarz, *Complete Works*, 594.
21. Buffet, "Coeurs volants," 40.

22. *Minotaure*, no. 10 (Winter 1937): 34. The "idea of the fabrication" from the *Box of 1914* served as the caption: "Si un fil droit horizontal d'un mètre de longueur tombe d'un mètre de hauteur sur un plan horizontal en se déformant à son gré et donne une figure nouvelle de l'unité de longueur."
23. *Dictionnaire abrégé du Surréalisme*, 13.
24. Duchamp, *Marcel Duchamp: The Portable Museum*, 219.
25. Schwarz, *Complete Works*, cat. 282c. Besides the edition 1/8–8/8, two exemplars were produced for the artist and the publisher ("ex. Rrose" and "ex. Arturo") as well as two exemplars for exhibition purposes. For the making of these replicas, a thread of exactly one meter in length was fastened by means of varnish to the canvas and not, as in the case of the original work, cut to a slightly longer length and then stitched through the canvas at both ends.
26. *L'Oeuvre de Marcel Duchamp*, Vol. 1, cat. no. 94.
27. Italics added. "*Pas rigoureusement* car / que faut-il entendre par rigueur d'expérience / expérience rigoureuse?—sinon une / prétention bien inutile à la répétition?" *The Box of 1914* (Arensberg Box), Philadelphia Museum of Art. I wish to thank Hector Obalk, Paris, for his help in deciphering this sentence.
28. Cf. Schwarz, *Complete Works*, cat. 280.
29. On the other hand, in an undated interview with Carroll Janis, Duchamp stressed that each thread was dropped just once. "Don't recall there was any mishap" (quoted in Shearer and Gould, "Hidden in Plain Sight").
30. Incidentally, the standard meter kept at the Bureau International des Poids et Mesures in Sèvres is not exactly 1 meter long but 1.02 meters long. Two notches on the platinum-iridium bar mark the exact distance of 1 meter.
31. See Camhi, "Did Duchamp Deceive Us?" on the activities of the New York "Art Science Research Laboratory." Duchamp's personality as an artist undergoes a new interpretation every twenty years according to current movements and developments in the art scene. After having been characterized as a dissident of painting, a man of few words, a chess player, an anti-artist, and a strategist, he has now been characterized in *Tout-fait: The Marcel Duchamp Studies Online Journal*—published in New York since 1999—as a "trickster" (*Tout-fait* 1, no. 2 [2000]).

32. The complete note, written on the back of a message dated 4 November 1914 under the heading "3 Courants d'air," reads as follows: "Exécuter photos d'un morceau d'étoffe '*pistons du courant d'air*', c.à.d. accepté et refusé par le courant d'air (3 fois).... en faire exécuter 6 clichés en simili pour pouvoir imprimer facilement. Probablement, sur *très bon papier photo* exécuter un tableau fait de clichés obtenus comme plus haut (aussi le décistoppage) = La photo devenant le tableau lui-même" (Duchamp, *Duchamp, Notes*, no. 117). Paul Matisse, the translator and editor of the *Notes*, wrongly translated the word "*décistoppage*" into English as "underexposure."
33. Schwarz, *Complete Works*, cat. 307 a/b.
34. Sanouillet, *Duchamp du signe*, 105; and Sanouillet and Peterson, *The Writings of Marcel Duchamp*, 74.
35. Kuh, "Marcel Duchamp," 81.
36. Quoted from Duchamp, *Almost Complete Works*, 52. On the Readymades as pseudoscientific experiments, cf. Molderings, "Ästhetik des Möglichen"; Molderings, "The Bicycle Wheel and the Bottle Rack"; Molderings, "It Is Not the Objects That Count."
37. Curiously enough, Duchamp did not include this work in the documents relating to the *Large Glass* in the *Green Box*. The reason may simply be that Duchamp did not have a photograph of the three canvases in 1933, although he did have the negatives of the "décistoppages."
38. Duchamp, *Duchamp, Notes*, no. 77: "Donner au texte l'allure d'une *démonstration* en reliant / les décisions prises par des formules conventionelles de / raisonnement inductif dans certains cas, déductifs dans d'autres. / Chaque décision ou évènement du tableau devient ou / un axiome ou bien une conclusion nécessaire, selon une / *loqique d'apparence*. Cette logique d'apparence sera exprimée / seulement par le *style* (formules mathématiques etc.) [additional marginal note: les principes, lois, ou phénom. / seront écrits comme / dans un théorème / dans les livres de géométrie. / soulignés. etc.] et n'otera pas au tableau son caractère de: *mélange d'évènements /imagés plastiquement*, car chacun de ces évènements est une / *excroissance* du tableau général. Comme excroissance l'évè / nement reste bien seulement *apparent* et n'a pas d'autre / prétention qu'une signification d'image (contre la sensibilité / plastique)."
39. Ibid., no 69 (verso): "Il ne peut plus être question d'un Beau plastique."

40. Artist's files, Department of Painting and Sculpture, the Museum of Modern Art, New York italics added.
41. According to Jennifer Gough-Cooper and Jacques Caumont, "Duchamp's starting point [was] 'stoppages et talons', a shop sign in the rue Claude-Bernard advertising invisible mending and heel repairs to socks and stockings" (Duchamp, "Ephemerides," 19 May 1914). This theory is also put forward by Didier Ottinger in his catalogue entry for the 3 *Standard Stoppages* in *Marcel Duchamp dans les collections du Centre Georges Pompidou* (Paris, 2001), 38. However, the existence of such a shop sign has not yet been proven.
42. "Étant donné l'unité de longueur à section élémentaire les tubes de section double auront une longueur double de (physique amusante) *l'étalon* à section élementaire" (Sanouillet, *Duchamp du signe*, 72n. 4, italics added). "Given the unit of length with an element. Section the tubes with a double section will have a length twice (Playful Physics) the standard of the element. sect" (Sanouillet and Peterson, *The Writings of Marcel Duchamp*, 49).
43. Cf. Adcock, *Marcel Duchamp's Notes from the Large Glass*, 7.
44. Cf. Duchamp, "Ephemerides," 10 June 1912. Concerning Roussel's influence on Duchamp's art, see interview with Sweeney in Sanouillet and Peterson, *The Writings of Marcel Duchamp*, 126; Décimo, "Marcel Duchamp et Jean-Pierre Brisset," 43; Raillard, "Roussel," 185–88; Sanouillet, "Marcel Duchamp and the French Intellectual Tradition," 52–53.
45. On Roussel's method, cf. Foucault, *Raymond Roussel*.
46. Quoted from Grössel, *Raymond Roussel*, 78; Roussel, *Comment j'ai écrit*, 11–12.
47. Roussel, *Comment j'ai écrit*, 16. "*Parler à platine*" means roughly "*faire du baratin.*" Thus the pun "*étalon à platine*" may be interpreted either as a "standard meter in platinum" or a "stallion with the gift of the gab."
48. On "*stoppage*" services offered by tailors, cf. *Annuaire de Commerce Didot-Bottin*, vol. 1.2 (Paris 1913), 3176, under "Tailleurs": Innovation (1), atelier spéc. pour la réparation de vêtements, stoppage, rue Jouffroy, no. 81.
49. Bouet, rue Monge, no. 37; Ch. Sanson, rue Monge, no. 38; and Duval, rue Lacépède, no. 11bis. Quoted from: *Annuaire du Commerce Didot-Bottin*, vol. 1.2 (Paris 1913), under "Stoppeurs—Repriseurs," 3176.

50. A. Joly, rue Croix-de-Petits-Champs 14 (ibid.).
51. Académie artistique des stoppeurs de Paris. Anc. Mes Beaumont & Cie. Stoppages dans tous les tissus et vêtements et déchirés ou piqués aus vers, etc., etc. 5 Boul. du Palais (ibid.).
52. Cf. Duchamp, "Ephemerides," 26 October [1912]; and Buffet-Picabia, *Aires abstraites*, 58–64.
53. Sanouillet and Peterson, *The Writings of Marcel Duchamp*, 26–27.
54. Apollinaire, *The Cubist Painters*, 42.
55. Ibid.; the English translation has been corrected in places by the author.
56. On the "scientific abstractions" on which the *Bicycle Wheel* and the *Bottlerack* were based, see Molderings, "Ästhetik des Möglichen," 119–124; "The Bicycle Wheel and the Bottle Rack," 130–33; and "It Is Not the Objects That Count," 148–51.
57. "À Marcel Duchamp / qui ouvre les fenêtres du hasard / son ami Guillaume Apollinaire." The dedication is dated 29 January 1913. Cf. auction catalogue *Bibliothèque d'un grand amateur européen*, Christie's, Paris, 23 May 2006, no. 4, 16.
58. Cf. Sanouillet and Peterson, *The Writings of Marcel Duchamp*, 80. Here the term "*teinter*" is incorrectly translated as "to tint." On Duchamp's fantasies on the art of dyeing, cf. De Duve, *Nominalisme pictural*, 185. In the rue Claude Bernard there were three "teinturiers." Cf. *Annuaire de Commerce Didot-Bottin*, Paris 1913, Vol II, Rues: rue Claude Bernard: no. 2, Fenard, teinturier; no. 17, Bard, teinture; no. 61, Bernadas, teinturier.
59. Cf. Duchamp, *Selected Correspondence*, 43. On Duchamp's early excursions into the artistic domain of his brother, the sculptor Raymond Duchamp-Villon, cf. Molderings, "The Bicycle Wheel and the Bottle Rack," 146–69.
60. The complete note reads: "Notes générales pour un tableau hilarant. Mettre toute la mariée sous globe, ou dans une cage transparente" (Duchamp, *Duchamp, Notes*, no. 77). Cf. also *Duchamp, Notes*, no. 68r, and the note on a geometrical experiment with the aid of a "show case with sliding glass panes" and a "glass-front highboy" in Sanouillet and Peterson, *The Writings of Marcel Duchamp*, 74.
61. Duchamp in conversation with R. Hamilton, 1959, quoted, in translation, from Clair, *Duchamp et la fin de l'art*, 63. The original French text reads: "La projection [de chaque partie de la *Mariée mise à nu*] en

perspective sur le Verre est un exemple parfait de *perspective* classique, c'est-à-dire que les divers éléments de l'Appareil célibataire furent d'abord imaginés répartis derrière le Verre, sur le sol, plutôt que distribués sur une surface à deux dimensions."

62. Apollinaire, *The Cubist Painters*, 43–44.
63. Ibid.
64. On the iconography of this picture, see Molderings, "Vom Tafelbild zur Objektkunst," 223.
65. Schwarz, *Complete Works*, cat. 634 and 648; Taylor, *Marcel Duchamp: Étant donnés*, 77, 354.
66. See *Annuaire de Commerce Didot-Bottin*, vol. 1.2 (Paris 1913), 3211: "Meillon (A) Fils, Maison spéciale. D'habillements administratifs, militaires et livrées . . . , rue Hippolyte-Lebas, 6.; Martin (H), Costumes, Habits, Fourrures, Uniformes Livrées, rue Royale, 14."
67. Schwarz, *Complete Works*, cat. 279 and 289.
68. Cf. the chapter "Die Akademie des Flaneurs" in Molderings, *Marcel Duchamp*, 66–79; d'Harnoncourt and Hopps, *Étant donnés*, 31; Joselit, *Infinite Regress*, 137–43.
69. Sanouillet and Peterson, *The Writings of Marcel Duchamp*, 74. "La question des devantures. Subir l'interrogatoire des devantures. L'exigence de la devanture. La devanture preuve de l'existence du monde extérieur. Quand on subit l'interrogatoire des devantures, on prononce aussi sa propre Condamnation. En effet le choix est allé et retour. De la demande des devantures, de l'inévitable réponse aux devantures, se conclut l'arrêt du choix. Pas d'entêtement, par l'absurde, à cacher le coït à travers une glace avec un ou plusieurs objets de la devanture. La peine consiste à couper la glace et à s'en mordre les pouces dès que la possession est consommée. C.Q.F.D." (Sanouillet, *Duchamp du signe*, 105–6).
70. Schwarz, *Complete Works*, cat. 511–12. Cf. also Girst, "Duchamp's Window Display"; Schleif, "Die Frage der Schaufenster"; Wohl, "Marcel Duchamp in Newark."

5. HUMOROUS APPLICATION OF NON-EUCLIDEAN GEOMETRY

1. See introduction, note 6.
2. Quoted from d'Harnoncourt and McShine, *Marcel Duchamp*, 273–74.

3. See similarly worded statement in a letter to Serge Stauffer in 1961. Stauffer, *Marcel Duchamp. Die Schriften*, 266. On Duchamp's interest in non-Euclidean geometry see Ashton, "An Interview with Marcel Duchamp," 245.
4. Poincaré, *The Foundations of Science*, 57. Cf. also Jouffret, *Traité élémentaire*, 186–88: "Un Univers à deux dimensions"; and Adcock, *Marcel Duchamp's Notes From the Large Glass*, 66–67, 96–99.
5. Poincaré, *The Foundations of Science*, 63.
6. Ibid.
7. Ibid., 65.
8. The fifth chapter of *Science and Hypothesis*, entitled "Experience and Geometry," begins with the assertion that "the principles of geometry are not experimental facts and that in particular Euclid's postulate cannot be proven experimentally" (80).
9. Ibid, 65.
10. Ibid, 79–80.
11. "Cette représentation est le dessin . . . d'une réalité possible en distendant un peu les lois physiques et chimiques" (Sanouillet, *Duchamp du signe*, 71).
12. Poincaré, *The Foundations of Science*, 239, italics added. On the fantastic visual implications of topology, see the chapter "Rubber-Sheet Geometry," in Kasner and Newman: *Mathematics and Imagination*, 265–98. This book was found among Duchamp's belongings after his death. On Riemann as the founder of topology, see Bourbaki, *Éléments d'histoire des mathématiques*.
13. On Duchamp's interest in topology see the recollections of the mathematician François Le Lionnais, "Échecs et Maths," in Duchamp, *L'Oeuvre de Marcel Duchamp*, 3:51; Clair, "Sexe et topologie," in Duchamp, *L'Oeuvre de Marcel Duchamp*, 3:52; and Clair, *Duchamp et la photographie*, 102–22. Also see Adcock, *Marcel Duchamp's Notes from the Large Glass*, 124–29; and Molderings, *Marcel Duchamp*, 42–47.
14. Sanouillet, *Duchamp du signe*, 66–67, 120. However, since the *3 Standard Stoppages* were a by-product of his preoccupation with the *Large Glass*, an element of topological geometry also found its way into the "measured," perspective space occupied by the bride's bachelors.
15. See the chapter "Analysis Situs and the Continuum" in Poincaré, *Mathematics and Science*. Poincaré died in 1912.

16. Ibid., 24–26. The original French text reads: "Dans cette discipline, deux figures sont équivalentes toutes les fois qu'on peut passer de l'une à l'autre par une déformation continue, quelle que soit d'ailleurs la loi de cette déformation pourvu qu'elle respecte la continuité. . . . Supposons un modèle quelquonque et la copie de ce même modèle executée par un dessinateur maladroit: les proportions sont alterées, les droites tracées d'une main tremblante ont subi de fâcheuses déviations et présentent des courbures malencontreuses. Du point de vue de la géométrie métrique, de celui même de la géométrie projective, les deux figures ne sont pas équivalentes: elles le sont au contraire du point de vue de l'Analysis situs."

17. On the 3 *Standard Stoppages* and the principle of topological deformation, see Adcock, "Conventionalism in Henri Poincaré and Marcel Duchamp," 255–57.

18. Poincaré: *Last Essays*, 26. The original French text reads: "de bien raisonner sur des figures mal faites. Ce n'est pas là une boutade, c'est une vérité qui mérite qu'on y réfléchisse. Mais qu'est-ce qu'une figure mal faite? C'est celle que peut exécuter le dessinateur maladroit dont nous parlions tout à l'heure; il altère les proportions plus ou moins grossièrement; ses lignes droites ont des zigzags inquiétants; ses cercles présentent des bosses disgracieuses; tout cela ne fait rien, cela ne troublera nullement le géomètre, cela ne l'empêchera pas de bien raisonner."

19. Ibid.: "And this is what makes analysis situs so interesting to us: it is in this discipline that geometric intuition truly plays a role."

20. Ibid., 42: "therein is the true domain of geometric intuition."

21. Ibid., 27. The original French text reads: "L'espace est relatif; je veux dire par là, non seulement que nous pourrions être transportés dans une autre région de l'espace sans nous en apercevoir . . . non seulement que toutes les dimensions des objets pourraient être augmentées dans une même proportion, sans que nous puissions le savoir, pourvu que nos instruments de mesure participent à cet agrandissement; mais je veux dire encore que l'espace pourrait être déformé suivant une loi arbitraire pourvu que nos instruments de mesure soient déformés précisément d'après la même loi."

22. Ibid., italics added. The original French text reads: "L'espace, considéré indépendamment de nos instruments de mesure, n'a donc ni propriété métrique, ni propriété projective, il n'a que des propriétés

topologiques (c'est-à-dire de celles qu'étudie l'Analysis Situs). Il est *amorphe*, c'est-à-dire qu'il ne diffère pas de celui qu'on en déduirait par une déformation continue quelquonque.... Comment l'intervention de nos instruments de mesure, et en particulier des corps solides donne à l'esprit l'occasion de déterminer et d'organiser plus complètement cet espace amorphe; comment elle permet à la géométrie projective d'y tracer *un réseau de lignes droites*, à la géométrie métrique de mesurer les distances de ces points . . . , c'est ce que j'ai expliqué longuement ailleurs" (italics added).

23. In one of the notes left by Duchamp, "*réseau*" is also used in the singular: "Réseau de 9 Stoppages étalon" (Duchamp, *Duchamp, Notes*, no. 120).
24. Henderson, *The Fourth Dimension*, 131.
25. Duchamp evidently knew of this possibility, as one of the notes he left proves: "The garden globe, the distorting mirrors / 2 mirrors one opposite the other, multiplying / the movements to infinity" (Duchamp, *Duchamp, Notes*, no. 196).
26. Gold, "A Discussion," no. 20.
27. Quoted, in translation, from Gleizes, *Kubismus*, 10.
28. Gleizes and Metzinger, *Du Cubisme*, 40: "On a négligemment accoutumé de confondre [l'espace pictural] soit avec l'espace visuel pur, soit avec l'espace euclidien. Euclide, en l'un des ses postulats, pose l'indéformabilité des figures en mouvements, cela nous épargne d'insister. Si l'on désirait rattacher l'espace des peintres à quelque géométrie, il faudrait en référer aux savants non euclidiens, méditer certains théorèmes de Riemann."
29. Henderson, *Duchamp in Context*, 188.
30. Cf. Antliff and Leighten, *Cubism and Culture*, 71–79.
31. Duchamp, *Duchamp, Notes*, nos. 161 v and 162 rv.
32. Poincaré, *The Foundation of Science*, 418.
33. Gold, "A Discussion," no. 8.
34. In exh. cat. *Twentieth Century Art from the Louise and Walter Arensberg Collection*, Chicago, Art Institute, 1949. Quoted from Duchamp, "Ephemerides," 19 October [1949]. On the subject of humor in art, Robert Smithson made the following observation as late as 1967: "The varieties of humor are pretty foreign to the American temperament. It seems that the American temperament doesn't associate art with humor. Humor is not considered serious" (Smithson, *The Writings*, 66).

35. Andre Breton, "Phare de La Mariée," *Minotaure*, no. 6 (Winter 1935): 45. It was through this essay—a review of the *Green Box*, which had appeared in the previous year—and through Gabrielle Buffet-Picabia's essay "Coeurs Volants," which appeared in 1936 in *Les Cahiers d'Art*, that Duchamp's career as an "antipainter" and "object artist" began in Paris.
36. Cf. Adcock, "Conventionalism in Henri Poincaré and Marcel Duchamp," 255–57; Adcock, *Marcel Duchamp's Notes From the Large Glass*, 55; Lenain, "Le Dernier tableau de Marcel Duchamp," 79–104. Even Karl Gerstner's instructive work monograph, *Marcel Duchamp: Tu m'*, leaves important parts of this painting unexplored.
37. "The Shadow cast by a 4-dim'l figure on our space is a 3-dim'l shadow. / Each ordinary 3-dim'l body . . . is *the* perspective projected by numerous 4-dim'l bodies upon the 3-dim'l medium" (Sanouillet and Peterson, *The Writings of Marcel Duchamp*, 89 and 96). See Molderings, "Ästhetik des Möglichen," 111–19.
38. Still detectable in the painting, as preliminary sketches, are three thinly penciled lines starting from each of the corners of the square. Duchamp evidently changed his plans during the execution of the painting and painted only two lines, a red one and a black one, as confirmed by his own description of the painting on a questionnaire sent to him by the surrealist painter and essayist Marcel Jean in 1952 during their preparations for the book *Le Surréalisme et la peinture*. Referring to *Tu m'*, Duchamp writes: "The right section of the picture is a muddle of more or less artificial calculations with compasses and the standard-stoppages whose 4 double lines start clearly from the corners of the white square" (*Lettres à Marcel Jean*, 46 and 77).
39. Poincaré, *The Foundations of Science*, 239.
40. Ibid., 167–72.
41. Schwarz, *Complete Works*, 1:223. *Tu m'* may of course also be interpreted as an anagram of Mutt, the pseudonym under which Duchamp had submitted the urinal *Fountain* for the exhibition of the "Society of Independent Artists" in the previous year. Cf. Linde, "MARiée CELibataire," in Schwarz, *Marcel Duchamp: Readymades*, 63.
42. Jean du Breuil, *La Perspective pratique*, chapter 2. Cf. especially the illustrations on the "The art of finding natural shadows, cast both by sunlight and by torchlight."

6. THE CRISIS OF THE SCIENTIFIC CONCEPT OF TRUTH

1. On Poincarés "Conventionalism," see Audureau, "Le Conventionalisme"; Brenner, "The French Connection"; Dantzig, *Henri Poincaré: Critic of Crisis*; Giedymin, *Science and Convention*; Greffe, Heinzmann, and Lorenz, *Henri Poincaré*.
2. Rey, *La Philosophie moderne*, 149. See also Brenner, "Le Conventionnalisme."
3. Rey, *La Philosophie moderne*, 48.
4. Ibid., 25. On the significance of the philosophy of science for the development of French philosophy at the beginning of the twentieth century, see Bourgeois, "La Société des philosophes"; and Brenner, "Le Conventionalisme," 228–29.
5. Rey, *La Philosophie moderne*, 28–29.
6. See Bourgeois, "La Société des philosophes." Numerous chapters in Poincaré's books *La Science et l'hypothèse* (1902) and *La Valeur de la science* (1905) had been prepared by way of essays in the *Revue de métaphysique et de morale* between the years of 1894 and 1903. See "Sur la nature du raisonnement mathématique," July 1894; "L'Espace et la géometrie," November 1895; "Réponses à quelques critiques," May 1987; "La mesure du temps," January 1898; "Les fondéments de la géometrie, à propos d'un livre de M. Russell," November 1899; "Sur la valeur objective de la science," May 1902; "L'Espace et ses trois dimensions (I)," May 1903; "L'Espace et ses dimensions (II)" July 1903.
7. See Brenner, "Le Conventionalisme," 230–231. Le Roy took over Bergson's professorial duties at the Collège de France from 1914 until 1921 and became Bergson's successor in the Académie Française in 1945.
8. Édouard Le Roy, "Science et Philosophie," *Revue de métaphysique et de morale* (July 1899): 375–425, (September 1899): 503–62, (November 1899): 708–31; Le Roy, "Un Positivisme nouveau," *Revue de métaphysique et de morale* (March 1901): 138–53.
9. Poincaré, "Sur la valeur objective de la science," *Revue de métaphysique et de morale* (May 1902): 263–93; reprint, in *La Valeur de la science* (Paris: Flammarion, 1905), 213–76.
10. Poincaré, *The Foundations of Science*, 321.
11. Le Roy's books are *Dogme et Critique* (Paris 1906) and *Une Philosophie nouvelle. Henri Bergson* (Paris 1912).

12. Poincaré, *The Foundations of Science*, 321.
13. Ibid., 325. See also Croco, "Intuition, construction, et convention."
14. Poincaré, *The Foundations of Science*, 328.
15. Ibid., 327.
16. See exh. cat. *L'Aventure du mètre*, Musée National des Techniques—CNAM (Paris, 1989).
17. Ibid., 29.
18. Ibid., 44.
19. The liter "is the valid volumetric unit of measure both for liquids and for dry materials, its content corresponding to a cube based on the tenth part of the meter." The liter thus corresponds to a cubic decimeter. The gram is "the absolute weight of the volume of pure water at freezing point corresponding to a cube based on the hundredth part of the meter" (ibid., 4, quoted in translation).
20. Ibid., 63.
21. Ibid., 69.
22. Poincaré, *The Foundations of Science*, 79–80.
23. Ibid., 234.
24. "Cette représentation est le dessin ... d'une réalité possible en distendant un peu les lois physiques et chimiques" (Sanouillet, *Duchamp du signe*, 71).
25. Rougemont, "Marcel Duchamp mine de rien," 43, 47. The original French text reads: "Leurs soi-disant démonstrations dépendent de leurs conventions. Tautologies que tout cela. ... La science n'est qu'une mythologie, ses lois et sa matière elle-même sont de purs mythes, et n'ont ni plus ni moins de réalité que les conventions d'un jeu quelconque." Cf. also the statement: "There is no finality; we build tautologically and get nowhere.—I once read part of a book by a Viennese group of mathematicians. They showed that all conceptions of reality were tautological except for black coffee. It was the only reality. I found that a very pleasing and amusing conception, and thought it showed a great deal of intelligence" (Gold, "A Discussion," nos. 37–38).
26. Édouard Le Roy, *Revue de métaphysique et de morale* (September 1899) 550. The original French text reads: "La science rationelle—terme extrême de la connaissance discursive—n'est qu'un jeu purement formel d'écriture sans signification intrinsèque."

27. Mayoux, *La Liberté une et divisible*, 95–96; English quotation taken from Duchamp, *Marcel Duchamp: The Portable Museum*, 252. The original French text reads: "Toutes ces balivernes, existence de Dieu, athéisme, déterminisme, libre arbitre, sociétés, mort, etc., sont des les pièces d'un jeu d'échecs appelé langage et ne sont amusantes que si on ne se préoccupe pas de gagner et de perdre cette partie d'échecs'.—En bon 'nominaliste', je propose le mot Patatautologies qui, après répétition fréquente, créera le concept de ce que j'essaie d'exprimer par ce moyen exécrable : le sujet, le verbe, le complément... etc."
28. Here I must correct those earlier opinions of mine that permit the conclusion that Poincaré himself had adopted a nominalist and agnostic approach to science. Cf. Molderings, *Marcel Duchamp*, 35–37.
29. *Revue de métaphysique et de morale* (May 1902): 265. Reprinted in *La Valeur de la science*, 218. Quoted from Poincaré, *The Foundations of Science*, 323–24.
30. Poincaré, *The Foundations of Science*, 106.
31. Ibid., 208–9.
32. Gaston Milhaud, "La Science et l'hypothèse par M. H. Poincaré," in *Revue de métaphysique et de morale* (November 1903): 784 and 788. The original French text reads: "Et en fait, malgré ses efforts pour justifier par leur opportunité les conventions et les définitions, il donnera toujours le sentiment qu'à ses yeux elles impliquent quelque chose de contraire à l'objectivité vraie, quelque chose qui y supplée sans doute le mieux possible, mais qui en même temps s'y oppose.... Et voilà pourquoi M. Poincaré dépouillera si aisément de *vérité* les définitions fondamentales de la science; voilà pourquoi il nous amènera—malgré ses efforts pour s'y opposer—à douter de leur objectivité; et voilà pourquoi enfin, depuis les postulats de la géométrie jusqu'au coeur même de la science de la Nature, il laissera subsister quelque chose d'arbitraire, d'indéterminé, d'insuffisamment justifié, qui malgré tout nous trouble et nous inquiète."
33. "N'impliquent nullement la ruine du réalisme." Tannery, *Science et philosophie*, 72.
34. Ibid., 73–74. The French text reads: "Qu'elle ne soit qu'un discours, un jeu de définitions, de conventions puis de déductions formelles, c'est ce que quelques philosophes, dont le talent scientifique n'est d'ailleurs pas contestable, se sont plu à soutenir. M. Poincaré leur avait fourni

quelques armes, dont ils avaient su profiter et d'ailleurs, tout n'est pas faux dans leur argumentation, puisque, quand la Science s'organise sous une forme logique, il faut bien mettre les définitions au commencement; à celui qui débute, ces définitions peuvent sembler arbitraires, et c'est, très souvent, l'ensemble même des déductions, l'accord des conclusions avec la réalité expérimentale, qui justifient ces définitions au moins d'une facon provisoire. Sans rien retirer de ce qu'il avait dit auparavant, M. Poincaré montre clairement que, si la Science est relative à l'homme, elle n'est pas relative à un individu, ce savant, qu'elle n'est pas une oeuvre artificielle, mais bien le produit naturel d'une entente."

35. Musée des Arts et Métiers, Inv. No. 3296.
36. Cf. Adcock, "Conventionalism in Henri Poincaré and Marcel Duchamp," 251, 257; Henderson, *Duchamp in Context*, 187–88.
37. While Adcock does in fact draw attention to certain differences between Poincaré's conventionalism and Duchamp's relativism and skepticism, he leaves out of consideration the ironic and humorous side to Duchamp's way of thinking and therefore fails to recognize Duchamp's essentially *anti*scientific approach ("Conventionalism in Henri Poincaré and Marcel Duchamp," 250–51). He even describes Duchamp's thinking as a "particular brand of positivism" influenced by Poincaré (*Duchamp's Notes from the Large Glass*, 39).
38. Sanouillet and Peterson, *The Writings of Marcel Duchamp*, 78. "Une Sorte de *Nominalisme pictural* (contrôler)" (Sanouillet, *Duchamp du signe*, 111). At the same time Duchamp was also working on the project of a "Nominalisme littéral." See Duchamp, *Duchamp, Notes*, no. 185. In his study *Pictorial Nominalism*, de Duve maintains that Duchamp had already given up painting when he was in Munich in the summer of 1912, ignoring not only the fact that *The Bride Stripped Bare by Her Bachelors, Even* was originally intended as a painting on canvas but also the fact that Duchamp was, until 1914, concerned first and foremost with questions of the renewal or transformation of painting. It was in this context that the *3 Standard Stoppages* was originally created in the form of "paintings of chance."
39. Cf. Apollinaire, *Méditations esthétiques*, 63.
40. Quoted in translation from Gleizes, *Kubismus*, 10.
41. Cf. Rey, *La Théorie de la physique*, 18. Abel Rey (1873–1940) was Gaston Milhaud's successor to the chair of "Histoire de la philosophie dans

ses rapports avec les sciences" at the Sorbonne. It was on his initiative that the Institut d'histoire des sciences—now the Institut d'histoire et de philosophie des sciences et des techniques—was founded at the Sorbonne's Faculté des lettres in 1932.

42. Ibid., 19. Translator's note: the English edition of Abel Rey's book, *The Theory of Physics Among Contemporary Physicists*, is out of print and no longer available. The quoted passage has survived in *Materialism and Empirio-Criticism* by V. I. Lenin (*Collected Works*, vol. 14, 256). The original French text reads: "Si ces sciences qui, historiquement ont été essentiellement émancipatrices, sombrent dans une crise qui ne leur laisse que la valeur de recettes techniquement utiles, mais leur enlève toute signification au point de vue de la connaissance de la nature, il doit en résulter dans l'art logique et dans l'histoire des idées, un complet bouleversement. . . . La connaissance du réel doit être cherchée et donnée par d'autres moyens. . . . Il faut aller dans une autre voie, et rendre à une intuition subjective, à un sens mystique de la réalité, tout ce que l'on croyait lui avoir arraché."
43. Édouard le Roy, *La Pensée intuitive*, 2 vols. (Paris, 1929–30); *Le Problème de Dieu* (Paris, 1929; *Introduction à l'étude du problème réligieux* (Paris, 1944).
44. Cf. Molderings, *Marcel Duchamp*, 91–94.
45. Gold, "A Discussion," no. 29.
46. On Duchamp's conception of art and life as a game, see Leiris, "La Mariée"; Molderings, "Ästhetik des Möglichen," 126–27; and Molderings, "Relativism and a Historical Sense," 20.
47. "If there was any philosophical idea involved in what I did, it was that nothing is serious enough to take seriously." Duchamp in an interview with Dorothy Norman in 1953, *Art in America* 4 (July–August 1969): 38.
48. Henderson, *Duchamp in Context*, 67, 184, 188.
49. This thesis is also expressed in Antliff and Leighten, *Cubism and Culture*, 109.
50. Henderson, *Duchamp in Context*, 77.
51. Cf. Duchamp's lecture, "The Creative Act," in Houston in 1957, in Sanouillet and Peterson, *The Writings of Marcel Duchamp*, 138–40; also see Goldaine and Astier, *Ces Peintres vous parlent*, 46.
52. Gold, "A Discussion," nos. 21 and 13.
53. "Physique amusante" (Sanouillet, *Duchamp du signe*, 72).

54. Quoted in translation from Molderings, "Une Application humouristique de géométrie non-euclidienne," 159, italics added.
55. Henderson, *Duchamp in Context*, 76–77. Antliff and Leighten concur with this thesis and likewise present Duchamp as an "anti-Bergsonist" (*Cubism and Culture*, 101).
56. One of the first contributions toward this end is Lucia Beier's essay "The Time Machine: A Bergsonian Approach to the 'Large Glass.'" The author attributes the term *"durée,"* an important one with reference to Duchamp's conception of the *Large Glass*, to Bergson's *L'Évolution créatrice* of 1907 and, by the same token, makes Duchamp's familiarity with this book altogether plausible. See also the section entitled "Duchamp, lecteur de Bergson?" in Décimo, "Marcel Duchamp et Jean-Pierre Brisset," 41–43.
57. Duchamp, *Duchamp, Notes*, nos. 135 and 273.
58. Gold, "A Discussion," no.19. Here Duchamp is possibly echoing his reading of Bergson's *La Pensée et le mouvant* of 1912. In some of his notes Duchamp deals explicitly with Bergson's theory of the *"durée"* and Nietzsche's concept of the "eternal return." Cf. Duchamp, *Duchamp, Notes*, no. 135.
59. Gold, "A Discussion," nos. 25 and 20.
60. Quoted from Tomkins, *Ahead of the Game*, 36–37. See also Duchamp's almost identical statement in his interview with Roberts, "I Propose to Strain the Laws of Physics," 47.
61. Cf. note, "Le Possible physique? Oui mais quel Possible physique. hypophysique plutôt." ("The Physical Possible? Yes but which physical possible. Rather hypophysics"). Duchamp, *Duchamp, Notes*, no. 82rv
62. D'Hanorncourt and McShine, *Marcel Duchamp*, 273–74.

7. PATAPHYSICS, CHANCE, AND THE AESTHETICS OF THE POSSIBLE

1. "Ethernity": a pun on the words "éternité" and "éther," the latter being a much discussed term among physicians of the nineteenth century.
2. "Gestes et opinions du Dr Faustroll, pataphysicien," *Vers et Prose* 23 (October–November–December 1910): 69–78.
3. Jarry, *Exploits and Opinions*, 21.
4. Ibid., 22.

5. On Jarry's influence on Duchamp, see Anastasi, "Duchamp on the Alfred Jarry Road"; Gervais, "Connections," 409; Gervais, *C'est. Marcel Duchamp*, 333; Henderson, *Duchamp in Context*, 47–51; Leiris, "La Mariée," 1088; Paz, *Nackte Erscheinung*, 131–33; Ramírez, *Duchamp*, 146–47; Seigel, *The Private Worlds of Marcel Duchamp*, 164–65; Steefel, *The Position of Duchamp's Glass*, 278–85.
6. Jarry, *Exploits and Opinions*, 22–23. It was this thought that inspired Duchamp's note "La Pendule *de profil* et *l'Inspecteur* d'espace" in the *Green Box*. In 1964 he made a folded-paper work entitled *Pendule en profil (Clock in Profile)* as an illustration for Robert Lebel's book *L'Inventeur du temps gratuit*. See Schwarz, *Complete Works*, cat. no. 610–12.
7. Drot, *Jeu d'échecs avec Marcel Duchamp*. The original and longer French version went as follows: "Ce n'était pas seulement faire un tableau, c'était faire un geste dans la vie qui était aussi esthétique que le tableau. Les choses qui m'intéressaient étaient introduire l'humour dans mes productions. C'était un humour qui n'était pas un humour noir non plus, c'était un humour qui ajoutait quelque chose ... de sérieux."
8. On Roussel, see Cabanne, *Dialogues with Marcel Duchamp*, 70. On Jarry, see Duchamp's relevant statements in Stauffer, *Marcel Duchamp. Interviews und Statements*, 76, 78, 102. See also J. J. Sweeney's foreword in the exhib. cat. *Jacques Villon, Raymond Duchamp-Villon, Marcel Duchamp*, unpaged.
9. Sanouillet, *Duchamp du signe*, 37; Sanouillet and Peterson, *The Writings of Marcel Duchamp*, 24.
10. Cabanne, *Dialogues with Marcel Duchamp*, 46–47.
11. Cf. Barberousse, "Le Nouveau visage du hasard."
12. Among the books found in Duchamp's estate was Pierre Camille Revel's treatise, *Le Hasard, sa loi et ses conséquences dans les sciences et en philosophie, suivi d'un essai sur La Métempsychose, basée sur les principes de la biologie et du magnétisme physiologique* (Paris, 1909). Cf. Clair, *Marcel Duchamp et la fin de l'art*, 300n. 9.
13. Poincaré, *The Foundations of Science*, 124, 230, 523. Elements of these theories also found their way into Duchamp's notes for the *Large Glass*. See Henderson, *Duchamp in Context*, 134–42.
14. Poincaré, *The Foundations of Science*, 345.
15. Sanouillet and Peterson: *The Writings of Marcel Duchamp*, 22.

16. Poincaré, *The Foundations of Science*, 347. See also Boniface, "Poincaré et le principe d'induction."
17. Poincaré, *The Foundations of Science*, 345–47.
18. See chapter 4, "Chance," in ibid., 395.
19. See Sanouillet and Peterson, *The Writings of Marcel Duchamp*, 30.
20. Poincaré, *The Foundations of Science*, 346–47.
21. Ibid., 363–64, italics added.
22. See Duchamp's corresponding statements in Stauffer, *Marcel Duchamp. Interviews und Statements*, 66, 164, 168.
23. Duchamp, *Duchamp, Notes*, 26r: "Mode: expériences—le résultat ne devant pas être gardé—ne présentant aucun intérêt."
24. See *internationale situationiste 1958–69* (Paris, 1975), and Ohrt, *Phantom Avantgarde*.
25. Sanouillet and Peterson, *The Writings of Marcel Duchamp*, 31. The original note reads: "Perdre la possibilité de reconnaître 2 choses semblables—2 couleurs, 2 dentelles, 2 chapeaux, 2 formes quelconques. Arriver à l'impossibilité de mémoire suffisante pour transporter d'un semblable à l'autre l'empreinte en mémoire" (Sanouillet, *Duchamp du signe*, 47).
26. Duchamp had possibly read this short essay in German during his three months' stay in Munich in 1912. While the extent to which Duchamp was familiar with the writings of Nietzsche has yet to be the subject of research, there is no doubt that he had in fact read Nietzsche. Cf. Duchamp, *Duchamp, Notes*, no. 135; and Duchamp's statement in his interview with Harriet and Carroll Janis in 1945: "Nietzsche, who was supposed to have read Stirner, was a very interesting episode in my life" (quoted in Francis Naumann, "Aesthetic Anarchy," 61). See also chapter 6, note 58, as well as Jean-Jacques Lebel's testimony of 1966: "Duchamp told me that of all the deadly boring 19th century philosophers Stirner and Nietzsche were the only ones that Picabia and he had read" (quoted, in translation, from J.-J. Lebel, "Mise au point (Picabia-Dynamo)," 6). Also see J.-J. Lebel's interview with Paul Franklin, "Coming of Age with Marcel," 14. Calvin Tomkins's assumption that "Duchamp never read any books by Bergson or Nietzsche" is somewhat hasty in view of this—albeit scanty—source material (Tomkins, *Duchamp*, 68). On the reception of Nietzsche in France between 1895 and 1914, see Bianquis, *Nietzsche en France*; and Le Rider,

Nietzsche in Frankreich, chiefly the chapter entitled "The 'Mercure de France' and Henri Albert," 39–69.

27. Friedrich Nietzsche, *On Truth and Lies in an Extra-Moral Sense*, fragment, 1873, from the *Nachlass*, compiled from translations by Walter Kaufmann and Daniel Breazeale, text amended in part by The Nietzsche Channel, http:/www.geocities.com/thenietzschechannel/tls.htm?200820. "Jedes Wort wird sofort dadurch Begriff, dass es eben nicht für das einmalige ganz und gar individualisierte Urerlebnis, dem es sein Entstehen verdankt, etwa als Erinnerung dienen soll, sondern zugleich für zahllose, mehr oder weniger ähnliche, d.h. streng genommen niemals gleiche, also auf lauter ungleiche Fälle passen mufs. Jeder Begriff entsteht durch Gleichsetzen des Nicht-Gleichen. So gewifs nie ein Blatt einem anderen ganz gleich ist, so gewiss ist der Begriff Blatt durch beliebiges Fallenlassen dieser individuellen Verschiedenheiten, durch ein Vergessen des Unterscheidenden gebildet und erweckt nun die Vorstellung, als ob es in der Natur aufser den Blättern etwas gäbe, das 'Blatt' wäre, etwa eine Urform, nach der alle Blätter gewebt, gezeichnet, abgezirkelt, gefärbt, gekräuselt, bemalt wären, aber von ungeschickten Händen, so dass kein Exemplar korrekt und zuverlässig als treues Abbild der Urform ausgefallen wäre" (Nietzsche, "Über Wahrheit und Lüge im aufsermoralischen Sinne," 373 [30–35]–374 [1–11]).

28. Ibid., 375 [20–21].

29. Ibid., 374 [21–24]. "Das Übersehen des Individuellen und Wirklichen gibt uns den Begriff. wie es uns auch die Form gibt, wohingegen die Natur keine Formen und Begriffe, also auch keine Gattungen kennt, sondern nur ein für uns unzugängliches und undefinierbares X."

30. Ibid., 375 [25–35] – 376 [1–2]. "Alles, was den Menschen gegen das Tier abhebt, hängt von dieser Fähigkeit ab, die anschaulichen Metaphern zu einem Schema zu verflüchtigen, also ein Bild in einen Beriff aufzulösen; im Bereich jener Schemata nämlich ist etwas möglich, was niemals unter den anschaulichen ersten Eindrücken gelingen möchte: eine pyramidale Ordnung nach Kasten und Graden aufzubauen, eine neue Welt von Gesetzen, Privilegien. Unterordnungen, Gränzbestimmungen zu schaffen, die nun der anderen anschaulichen Welt der ersten Eindrücke gegenübertritt, als das Festere, Allgemeinere, Bekanntere, Menschlichere und daher als das Regulierende und Imperativische."

31. Sanouillet, *Duchamp du signe*, 55.
32. Roberts, "I Propose to Strain the Laws of Physics," 63.
33. Paz, *Duchamp: Appearance Stripped Bare*, 15–16.
34. Sanouillet and Peterson, *The Writings of Marcel Duchamp*, 33.
35. Ibid., 127.
36. Stauffer, *Marcel Duchamp. Interviews und Statements*, 80–81.
37. Cf. Henderson, *Duchamp in Context*, 54.
38. See Betancourt, "Chance Operations/Limiting Frameworks"; Duchamp, *The Entire Music of Marcel Duchamp*, Multhipla Records, no. 1, Milan 1976; Duchamp, *Music by Marcel Duchamp*, S.E.M. Ensemble Petr Kotik John Cage, Edition Block, Berlin 1991; Henderson, *Duchamp in Context*, 60–61; James, "Duchamp's Silent Noise/Music for the Deaf."
39. Sanouillet and Peterson, *The Writings of Marcel Duchamp*, 32.
40. Schwarz, *Complete Works*, vol. 2, no. 406. Sanouillet and Peterson, *The Writings of Marcel Duchamp*, 185–88.
41. In his *Science and Hypothesis*, Poincaré had devoted a long chapter to probability calculus (*The Foundations of Science*, 155–73) and had also calculated in this same chapter a function for ascertaining the chances of winning at "Rouge et Noir" (167–68). See also *Science and Method* (ibid., 398–99). Émile Borel, too, in his book *Le Hasard* of 1914, explored the practical use of probability calculus for gambling.
42. Duchamp, *Selected Correspondence*, 148–149
43. Ibid., 144: "Je dessine maintenant sur le hasard."
44. Reichenbach, *Philosophische Grundlagen der Quantenmechanik*; Audretsch and Mainzer, *Wieviele Leben hat Schrödingers Katze*; Grupen: "Die Natur des Zufalls"; and Coy, "Berechenbares Chaos."
45. Quoted, in translation, from Pauli, *Wissenschaftlicher Briefwechsel*, 56.
46. Quoted, in translation, from Fischer, *An den Grenzen des Denkens*, 147.
47. According to Lebel, Duchamp had anticipated the theory of relativity, which is chronologically impossible (R. Lebel, *Sur Marcel Duchamp*, 30), while Watts (*Chance*, 35) and Williams ("Pata or Quantum") suggest the same with reference to quantum physics.
48. Quoted, in translation, from Stauffer, *Interviews und Statements*, 123. Originally appeared in Ulf Linde, "Samtal med Marcel Duchamp," *Dagens Nyheter* (Stockholm), 10 September 1961.
49. Gold, "A Discussion," no. 27.

50. See Stauffer, *Marcel Duchamp Schriften*, 95; and Duchamp, *Duchamp, Notes*, no. 773.
51. Quoted from Janis and Janis, "Marcel Duchamp Anti-Artist," 23.
52. Duchamp's incorporation of chance in his work was frequently interpreted during the 1950s and 1960s as a Dadaistic aestheticization of chance in reaction to the First World War. See Hans Richter, *Der Zufall*, in exhib. cat. *Dada. Dokumente einer Bewegung*, Düsseldorf 1958, unpaged; and Richter, *Dada. Kunst und Antikunst*, 51–59; and Richardson, *Modern Art*, 138–39. However, there is no connection, neither chronologically nor in terms of content.
53. On the nationalistic tones that accompanied, in particular, the Anglo-French debate on the standard meter in 1912, see Henderson, *Duchamp in Context*, 62.
54. See Duchamp's statement made in conversation with Jean Schuster in 1955 (Schuster, "Marcel Duchamp vite," 145).
55. Roberts, "I Propose to Strain the Laws of Physics," 63.
56. The poem first appeared in the magazine *Cosmopolis* 6, no. 17 (May 1897). On the significance of Mallarmé's poetry for Duchamp, see Cabanne, *Dialogues with Marcel Duchamp*, 30; Hassold, "The Possibilities of Chance"; Molly Nesbit and Naomi Sawelson-Gorse, "Concept of Nothing."
57. Paz, *Marcel Duchamp ou le château de la pureté*, 83.
58. On the *Bottlerack* and the *Bicycle Wheel* as "sculptures toute-faites," see Duchamp, *Selected Correspondence*, 43.
59. See Molderings, "Ästhetik des Möglichen," 124–27.
60. Sanouillet and Peterson, *The Writings of Marcel Duchamp*, 73. Sanouillet, *Duchamp du signe*, 104: "Possible. *La figuration d'un possible.* (pas comme contraire d'impossible ni comme relatif à probable ni comme subordonné à vraisamblable). Le *possible* est seulement un '*mordant*' *physique* [gerne vitriol] brûlant toute esthétique ou callistique." "Le callistique" (callistics) is an ironic neologism of Duchamp's, based on the Greek work "*kállos*" (beauty) and the analogy with "ballistics."
61. See *Marcel Duchamp dans les collections du Centre Georges Pompidou*, no. 5a, 26–27. Concerning the history of publication of this note see ibid., 28–29; and Vanpeene: "Introduction à 'POSSIBLE.'"
62. "Le possible impliquant le devenir—le passage de l'un à l'autre a lieu dans l'infra mince" (Duchamp, *Duchamp, Notes*, no. 1). This note reads

like a marginal annotation of Henri Bergson's essay *Le Possible et le réel* of 1930, which was published in the collection of essays *La Pensée et le mouvant* in 1934. By reason of the link between the idea of the "possible" with that of the "infra-mince," Duchamp's note can be dated to the end of the 1930s.

63. Duchamp remembered the title wrongly as "Le Moi et sa propriété." The correct French title is "L'Unique et sa propriété."

8. RADICAL INDIVIDUALISM

1. The connections between the 3 *Standard Stoppages* and the philosophy of Max Stirner were first investigated by Naumann in *The Mary and William Sisler Collection*, 170–71. See also Naumann, "Aesthetic Anarchy," 58–62; Naumann, "Marcel Duchamp: A Reconciliation of Opposites," 53; as well as Décimo, *Marcel Duchamp mis à nu*, 113, 209.
2. See Rey, *La Philosophie moderne*.
3. Asked by Serge Stauffer in 1960, "Y a-t-il un philosophe ou une philosophie qui ont particulièrement retenu votre attention (Max Stirner par exemple?)," Duchamp replied: "Oui, au moins son 'Unique et sa propriété'" (Stauffer, *Marcel Duchamp. Die Schriften*, 290: question no. 96). Cf. Duchamp's almost identically worded statement in his interview with Harriet and Carroll Janis in 1945, quoted in Naumann, "Aesthetic Anarchy," 61.
4. On the significance of Pyrrhon of Elis for Duchamp's thinking, see McEvilley, "Empyrrhical Thinking," 122–24; Molderings, *Marcel Duchamp*, 96–98; Molderings, "Objects of Modern Skepticism," 273–74. Pyrrhon's theories are also mentioned in Stirner, *The Ego and Its Own*, 26.
5. Max Stirner, *L'Unique et sa propriété*, trans. (to French) and intro. Henri Lasvignes (Paris: Éditions de "la Revue Blanche," 1900); another French translation by Robert-L. Reclaire was published at the same time by P.-V. Stock, *Bibliothèque sociologigue*, no. 28; four chapters of *The Ego and Its Own* had previously been published in the review *Mercure de France* between May 1894 and May 1895. See Le Rider, *Nietzsche in Frankreich*, 50.
6. See also L'Aminot, "Max Stirner im Ausland"; Guérin, *Ni dieu ni maître*, esp. 12–14. In France at the turn of the century Stirner was anything but an "obscure German philosopher," as Naumann describes him in his

book *Marcel Duchamp: The Art of Making Art in the Age of Mechanical Reproduction* (46).
7. On the manifesto and history of the magazine *L'Anarchie*, see Parry, *The Bonnot Gang*, 21–32.
8. Advertised as "des témoignages de nos tendances essentiellement individualistes et anarchiquement idéalistes," the only art books offered by the *L'Action d'art* bookshop, when it opened in July 1913, were Gleizes and Metzinger's *Du Cubisme* and Apollinaire's *Les Peintres cubistes*. Cf. *L'Action d'art*, no. 9 (25 July 1913): 4. On the connections between the authors of *L'Action d'art* and the painters of Puteaux, see Antliff, *Inventing Bergson*, 136. and Antliff and Leighten, *Cubism and Culture*, 130. Among the attentive readers of this magazine at the time was the young André Breton. See Bonnet, *André Breton*, 51–54.
9. See Lacaze-Duthiers, *La Tour d'ivoire vivante*; and Antliff and Leighten, *Cubism and Culture*, 136, 140.
10. In "Les Poètes réfractaires. II. Vivre son rêve," André Colomer writes: "La société est le règne des médiocres" (*L'Action d'art*, no. 9 [25 July 1913]: 3). See also Gérard de Lacaze-Duthiers, *Le Culte de l'idéal ou l'aristocratie*; Lacaze-Duthiers, *Vers l'aristocratie*; and Palante, *L'Individualisme aristocratique*.
11. Cf. *L'Action d'art*, 6, 10 mai 1913, 2–3. Bonnot was at that time the most notorious leader of a gang of anarchists that specialized in hold-ups and robberies. He was killed during one of their robberies in 1913.
12. Quoted, in translation, from Colomer, "Les Poètes réfractaires. II," 3. The original French text reads: "l'eclosion d'une individualité avide de se parfaire d'une personnalité vers sa réalisation la plus harmonieuse, l'affirmation d'un être, d'une âme qui se veut dans toute sa force personnelle."
13. Colomer, "Aux Sources de l'Héroisme Individualiste. III," 2. The original French text reads: "Ils le bornent étroitement, ils le confinent à une activité toute théorique, à une activité de luxe pour ainsi dire."
14. Colomer, "Les Poètes réfractaires. II," 3. The original French text reads: "S'il écrit, s'il chante, s'il peint, s'il sculpte, ce n'est pas pour réaliser des œuvres dont sa patrie ou l'humanité, ou la société pourront le récompenser, c'est pour se réaliser lui-même."

15. Quoted, in translation, from Lacaze-Duthiers, "L'Individualisme esthétique." The original French text reads: "Sa vie est son œuvre même.... L'art est la révolte au sens le plus élevé."
16. Quoted, in translation, from Drot, *Jeu d'échecs avec Marcel Duchamp*.
17. Marcel Duchamp, interview with Jean Antoine, RTBF, summer 1966; quoted from Rose, "Life Is a Game; Life Is Art." The original French statement went as follows: "J'ai voulu . . . me servir de l'art comme pour établir un *modus vivendi*, une sorte de façon de comprendre la vie, c'est-a-dire probablement d'essayer de faire de ma vie elle-même une œuvre d'art, au lieu de passer ma vie à faire des œuvres d'art sous forme de tableaux, sous forme des sculptures."
18. Sanouillet and Peterson, *The Writings of Marcel Duchamp*, 74. The original note reads: "Peut-on faire des œuvres qui ne soient pas 'd'art'?" (Sanouillet, *Duchamp du signe*, 105).
19. Ashton, "An Interview with Marcel Duchamp," 247.
20. In 1965, when interviewed by Don Morrison of the *Minneapolis Star* about the Readymades, Duchamp said: "I don't like the word 'anti'. They are an-art or non-art." Quoted in Duchamp, "Ephemerides," 18 October [1965]. Cf. also Drot, *Jeu d'échecs avec Marcel Duchamp*.
21. Quoted, in translation, from Rougemont, "Marcel Duchamp mine de rien," 43. The original French text reads: "Les masses sont inéducables. Elles nous détestent et nous tueraient volontiers. Ce sont les imbéciles qui, en se liguant contre les individus libres et inventifs, solidifient ce qu'ils appellent la réalité, le monde 'matériel' tel que nous le souffrons. . . . C'est ce même monde que la science, ensuite, observe, et dont elle décrète les prétendues lois. Mais tout l'effort de l'avenir sera d'inventer, par réaction à ce qui se passe maintenant, le silence, la lenteur, la solitude. Aujourd'hui on nous traque."
22. Quoted, in translation, from Charbonnier, *Entretiens avec Marcel Duchamp*, 55
23. See Bernheim, *Picabia*, 26–28.
24. Buffet-Picabia, *Rencontres*, 37.
25. See Leighten, *Re-Ordering the Universe*, 53–69.
26. See *L'Action d'art*, no. 4 (1 April 1913): 1. Cf. also Leighten, *Re-Ordering the Universe*, 53–69.
27. Buffet-Picabia, "Some Memories of Pre-Dada," 257.

28. See Fleming (ed.), *Max Stirners "Der Einzige und sein Eigentum" im Spiegel der zeitgenössischen deutschen Kritik*.
29. See Laska, *Ein dauerhafter Dissident*.
30. See Safranski, *Nietzsche: A Philosophical Biography*, 125; see also Deleuze, *Nietzsche et la philosophie*, 183–86; Anselm Ruest [Ernst Samuel], *Max Stirner*, 287–303; and Ruest, "Stirner und Nietzsche. Ein Vorwort," 916–17. I wish to thank Kurt W. Fleming, director of the Max Stirner Archive in Leipzig, for having furnished me with important research documents on Stirner.
31. Safranski, *Nietzsche: A Philosophical Biography*, 125.
32. Ibid., 127.
33. Friedrich Nietzsche, *On Truth and Lies in an Extra-Moral Sense*, fragment, 1873, from the *Nachlass*, compiled from translations by Walter Kaufmann and Daniel Breazeale, text amended in part by The Nietzsche Channel, http:/www.geocities.com/thenietzschechannel/tls.htm?200820 (see chapter 7, note 27). "Was ist also Wahrheit? Ein bewegliches Heer von Metaphern, Metonymien, Anthropomorphismen, kurz eine Summe von menschlichen Relationen, die, poetisch und rhetorisch gesteigert, übertragen, geschmückt wurden, und die nach langem Gebrauche einem Volke fest, canonisch und verbindlich dünken; die Wahrheiten sind Illusionen, von denen man vergessen hat, dass sie welche sind" (Nietzsche, *Über Wahrheit und Lüge*, 374 [30–35]–375 [1–3]).
34. Gold, "A Discussion," no. 23.
35. Seitz, "What's Happened to Art?" 113.
36. Stirner, *The Ego and Its Own*, 5. The title of the introduction is the first line of Goethe's poem "Vanitas! Vanitatum Vanitas" ("Ich hab' mein Sach' auf Nichts gestellt") and has been freely translated in the English edition quoted here as "All Things Are Nothing to Me." See editor's notes 2 and 301, 326, and 376.
37. Ibid., 7.
38. Duchamp in conversation with G. H. Hamilton and R. Hamilton, 1959. Quoted from audio cassette, *Audio Arts Magazine* 2, no. 4 (1975).
39. The book was among the few that were found in Duchamp's estate. Published by Jean-Jacques Pauvert, the new edition of *L'Unique et sa propriété* was a reprint of R. Reclaire's translation of 1900. On Duchamp's purchase of the book, see Stauffer: "Du Coq à l'Âne mit Marcel

Duchamp," in *Marcel Duchamp Die Schriften*, 301. According to the memoirs of the New York surrealist dealer Julien Levy, Duchamp had already recommended Stirner's book to the painter Matta Echaurren in the 1940s: "Once Duchamp suggested a book for him to read, the *Ego and Its Own* by Max Stirner. This rather thin distillation of complete nihilism from Nietzsche [*sic*] became Matta's unprofitable Bible" (*Memoir of an Art Gallery*, 248).

40. Quoted from Janis and Janis, "Marcel Duchamp, Anti-Artist," 24. Cf. also Gold, "A Discussion," no. 1: "Problems of the mind reduce to tautologies. Our talk about them adds nothing."
41. Stirner, *The Ego and Its Own*, 324.
42. Quoted, in translation, from Drot, *Jeu d'échecs avec Marcel Duchamp*. See also Seitz, "What Happened to Art?" 113.
43. D'Harnoncourt and McShine, *Marcel Duchamp*, 273.
44. Quoted from Tomkins, *Ahead of the Game*, 36.
45. In the year of the symposium, Duchamp wrote to his Swiss admirer and translator, Serge Stauffer: "Stirner is a 'grand bonhomme', whom one perhaps does not know at all in Germany . . . ? . . . Stirner meant something else than anarchism, although people confuse him with it and fight against him in its name" (*Marcel Duchamp. Die Schriften*, 301). How familiar Duchamp's friends were with Stirner's ideas is evidenced by an article by Patrick Waldberg, in which Duchamp is presented as the embodiment of Stirner's "unique" ("Marcel Duchamp l'unique").
46. Quoted from Duchamp, "Ephemerides," Friday, 1960, Hempstead.
47. Ibid. Cf. also Duchamp's statement of 1963: "I wanted to get rid of the herd instinct in artists; to individualize, to singularize, is what every artist should do instead of going toward mass production as we do today" (Roberts, "I Want to Strain the Laws of Physics," 47).
48. Quoted from Duchamp, "Ephemerides," Friday, 1960, Hempstead. See Duchamp's identically worded statements in Ashton, "An Interview with Marcel Duchamp," 246.
49. Poincaré, *The Foundations of Science*, 207, 209.
50. Ibid., 209.
51. Ibid., 207.
52. Ibid., 208.

53. Heisenberg, "Die Bedeutung des Schönen in der exakten Naturwissenschaft" (1971), reprint, in Heisenberg, *Quantentheorie und Philosophie*, 103; see also 40–41.
54. Poincaré, *The Foundations of Science*, 391; see also 392–93.
55. Ibid., 102.
56. Lyotard, *Les TRANSformateurs Duchamp*, esp. 29–31.
57. Cf. Gilles Deleuze and Felix Guattari, *Anti-Oedipus*, 17–19.
58. See Gilles Deleuze, *The Logic of Sense*, 69–85. See also Balke, "Den Zufall denken."
59. Rorty, *Contingency, Irony, and Solidarity*, 22. On the correspondences between Duchamp's aesthetic and Rorty's philosophy, see Molderings, "Relativism and a Historical Sense," 15–16.
60. Roberts, "I Propose to Strain the Laws of Physics," 63.
61. Quoted from Sweeney in Sanouillet and Peterson, *The Writings of Marcel Duchamp*, 125.
62. Cabanne, *Dialogues with Marcel Duchamp*, 39.
63. Cf. Clair, *Sur Marcel Duchamp et la fin de l'art*.
64. Constable, *Discourses on Art*, 66. See also Lambert, *John Constable and the Theory of Landscape Painting*, 55–60.
65. Ashton, "An Interview with Marcel Duchamp," 198.

BIBLIOGRAPHY

Abbott, Edwin A. *Flatland: A Romance of Many Dimensions*. London, 1884.
Adcock, Craig E. "Conventionalism in Henri Poincaré and Marcel Duchamp." *Art Journal* 44, no. 3 (1984): 249–58.
——. *Marcel Duchamp's Notes from the Large Glass: An N-Dimensional Analysis*. Ann Arbor, Mich.: UMI Research Press, 1983.
Alberti, Leon Battista. *Opere volgari*. Vol. 3. Ed. Cecil Grayson. Bari: Giuseppe Laterza & Figli, 1973.
Anastasi, William. "Duchamp on the Alfred Jarry Road." *Artforum* 30 (1991): 86–90.
Antliff, Mark. *The Culture of Revolt: Art and Anarchism in America, 1908–1920*. Ann Arbor: UMI, 1998.
——. *Inventing Bergson: Bergson, Cultural Politics, and the Parisian Avant-garde*. Princeton, N.J.: Princeton University Press, 1993.
Antliff, Mark, and Patricia Leighten. *Cubism and Culture*. London: Thames & Hudson, 2001.
Apollinaire, Guillaume. *Alcools. Poèmes, 1898–1913*. Paris: Mercure de France, 1913.
——. *Chroniques d'art, 1902–1918*. Comp. and notes by L.-C. Breunig. Paris: Gallimard, 1960.
——. *The Cubist Painters: Aesthetic Meditations, 1913*. Trans. Lionel Abel. The Documents of Modern Art 1. New York: George Wittenborn, 1962.
——. *Méditations esthétiques. Les peintres cubistes*. Ed. and annot. L.-C. Breunig and J.-Cl. Chevalier. Paris: Hermann, 1980.
"Artist Marcel Duchamp Visits U-Classes, Exhibits at Walker." *Minnesota Daily*, October 22, 1965.
Ashton, Dore. "An Interview with Marcel Duchamp." *Studio International* 171, no. 878 (June 1966): 244–47.
Audretsch, J., and K. Mainzer. *Wieviele Leben hat Schrödingers Katze. Zur*

Physik und Philosophie der Quantenmechanik. Mannheim: B.I. Wissenschaftsverlag, 1990.

Audureau, Éric. "Le Conventionalisme, conséquence de l'intuitionisme." In *Poincaré et la théorie de la connaissance*, ed. Audureau, *Philosophiques* 1 (Spring 2004): 57–88

———, ed. *Poincaré et la théorie de la connaissance. Philosophiques* 1 (Spring 2004): 3–289.

Balke, Friedrich. "Den Zufall denken. Das Problem der Aleatorik in der zeitgenössischen französischen Philosophie." In *Die Künste des Zufalls*, ed. Peter Gendolla and Thomas Kamphusmann, 48–77. Frankfurt: Suhrkamp, 1999.

Barberousse, Anouk. "Le Nouveau visage du hasard." In *Le Moment 1900 en philosophie*, ed. Frédéric Worms, 189–96. Lilleneuve d'Ascq: Presses Universitaires du Septentrion, 2004.

Barr, Alfred H., Jr. *Fantastic Art Dada Surrealism*. New York: The Museum of Modern Art, 1936.

Basch, Victor: *L'Individualisme anarchiste. Max Stirner*. Paris: Alcan, 1904.

Beier, Lucia. "The Time Machine: A Bergsonian Approach to the 'Large Glass.'" *Gazette des Beaux-Arts* 88 (November 1976): 194–200.

Bergson, Henri. *La Pensée et le mouvant*. Paris: Librairie Félix Alcan, 1934.

Bergson, Henri, Charles Poincaré, Gide, et al. *Le Matérialisme actuel*. Paris: Flammarion, 1913.

Bernheim, Cathy. *Picabia*. Paris: Éditions du Félin, 1995.

Betancourt, Michael. "Chance Operations/Limiting Frameworks: Sensitive Dependence on Initial Conditions." *Tout-fait: The Marcel Duchamp Studies Online Journal* 2, no. 4 (January 2002).

Bianquis, Geneviève. *Nietzsche en France. L'Influence de Nietzsche sur la pensée française*. Paris: Félix Alcan, 1929.

Boehm, Gottfried. "Zwischen Auge und Hand. Bilder als Instrumente der Erkenntnis." In *Konstruktionen Sichtbarkeiten*, ed. Jörg Huber and Martin Heller, 215–27. Interventionen 8. Vienna: Springer, 1999.

Boniface, Jacqueline "Poincaré et le principe d'induction." In *Poincaré et la théorie de la connaissance*, ed. Éric Audureau, *Philosophiques* 1 (Spring 2004): 131–49.

Bonnet, Marguerite. *André Breton. Naissance de l'aventure surréaliste*. Paris: José Corti, 1975

Borel, Émile. *Le Hasard*. Paris: Félix Alcan, 1914.

Bosse, Abraham. *Manière universelle de M. Desargues pour pratiquer la perspective par Petit-Pied comme le Géométral. Ensemble les places et proportions des Fortes & Foibles touches, Teintes ou couleurs.* Paris: Pierre Deshayes, 1647.

Bottazini, Umberto. *Poincaré, philosophe et mathématicien.* Paris: Pour la Science, 2000.

Boucher, Maurice. *Essai sur l'Hyperespace. Le Temps, la matière, et l'énergie.* Paris: Félix Alcan, 1903.

———. *Introduction à la géométrie à quatre dimensions d'après les méthodes de la géométrie élémentaire.* Paris: Librairie scientifique A. Hermann et fils, 1917.

Bourbaki, Nicolas. *Éléments d'histoire des mathématiques.* Paris: Masson, 1984.

Bourgeois, Bernard. "La Société des philosophes en France en 1900." In *Le Moment 1900 en philosophie*, ed. Frédéric Worms, 63–79. Lilleneuve d'Ascq: Presses Universitaires du Septentrion, 2004.

Brenner, Anastasios. "Le Conventionalisme: Crise de la physique et réflexion philosophique (Poincaré, Duhem, Le Roy)." In *Le Moment 1900 en philosophie*, ed. Frédéric Worms, 227–35. Lilleneuve d'Ascq: Presses Universitaires du Septentrion, 2004.

———. "The French Connection: Conventionalism and the Vienna circle." In *History of Philosophy of Science: New Trends and Perspectives*, ed. Michael Heidelberger and Friedrich Stadler, 277–86. Dordrecht: Kluwer Academic Publishers 2002.

Brown, James Robertson. *The Laboratory of the Mind: Thought Experiments in the Natural Sciences.* London: Routledge, 1991.

Breuil, Jean du. *La Perspective pratique nécessaire à tous les peintres, graveurs, sculpteurs, architectes, orfevres, brodeurs, tapissiers, et autres qui se meslent à dessiner par un réligieux de la Compagnie de Iésus.* 3 vols. Paris: M. Tavernier et F. Langlois, 1642–1649.

Buffet, Gabrielle: "Coeurs volants." *Cahiers d'art* 11 (1936): 34–44.

Buffet-Picabia, Gabrielle. *Aires abstraites.* Geneva: Pierre Cailler Éditeur, 1957.

———. *Rencontres avec Picabia, Apollinaire, Cravan, Duchamp, Calder.* Paris: Belfond, 1977.

———. "Some Memories of Pre-Dada: Picabia and Duchamp." 1949. In *The Dada Painters and Poets*, ed. Robert Motherwell, 255–67. The Documents of Modern Art, no. 8. New York: George Wittenborn, 1951.

Buskirk, Martha, and Mignon Nixon, eds. *The Duchamp Effect: Essays, Interviews, Round Table.* An October Book. Cambridge, Mass.: The MIT Press, 1996.

Cabanne, Pierre. *Dialogues with Marcel Duchamp*. Trans. Ron Padgett. New York: Viking Press, 1971.

Camerota, Filippo. "Renaissance Descriptive Geometry: The Codification of Drawing Methods." In *Picturing Machines, 1400–1700*, ed. Wolfgang Lefêvre, 175–208. Cambridge, Mass.: The MIT Press, 2004.

Camhi, Leslie. "Did Duchamp Deceive Us?" *Art News* (February 1999): 98–102.

Charbonnier, Georges. *Entretiens avec Marcel Duchamp*. (1960/1961). Marseille: André Dimanche, 1994.

Cigoli, Ludovico Cardi da. *Trattato practivo di prospettiva di Ludovico Cardo detto il cigoli*. Ed. R. Profumo. Rome: Bonsognori, 1992.

Chilvers, Ian, and Harold Osborne. *The Oxford Dictionary of Art*. Oxford: Oxford University Press, 1988

Clair, Jean. *Duchamp et la photographie*. Paris: Chêne, 1977.

———, ed. *Marcel Duchamp: Tradition de la rupture ou rupture de la tradition?* Centre culturel international de Cérisy-La-Salle. Paris: Union générale d'éditions, 1979.

———. *Marcel Duchamp et la fin de l'art*. Paris: Gallimard, 2000.

Cohnitz, Daniel. *Gedankenexperimente in der Philosophie*. Paderborn: Mentis Verlag 2006.

Colomer, André. "Aux Sources de l'Héroisme Individualiste. M. Bergson et les 'Jeunes Gens d'aujourd'hui.'" *L'Action d'art*, no. 2 (1 March 1913): 1–2.

———. "Aux Sources de l'Héroisme Individualiste. III. La Science & l'Intuition: Leurs rôles dans l'individualisme." *L'Action d'art*, no. 6 (10 May 1913): 2–3.

———. "Les Poètes réfractaires. II. Vivre son rêve." *L'Action d'art*, no. 9 (25 July 1913): 3.

Constable, John. *John Constable's Discourses on Art*. Ed. Ronald B. Becket. Suffolk Records Society, vol. 14. Ipswich: Suffolk Records Society, 1970.

Coy, Wolfgang. "Berechenbares Chaos." In *Die Künste des Zufalls*, ed. Peter Gendolla and Thomas Kamphusmann, 34–47. Frankfurt: Suhrkamp, 1999.

Croco, Gabriella. "Intuition, construction, et convention de Poincaré." In *Poincaré et la théorie de la connaissance*, ed. Éric Audureau, *Philosophiques* 1 (Spring 2004): 151–77.

Daniels, Dieter. *Duchamp und die anderen. Der Modellfall einer künstlerischen Wirkungsgeschichte in der Moderne*. Cologne: DuMont Buchverlag, 1992.

Dantzig, Tobias. *Henri Poincaré: Critic of Crisis. Reflections on His Universe of Discourse.* New York: Charles Scribner's Sons, 1954.

Davies, Bowdoin, Jr. *Duchamp: Domestic Patterns, Covers, and Threads.* New York: Midmarch Arts Press, 2002.

Da Vinci, Leonardo. *I manoscritti di Leonardo da Vinci: Il codice A (2172) nell'istituto di Francia.* Rome: Libreria dello Stato, 1936–1938.

Décimo, Marc. *La Bibliothèque de Marcel Duchamp, peut-être.* Paris: Les Presses du Réel, 2002.

——. "Marcel Duchamp et Jean-Pierre Brisset: Deux artistes en leur genre." *Étant donné Marcel Duchamp* 4 (2002): 31–51.

——. *Marcel Duchamp mis à nu. A propos du processus créatif.* Dijon: Les Presses du Réel, 2004.

——. *Maurice Princet. Le mathématicien du Cubisme.* Pairs: L'Échoppe, 2006.

De Duve, Thierry. *Pictorial Nominalism: On Marcel Duchamp's Passage from Painting to the Readymade.* Trans. Dana Polan. Minneapolis: University of Minnesota Press, 2005.

——, ed. *The Definitively Unfinished Marcel Duchamp.* Cambridge, Mass.: The MIT Press, 1991.

Dee, John. "Ce Façonnement symétrique." In *Marcel Duchamp: Tradition de la rupture ou rupture de la tradition?* ed. Jean Clair, 351–97. Colloque de Cérisy-la-Salle. Paris: Union générale d'éditions, 1979

Deleuze, Gilles. *The Logic of Sense.* London: Continuum, 2004.

——. *Nietzsche et la philosophie.* Paris: Presses universitaires de France, 1962.

Deleuze, Gilles, and Félix Guattari: *Anti-Oedipus: Capitalism and Schizophrenia.* London: Penguin, 2009.

Denis, Maurice. "Définition du Néo-Traditionnisme." *Art et critique*, 23 and 30 August 1898. In *Du Symbolisme au Classicisme*, 33–46. Paris: Hermann, 1964.

Deutsches Museum von Meisterwerken der Naturwissenschaft und Technik. Führer durch die Sammlungen der Abteilung I: München, Maximilianstrafse 26. Munich: B.G. Teubner, [1907].

d'Harnoncourt, Anne, and W. Hopps. *Étant donnés: 1° la chute d'eau 2° le gaz d'éclairage . . . Reflections on an New Work by Marcel Duchamp.* Philadelphia: Philadelphia Museum of Art, 1987.

d'Harnoncourt, Anne, and Kynaston McShine, eds. *Marcel Duchamp.* New York: The Museum of Modern Art, 1974; Philadelphia: Philadelphia Museum of Art, 1974.

Dictionnaire abrégé du Surréalisme. Paris: Galérie des Beaux Arts, 1938.

Didi-Hubermann, Georges, and Laurent Mannoni. *Mouvements de l'air. Étienne-Jules Marey, Photographies des fluides*. Paris: Gallimard, 2004.

Drot, Jean-Marie. *Jeu d'échecs avec Marcel Duchamp*. TV film. Pasadena and New York, 1963. Broadcast on 8 June 1964 (ORTV). VHS version with English subtitles: *Marcel Duchamp: A Game of Chess*, Phaidon Video, London, 1995.

Duchamp, Marcel. *Affect^t Marcel: The Selected Correspondence of Marcel Duchamp*. Ed. Francis M. Naumann and Hector Obalk. London: Thames & Hudson, 2000.

———. *A l'Infinitif*. New York: Cordier & Ekstrom, 1967.

———. *The Almost Complete Works of Marcel Duchamp*. Exh. cat. London: Tate Gallery, 1966.

———. *The Bride Stripped Bare by Her Bachelors, Even*. A typographic version by Richard Hamilton of Marcel Duchamp's *Green Box*, trans. George Heard Hamilton. London: Percy Lund, Humphries and Co., George Wittenborn, 1960.

———. "Chronology: Certain Facts of and About Marcel Duchamp." In *By or of Marcel Duchamp or Rrose Sélavy: A Retrospective Exhibition*. Exh. cat., unpaged. Pasadena: Pasadena Art Museum, 1963.

———. "Ephemerides on and About Marcel Duchamp and Rrose Sélavy, 1887–1968." By Jennifer Gough-Cooper and Jacques Caumont. In *Marcel Duchamp Work and Life*, ed. Pontus Hulten, unpaged. Cambridge, Mass.: The MIT Press, 1993; London: Thames and Hudson, 1993.

———. *Lettres à Marcel Jean de Marcel Duchamp/Letters to Marcel Jean from Marcel Duchamp*. Munich: Silke Schreiber, 1987.

———. *Marcel Duchamp dans les collections du Centre Georges Pompidou, Musée national d'art moderne*. Collection Catalogue. Paris: Centre National d'Art et de Culture Georges Pompidou, 2001.

———. *Marcel Duchamp, Notes*. Ed. Paul Matisse. Paris: Centre National d'Art et de Culture Georges Pompidou, 1980.

———. *Marcel Duchamp: The Portable Museum*. Inventory of an edition by Ecke Bonk. Trans. David Britt. London: Thames and Hudson, 1989.

———. *Not Seen and/or Less Seen of/by Marcel Duchamp/Rrose Sélavy, 1906–1964*. Exh. cat. New York: Cordier & Ekstrom, 1965.

———. *L'Oeuvre de Marcel Duchamp*. Exh. cat. 4 vols. Paris: Musée National d'Art Moderne, Centre Georges Pompidou, 1977.

Duchamp, Marcel, and André Breton. *Le Surrealisme en 1947. Exposition Internationale du Surréalisme*. Paris: Maeght, 1947.

Dürer, Albrecht. *The Painter's Manual: A Manual of Measurement of Lines, Areas, and Solids by Means of Compass and Ruler*. Trans. and comm. Walter L. Strauss. New York: Abaris, 1977.

Edwards, Hugh, comp. *Surrealism and Its Affinities: The Mary Reynolds Collection*. Chicago: The Art Institute of Chicago 1973.

Fink, Eugen. *Spiel als Weltsymbol*. Stuttgart: W. Kohlhammer, 1960.

Fischer, Ernst Peter. *An den Grenzen des Denkens. Wolfgang Pauli—Ein Nobelpreisträger über die Grenzen der Wissenschaft*. Freiburg: Herder, 2000.

Fleming, Kurt W., ed. "Max Stirners *Der Einzige und sein Eigentum* im Spiegel der zeitgenössischen deutschen Kritik." *Stirneriana*, Heft 20. Leipzig: Max-Stirner-Archiv, 2001.

———, ed. "Max Stirner und Friedrich Nietzsche." *Der Einzige: Vierteljahresschrift des Max-Stirner-Archivs Leipzig* 4, no. 16 (2001).

Foucault, Michel. *Raymond Roussel*. Paris: nrf, 1963.

Franklin, Paul B. "Coming of Age with Marcel: An Interview with Jean-Jacques Lebel." *Étant donné Marcel Duchamp* 7 (2006): 11–29.

———. "A Whodunit." *Étant donné Marcel Duchamp* 8 (2007): 158–63.

Frizot, Michel, *Étienne-Jules Marey Chronophotographe*. Paris: Nathan/Delpire, 2001.

Galison, Peter. *Einstein's Clock, Poincaré's Maps: Empires of Time*. New York: Norton, 2003.

Gendolla, Peter, and Thomas Kamphusmann, eds. *Die Künste des Zufalls*. Frankfurt: Suhrkamp, 1999.

Gerstner, Karl. *Marcel Duchamp: Tu m'*. Ostfildern-Ruit: Cantz, 2003.

Gervais, André. *C'est. Marcel Duchamp dans la "fantasie heuereuse de l'histoire."* Nimes: Jacqueline Cambon, 2000.

———. "Connections: Of Art and Arrhe." In *The Definitively Unfinished Marcel Duchamp*, ed. Thierry de Duve, 397–425. Cambridge, Mass.: The MIT Press, 1991.

———. *La Raie alitée d'effets. A propos of Marcel Duchamp*. Ville La Salle, Québec: Editions Hurtubis HMH, 1984.

Giedymin, Jerzy. *Science and Convention: Essays on Poincaré's Philosophy of Science and the Conventionalist Tradition*. Oxford: Pergamon Press, 1982.

Gilles, Joël. "Duchamp au bouchon." *Étant donné Marcel Duchamp* 5 (2003): 127–33.

Girst, Thomas. "Duchamp's Window Display for André Breton's *Le Surréalisme et la Peinture* (1945)." *Tout-fait: The Marcel Duchamp Studies Online Journal* 2, no. 4 (2002).

Giunti, Roberto. "R. rO. S. E. Sel. A. Vy." *Tout-fait: The Marcel Duchamp Studies Online Journal* 2, no. 4 (2002).

Gleizes, Albert. *Kubismus*. 1928. Mainz: Florian Kupferberg, 1980.

Gleizes, Albert, and Jean Metzinger. *Du Cubisme*. Paris: Figuiere et Cie, 1912. Reprint: Paris: Éditions Présence, 1980.

Gold, Laurence Stephen. "A Discussion of Marcel Duchamp's Views on the Nature of Reality and Their Relation to the Course of His Artistic Career." Bachelor's thesis, Princeton University, 1958.

Goldaine, Louis, and Pierre Astier. *Ces Peintres vous parlent*. Paris: Ed. du Temple, 1964.

Greffe, Jean-Louis, Gerhard Heinzmann, and Kuno Lorenz, eds. *Henri Poincaré. Science et philosophie. Science and Philosophy. Wissenschaft und Philosophie*. Berlin: Akademie Verlag; Paris: Albert Blanchard, 1996.

Grössel, Hans, ed. *Raymond Roussel. Eine Dokumentation*. Munich: edition text + kritik, 1977.

Grupen, C. "Die Natur des Zufalls." In *Die Künste des Zufalls*, ed. Peter Gendolla and Thomas Kamphusmann, 15–33. Frankfurt: Suhrkamp, 1999.

Guérin, Daniel. *Ni dieu ni maître. Anthologie de l'anarchisme, I*. Paris: François Maspero, 1999.

Hamilton, George Heard. "Duchamp Duchamp-Villon Villon." *Bulletin of the Associates in Fine Arts at Yale University* 13, no. 2 (1945): 1–8.

Hassold, C. "The Possibilities of Chance: A Comparative Study of Stéphane Mallarmé and Marcel Duchamp." Ph.D. diss., Florida State University 1972.

Heidelberger, Michael, and Friedrich Stadler, eds., *History of Philosophy of Science: New Trends and Perspectives*. Dordrecht: Kluwer Academic Publishers 2002.

Heisenberg, Werner. *Quantentheorie und Philosophie*. Stuttgart: Reclam, 1979.

Henderson, Linda D. *Duchamp in Context: Science and Technology in the Large Glass and Related Works*. Princeton, N.J.: Princeton University Press, 1998.

———. *The Fourth Dimension and Non-Euclidean Geometry in Modern Art*. Princeton, N.J.: Princeton University Press, 1983.

———. "A New Facet of Cubism: 'The Fourth Dimension' and 'Non-Euclidean Geometry' Re-Interpreted." *The Art Quarterly* 34, no. 4 (1971): 411–33.

———. "Uncertainty, Chaos, and Chance in Early Twentieth-Century Art: The Cases of Wassily Kandinsky and Marcel Duchamp." *Étant donné Marcel Duchamp* 4 (2002): 131–45.

Herbert, Robert L. *Modern Artists on Art*. Englewood Cliffs, N.J.: Prentice-Hall, 1964.

Herbert, Robert L., Eleanor S. Apter, and Elise K. Kenney, eds. *The Société Anonyme and the Dreier Bequest at Yale University. A Catalogue Raisonné*. Collection catalogue. New Haven, Conn.: Yale University Art Gallery, 1984.

Hogrebe, Wolfram. *Echo des Nichtwissens*. Berlin: Akademie-Verlag, 2005.

Holeczek, Bernhard, and Linda von Mengden: *Zufall als Prinzip. Spielwelt, Methode und System in der Kunst des 20. Jahrhunderts*. Exh. cat. Ludwigshafen: Wilhelm-Hack-Museum, Heidelberg, 1992.

Holton, Gerald: "Henri Poincaré, Marcel Duchamp, and Innovation in Science and Art." *Leonardo*, no. 2 (2001): 127–34.

Huber, Renate. *Einstein und Poincaré. Die philosophische Beurteilung physikalischer Theorien*. Paderborn: Mentis, 2000.

Hugnet, Georges. "L'Esprit Dada dans la peinture (I)." *Cahiers d'art*, no. 1–2 (1932): 57–65.

Jacques Villon, Raymond Duchamp-Villon, Marcel Duchamp. Exh. Cat. New York: Solomon R. Guggenheim Museum, New York and Houston, Museum of Fine Arts, 1957.

James, Carol. "Duchamp's Silent Noise/Music for the Deaf." In *Duchamp: Artist of the Century*, ed. Rudolf Kuenzli and Francis M. Naumann, 106–26. Cambridge, Mass.: The MIT Press, 1990.

Janecke, Christian. *Kunst und Zufall. Analyse und Bedeutung*. Nuremberg: Verlag für moderne Kunst, 1995.

Janis, Harriet, and Sidney Janis. "Marcel Duchamp, Anti-Artist." *View*, series 5, no. 1 (1945): 18–19, 21, 23–24, 53–54.

Jarry, Alfred. *Exploits and Opinions of Dr. Faustroll, Pataphysician*. Trans. Simon Watson Taylor. Cambridge, Mass.: Exact Change, 1996.

———. *Gestes et Opinions du Docteur Faustroll, Pataphysicien*. In *Oeuvres complètes*, vol. 1. Paris: Coll. Bibliothèque de la Pléiade, 1980.

Jean, Marcel. *Histoire de la peinture surréaliste*. Paris: Seuil, 1959.

Joselit, David. *Infinite Regress: Marcel Duchamp, 1910–1941*. Cambridge, Mass.: The MIT Press, 1997.

Jouffret, Esprit-Pascal. *Mèlanges de géométrie à quatre dimensions*. Paris: Gauthier-Villars, 1906.

---. *Traité élémentaire de géométrie à quatre dimensions et introduction à la géométrie à n dimensions*. Paris: Gauthier-Villars, 1903.

Jouffroy, Alain. "Conversation avec Marcel Duchamp." (New York, 1961). In *Marcel Duchamp*, 17–66. Paris: Centre Georges Pompidou and Dumerchez, 1997.

Kasner, Edward, and James Newman. *Mathematics and the Imagination*. New York: Simon and Schuster, 1940.

Kemp, Martin. *The Science of Art: Optical Themes in Western Art from Brunelleschi to Seurat*. New Haven, Conn.: Yale University Press, 1990.

Kienzler, Wolfgang. "Was ist ein Gedankenexperiment?" In *Kreativität*. XX. Deutscher Kongress für Philosophie, vol. 1., ed. Günter Abel, 447–55. Hamburg: Meiner 2006.

Krauss, Christel. "Der Begriff des hasard bei Paul Valéry. Theorie und dichterische Praxis." Doctoral diss. Heidelberg: Ruprecht-Karl-Universität, 1969.

Krauss, Rosalind E. "Notes on the Index: Part I." In *The Originality of the Avant-garde and Other Modernist Myths*, 196–209. Cambridge, Mass.: The MIT Press, 1986.

Kuenzli, Rudolf, and Francis M. Naumann, eds. *Marcel Duchamp: Artist of the Century*. Cambridge, Mass.: The MIT Press, 1990.

Kuh, Katharine. "Marcel Duchamp." In *The Artist's Voice: Talks with Seventeen Artists*, 81–93. New York: Harper & Row, 1962.

Lacaze-Duthiers, Gérard de. *Le Culte de l'idéal ou l'aristocratie*. Paris: Alcan, 1909.

---. "L'Individualisme esthétique et l'aristocratie." *L'Action d'art*, no. 13 (25 September 1913): 2.

---. *La Tour d'ivoire vivante*. Paris: Alcan, 1921.

---. *Vers l'aristocratie*. Paris: Éditions Action d'art, 1913.

Lambert, Ray. *John Constable and the Theory of Landscape Painting*. Cambridge: Cambridge University Press, 2005.

L'Aminot, Tanguy. "Max Stirner im Ausland: Frankreich." *Der Einzige. Vierteljahresschrift des Max Stirner-Archivs Leipzig*, no. 1/2 (9/10) (2000): 9–20.

Laska, Bernd A. *Ein dauerhafter Dissident. 150 Jahre Stirners 'Einziger'. Eine kurze Wirkungsgeschichte*. Nuremberg: LSR-Verlag, 1996.

Lebel, Jean-Jacques. "Mise au point (Picabia-Dynamo)." *La Quinzaine littéraire* (Paris), 1–15 October 1988, 6.

Lebel, Robert. *Sur Marcel Duchamp*. Paris: Trianon, 1959.

Lefêvre, Wolfgang, ed. *Picturing Machines, 1400–1700*. Cambridge, Mass.: The MIT Press, 2004.

Léger, Fernand. *Fonctions de la peinture*. Paris: Gallimard, 2004.

Leighten, Patricia. *Re-Ordering the Universe: Picasso and Anarchism, 1897–1914*. Princeton, N.J.: Princeton University Press, 1989.

Leja, Michael. *Looking Askance: Skepticism and American Art from Eakins to Duchamp*. Berkeley: University of California Press, 2004.

Leiris, Michel. "La Mariée mise à nu par ses Célibataires, même, par Marcel Duchamp." *La Nouvelle Revue Française*, no. 279 (December 1936): 1087–89.

Lenain, Thierry. "Le Dernier tableau de Marcel Duchamp. Du trompe l'oeil au regard désabusé." *Annales d'histoire de l'art et archéologie* (Brussels) 6 (1984): 79–104.

Le Penven, Françoise. *L'Art d'écrire de Marcel Duchamp: A propos de ses notes manuscrites*. Nimes: Jacqueline Chambon, 2003.

Le Rider, Jacques. *Nietzsche in Frankreich*. Munich: Wilhelm Fink, 1997

Le Roy, Édouard. *Une Philosophie nouvelle. Henri Bergson*. Third ed. Paris: Félix Alcan, 1913.

Lévy, Albert: *Stirner et Nietzsche*. Paris: Société nouvelle, 1904.

Levy, Julien. *Memoir of an Art Gallery*. New York: Putnam, 1977.

Linde, Ulf. "MARiée CELibataire." In *Marcel Duchamp: Readymades, Etc. (1913–1964)*, ed. Arturo Schwarz, 39–68. Milan: Galleria Schwarz; Paris: Le Terrain Vague, 1964.

Lyotard, Jean-François. *Les TRANSformateurs Duchamp*. Paris: Éditions Galilée, 1977.

Mallarmé, Stéphane. *Un Coup de dés jamais n'abolira le hasard*. Paris: Éditions de la Nouvelle Revue Française, 1914.

Marey, Étienne-Jules. *Movement*. Trans. Eric Pritchard. London: William Heinemann, 1895.

"Mary Reynolds and the Spirit of Surrealism." *The Art Institute of Chicago Museum Studies* 22, no. 2 (1996).

Masheck, Joseph, ed. *Marcel Duchamp in Perspective*. Englewood Cliffs, N.J.: Prentice-Hall, 1975.

Matisse, Paul. "Marcel Duchamp." *Cahiers du musée national d'art moderne*, no. 3 (1980): 14–25.

Mayoux, Jehan. *La Liberté une et divisible. Textes critiques et politiques*. Ussel: Éd. Peralta 1979.

McEvilley, Thomas. "Empyrrhical Thinking (and Why Kant Can't)." *Artforum*, no. 27 (October 1988): 120–27.

Mink, Janis. *Marcel Duchamp, 1887–1968*. Cologne: Taschen, 1994.

Molderings, Herbert. "Eine andere Erziehung der Sinne. Marcel Duchamps New Yorker Atelier als Wahrnehmungslabor." In *Bild/Geschichte. Festschrift für Horst Bredekamp*, ed. Philine Helas et al., 219–34. Berlin: Akademie Verlag, 2007.

———. "Une application humouristique de géométrie non-euclidienne." *Étant donné Marcel Duchamp* 4 (2002): 158–61.

———. "Ästhetik des Möglichen. Zur Erfindungsgeschichte der Readymades." In *Ästhetische Erfahrung im Zeichen der Entgrenzung der Künste*, ed. Gert Mattenklott, 103–35. Special issue of *Zeitschrift für Ästhetik und Allgemeine Kunstwissenschaft*. Hamburg: Meiner, 2004.

———. "The Bicycle Wheel and the Bottle Rack: Marcel Duchamp as Sculptor." In *Marcel Duchamp Respirateur*, 146–69. Exh. cat. Schwerin: Staatliches Museum; Ostfildern: Cantz, 1995.

———. "Un Cul-de-lampe: Réflexions sur la structure et l'iconographie d'Étant donnés." *Étant donné Marcel Duchamp* 3 (2001) : 92–111.

———. "Film, Fotografie und ihr Einfluſs auf die Malerei in Paris um 1910. Marcel Duchamp—Jacques Villon—Frank Kupka." *Wallraf-Richartz-Jahrbuch* 37 (1975): 247–86.

———. "Henri Poincaré/Mathematiker—Marcel Duchamp/Künstler." In *Übergangsbogen und Überhöhungsrampe. Naturwissenschaftliche und künstlerische Verfahren*, ed. Bogomir Ecker and Bettina Sefkow, 14–17. Hamburg: Hochschule für bildende Künste, Material-Verlag, 1996.

———. "It Is Not the Objects That Count, but the Experiments: Marcel Duchamp's New York Studio as a Laboratory of Perception." In *Re-Object: Marcel Duchamp, Damien Hirst, Jeff Koons, Gerhard Merz*, ed. Eckhard Schneider, 35–51 and 146–54. Bregenz: Kunsthaus Bregenz 2007.

———. *Marcel Duchamp. Parawissenschaft, das Ephemere und der Skeptizismus*. Frankfurt: Qumran, 1983.

———. "The Munich Sources Behind Marcel Duchamp's 'Large Glass.'" In *American Artists in Munich: Artistic Migration and Cultural Exchange Processes*, ed. Christian Fuhrmeister, Hubertus Kohle, and Veerle Thielemans, 225–46. Berlin: Deutscher Kunstverlag, 2009.

———. "Objects of Modern Skepticism." In *The Definitively Unfinished Marcel Duchamp*, ed. Thierry de Duve, 243–65. Cambridge, Mass.: The MIT Press, 1991.

———. "Relativism and a Historical Sense: Duchamp in Munich (and Basle . . .)." In *Marcel Duchamp*, 15–23, exh. cat. Basel: Musée Jean Tinguely, 2002.

———. "Vom Tafelbild zur Objektkunst: Kritik der 'reinen Malerei.'" In *Kunst. Die Geschichte ihrer Funktionen*, ed. Werner Busch and Peter Schmoock, 204–32. Weinheim: Quadriga/Beltz, 1987.

Mooij, Jan Johann Albinn. *La Philosophie des mathématiques de Henri Poincaré*. Paris: Gauthier-Villars, 1966.

Morellet, François. *François Morellet*. Exh. cat. Eindhoven: van Abbemuseum, 1971.

Mundy, Jennifer, ed. *Duchamp Man Ray Picabia*. London: Tate Publishing, 2008.

Nabonnand, Philippe. "Bibliographie des travaux récents sur Henri Poincaré (2001–2005)." *Philosophia Scientiae: Studies in History and Philosophy of Sciences* 9, no. 1 (2005): 195–206.

Naumann, Francis M. "Aesthetic Anarchy." In *Duchamp Man Ray Picabia*, ed. Jennifer Mundy, 59–63. London: Tate Publishing, 2008.

———. "Marcel Duchamp: A Reconciliation of Opposites." In *The Definitively Unfinished Marcel Duchamp*, ed. Thierry de Duve, 41–67. Cambridge, Mass.: The MIT Press, 1991.

———. *Marcel Duchamp: The Art of Making Art in the Age of Mechanical Reproduction*. New York: Harry N. Abrams, 1999.

———. *The Mary and William Sisler Collection*. Exh. cat. New York: The Museum of Modern Art, 1984.

Nesbit, Molly, and Naomi Sawelson-Gorse. "Concept of Nothing: New Notes by Marcel Duchamp and Walter Arensberg." In *The Duchamp Effect*, ed. Martha Buskirik and Mignon Nixon, 131–75. An October Book. Cambridge, Mass.: The MIT Press, 1996.

Nietzsche, Friedrich. "Über Wahrheit und Lüge im aufsermoralischen Sinne." In *Nietzsche Werke. Kritische Gesamtausgabe*, ed. by Giorgio Colli and Mazzino Montinari. Vol. 3.2, *Nachgelassene Schriften 1870–1873*, 369–384. Berlin: Walter de Gruyter, 1973.

Nodelman, Sheldon. "The Decollation of Saint Marcel." *Art in America* 94, no. 9 (October 2006): 107–19.

Ohrt, Roberto. *Phantom Avantgarde. Eine Geschichte der Situationistischen Internationale und der modernen Kunst*. Hamburg: Nautilus, 1997

Osborne, Harold, ed. *The Oxford Companion to Art*. London: Oxford University Press, 1981.

Pach, Walter. *Queer Thing, Painting: Forty Years in the World of Art*. New York: Harper & Brothers, 1938.

Palante, Georges. *L'Individualisme aritstocratique*. Textes choisis et présentés par Michel Onfray. Paris: Les belles lettres, 1995.

Panofsky, Erwin. *Perspective as Symbolic Form*. Trans. Christopher S. Wood. New York 1997.

Parry, Richard. *The Bonnot Gang*. London: Rebel Press, 1987.

Pauli, Wolfgang. *Wissenschaftlicher Briefwechsel mit Bohr, Einstein, Heisenberg et al*. Vol. 4-1, ed. K. v. Meyenn. Berlin: Springer, 1996

Paz, Octavio. *Marcel Duchamp: Appearance Stripped Bare and The Castle of Purity*. Trans. Donald Gardner. New York: Arcade, 1991.

———. *Marcel Duchamp ou le château de la pureté*. Geneva: Éditions Claude Givaudan, 1967.

———. *Nackte Erscheinung. Das Werk von Marcel Duchamp*. Frankfurt: Suhrkamp, 1991.

Picard, Émile. *La Sience moderne et son état actuel*. Paris: Flammarion, 1909.

Poincaré, Henri. *The Foundations of Science. Science and Hypothesis. The Value of Science. Science and Method*. Trans. George Bruce Halsted. With a special preface by Poincaré. Intro. Josiah Royce. Lancaster, Penn.: The Science Press, 1946.

———. *Dernières pensées*. Paris: Flammarion, 1913.

———. *Mathematics and Science: Last Essays (Dernières Pensées)*. Trans. John W. Bolduc. New York: Dover, 1963.

Raillard, Georges. "Roussel. Les fils de la vierge." In *L'Oeuvre de Marcel Duchamp*, by Duchamp, Exh. cat., 4 vols., 3:185–202. Paris: Musée National d'Art Moderne, Centre Georges Pompidou, 1977.

Ramírez, Juan Antonio. *Duchamp: Love and Death, Even*. Trans. Alexander R. Tulloch. London: Reaktion Books, 1998.

Reichenbach, Hans. *Philosophische Grundlagen der Quantenmechanik*. Basel: Birkhäuser: 1949.

Rey, Abel. *La Philosophie moderne*. Paris: Flammarion, 1911.

———. *La Théorie de la physique chez les physiciens contemporains*. Paris: Félix Alcan, 1907.

Rheinberger, Hans Jörg. *Experimentalsysteme und epistemische Dinge. Eine Geschichte der Proteinsynthese im Reagenzglas*. Gottingen: Wallstein Verlag, 2001.

Ribemont-Dessaignes, Georges. *Déjà jadis ou du mouvement Dada à l'espace abstrait*. Paris: Julliard, 1958.

Richardson, John Adkins. *Modern Art and Scientific Thought*. Urbana: University of Chicago Press, 1971.

Richter, Hans. *Dada. Kunst und Antikunst*. Cologne: DuMont Schauberg, 1964.

Roberts, Francis. "I Propose to Strain the Laws of Physics." Interview with Marcel Duchamp, Pasadena, 1963. *Art News* (December 1968): 46–47, 62–64.

Rorty, Richard. *Contingency, Irony, and Solidarity*. Cambridge: Cambridge University Press, 1989.

Rose Sue, trans. "Life Is a Game; Life Is Art." *The Art Newspaper* (April 1993): 17.

Rougemont, Denis de. "Marcel Duchamp mine de rien." *Preuves. Cahiers mensuels du Congrès pour la liberté de la Culture*, no. 204 (February 1968): 43–47.

Rougier, Louis. *La Philosophie géométrique de Henri Poincaré*. Paris: Félix Alcan, 1920.

Roussel, Raymond. *Comment j'ai écrit certains de mes livres*. Paris: Gallimard, 1979

Rowell, Margit. "Kupka, Duchamp, and Marey." *Studio International* (January–February 1975): 48–51.

Ruest, Anselm [Ernst Samuel]. *Max Stirner. Leben-Weltanschauung-Vermächtnis*. Berlin: Hermann Seemann Nachfolger, 1906.

———. "Stirner und Nietzsche. Ein Vorwort." In *Die Aktion. Zeitschrift für freiheitliche Politik und Literatur*, no. 29 (1911): 916–17.

Safranski, Rüdiger. *Nietzsche: A Philosophical Biography*. Trans. Shelley Frisch. New York: Norton, 2003.

Sanouillet, Michel. *Marcel Duchamp. Duchamp du signe. Ecrits*. Paris: Flammarion, 1975.

———. "Marcel Duchamp and the French Intellectual Tradition." In *Marcel Duchamp*, ed. Anne d'Harnoncourt and Kynaston McShine, 48–55. New York: The Museum of Modern Art, 1974; Philadelphia: Philadelphia Museum of Art, 1974.

Sanouillet, Michel, and Elmer Peterson, eds. *The Writings of Marcel Duchamp*. New York: Da Capo Press, 1989.

Schellwien, Robert. *Max Stirner und Friedrich Nietzsche. Erscheinungen des modernen Geistes und das Wesen des Menschen*. Leipzig: C.E.M. Pfeffer, 1892.

Schleif, Nina. "Die Frage der Schaufenster. Marcel Duchamps Arbeiten in Schaufenstern." *Tout-fait: The Marcel Duchamp Studies Online Journal* 2, no. 5 (2003).

Schmid, Anne-Françoise. *Une Philosophie de savant. Henri Poincaré & la logique mathématique*. Paris: François Maspero, 1978.

Schmidt, Gunnar. *Ästhetik des Fadens. Zur Medialisierung eines Materials in der Avantgardekunst*. Bielefeld: transcript Verlag, 2007.

Schuster, Jean. "Marcel Duchamp vite." *Le Surréalisme, même*, no. 2 (Spring 1957): 143–45.

Schwarz, Arturo. *The Complete Works of Marcel Duchamp*. Catalogue raisonné. Rev. and expanded ed. 2 vols. New York: Delano Greenidge, 1997.

——, ed. *Marcel Duchamp: Readymades, Etc. (1913–1964)*. Milan: Galleria Schwarz, 1964; Paris: Le Terrain Vague, 1964.

Seigel, Jerold. *The Private Worlds of Marcel Duchamp: Desire, Liberation, and the Self in Modern Culture*. Berkeley: University of California Press, 1995.

Seitz, William. "What's Happened to Art? An Interview with Marcel Duchamp on Present Consequences of New York's 1913 Armory Show." *Vogue*, 15 February 1963, 110–13, 129–31.

Shattuck, Roger: *The Banquet Years. The Origins of the Avant-garde in France, 1885 to World War I*. New York: Vintage Books, 1968.

Shearer, Rhonda Roland. "Marcel Duchamp's Impossible Bed and Other 'Not' Readymade Objects: A Possible Route of Influence from Art to Science." *Art and Academe* 10, no. 1 (1997); 26 –62, no. 2 (1998): 76–95.

Shearer, Rhonda Roland, and Stephen J. Gould. "Hidden in Plain Sight: Duchamp's 3 *Standard Stoppages*. More Truly a 'Stoppage' Than We Ever Realized." *Tout-fait: The Marcel Duchamp Studies Online Journal* 1, no. 1 (1999).

Simar, Émile. *La Nature et la portée de la méthode scientifique*. Québec: Les Presses universitaires; Paris: J. Vrin, 1958.

Smithson, Robert. *The Writings of Robert Smithson*, ed. Nancy Holt. New York: New York University Press, 1979.

Sorensen, Roy A. *Thought Experiments*. Oxford: Oxford University Press 1992.

Stauffer, Serge. *Marcel Duchamp. Die Schriften*. Zurich: Regenbogen-Verlag, 1981.

——. *Marcel Duchamp. Interviews und Statements*. Stuttgart: Cantz, 1991.

Steefel, Lawrence D., Jr. *The Position of Duchamp's Glass in the Development of His Art*. New York: Garland, 1977.

Steiner, Theo. *Duchamps Experiment. Zwischen Wissenschaft und Kunst*. Munich: Wilhelm Fink Verlag, 2006.

Stirner, Max. *The Ego and Its Own*. Ed. David Leopold. Cambridge Texts in the History of Political Thought. Cambridge: Cambridge University Press, 1995.

Suquet, Jean. *Éclipses et splendeurs de la virgule*. Paris: L'Échoppe, 2005.

———. *Le Grand verre rêvé*. Paris: Aubier, 1991.

———. *Le Guéridon et la virgule*. Paris: Christian Bourgeois, 1976.

———. *In vivo, in vitro. Le Grand verre à Vénise*. Paris: L'Échoppe, 1994.

———. *Marcel Duchamp ou l'éblouissement de l'éclaboussure*. Paris: L'Harmattan, 1998.

Sweeney, James Johnson. "Eleven Europeans in America." In *The Museum of Modern Art Bulletin* 13, no. 4–5 (1946), 19–21.

Tannery, Jules. *Science et philosophie*. Paris: Félix Alcan, 1912.

Taylor, Michael. *Marcel Duchamp: Étant donnés*. Philadelphia: Philadelphia Museum of Art, 2009.

Tomkins, Calvin. *Ahead of the Game: Four Versions of Avant-garde. John Cage, Marcel Duchamp, Jean Tinguely, Robert Rauschenberg*. Harmondsworth, U.K.: Penguin Books, 1965.

———. *Duchamp: A Biography*. New York: Henry Holt, 1996.

Umland, Anne, and Adrian Sudhalter with Scott Gerson, eds. *Dada in the Collection of the Museum of Modern Art*. Studies in Modern Art 9. New York: The Museum of Modern Art, 2008.

Valabrègue, Antony. *A. Bosse*. Paris, 1892.

Vanpeene, Michel. "Introduction à 'POSSIBLE.'" *Étant donné Marcel Duchamp* 3 (2001): 134–39.

Waldberg, Patrick. "Marcel Duchamp l'unique et ses propriétés. Robert Lebel." *Critique* 149 (October 1959): 850–65. English translation: "Marcel Duchamp, the Unique One and His Properties." *Étant donné Marcel Duchamp* 7 (2006): 44–55.

Watts, Harriett Ann. *Chance: A Perspective on Dada*. Ann Arbor, Mich.: UMI, 1980.

Williams, J. "Pata or Quantum: Duchamp and the End of Determinist Physics." *Tout-fait: The Marcel Duchamp Studies Online Journal* 3 (December 2000).

Wohl, Hellmut. "Marcel Duchamp in Newark." *The Burlington Magazine* 145 (2004): 36–39.

Worms, Frédéric, ed. *Le Moment 1900 en philosophie*. Lilleneuve d'Ascq: Presses Universitaires du Septentrion, 2004.

INDEX

Page references in italics refer to figures.

Abbot, Edwin A., 14, 84
abstraction, 123–24, 137
Adcock, Craig.E., xv, 108
aesthetic: and ethics, 131, 133; of the possible, xiv, xv, 32, 45, 97, 124, 130; and science, 44, 57, 112, 123–24, 130
Alberti, Leone Battista, xiii, 16, 29
analysis situs, 14, 86–88
anarchism, xvi, 133–35
an-art, 135
Apollinaire, Guillaume, 10, 78, 79, 80, 82, 109, 136
Arensberg, Louise and Walter, 54
Arp, Hans, 56, 57, *57*, 58, 66
Auer von Welsbach, Carl, 81
axioms, xv, 32, 42, 101

Barr, Alfred, 51, 66, 67, 68
barrel game, 37
Basch, Victor, 133
beauty, 130, 136, 141–43
Benjamin, Walter, 92
Bergson, Henri, xv, 99, 109, 112, 113, 114, 134
Betti, Erico, 87
Boecklin, Arnold, 8, 10

Bohr, Nils, 127
Bosse, Abraham, 25, *27*
Braque, Georges, 31, 80
Breton, André, 39, 93
Buffet-Picabia, Gabrielle, 69, 78, 136

Cabanne, Pierre, 1, 21, 22, 31, 119
causality, 120–21
chance, xi, 2, 50, 68, 119, 121, 124–25, 129, 131, 139, 141–42; "canned," 1, 2, 70; as a medium, xii, 35–37, 49–51, 56–57, 79
chronophotography, 58–61
Cigoli, Ludovico Cardi da, 25, *26*
Clair, Jean, xiii
Colomer, André, 134–35
Constable, John, 144
contingence and determinism, 120–22
conventionalism, xv, 43, 99–101, 105–9

da Vinci, Leonardo, 17, 18, 98, 111
Dada, 128–29
Delanglade, Frédéric, 40
Delaunay, Robert, 79, 112
Deleuze, Gilles, 142

Desargues, Girard, 25, 28
Descartes, René, 25, 112
determinism, 120–21
dimensions as cuts, 13–14
Doucet, Jacques, 125
Dreier, Katherine S., xii, 51, 54, 66, 68, 69, 92, 93
du Breuil, Jean, 15, 16, 17, 29, 38, 38, 98
Duchamp, Alexina, 52
Duchamp, Marcel, ii, 30, 132; *Works*: *Bicycle Wheel*, xiv, 79, 96, 130; *Bottlerack*, xiv, 63, 66, 79, 130; *Box of 1914*, 1–2, 2, 31, 37, 50, 54, 61, 73, 111, 119; *capillary tubes*, 45, 47; *Chocolate Grinder I*, 18–20, 73; *Chocolate Grinder II*, 19, 20, 20–22, 29, 30, 32, 35, 82; *draft pistons*, 29, 36, 38, 43, 73; *handler of gravity*, 39–40, 40; *Large Glass*, xiii, 7–10, 9, 35–39, 41, 45, 56, 74–75, 79, 81, 87; *La Route Paris-Jura*, 50, 78; *malic moulds*, 46–49, 72; *Monte Carlo Bond*, 97, 125, 126; *Network of Stoppages*, 45–46, 46, 47, 74, 89; *nine shots*, 36, 43; *Pharmacie*, 81; "3 décistoppages étalon" (3 standard decistoppages), 53–55, 55, 61, 73; *Three Standard Stoppages*, xi–xvi, 1, 5, 20–22, 33–35, 34, 43–44, 49, 53, 54–55, 57, 63–64, 66–74, 67, 69, 71, 88–92, 96, 104, 108, 111, 129; *Tu m'*, 48, 51, 93–98, 94–95
Duchamp-Villon, Raymond, 10, 112
Duhem, Pierre Maurice, 99

Dürer, Albrecht, 23, 24, 24, 29

Einstein, Albert, 12, 39
Epstein, Jacob, 136
Euclid of Alexandria, 85, 86, 90, 91, 101
exception, laws of, 117, 125, 131, 133
experiment, 41, 56, 58–61, 63, 70, 74, 106; experimental visual thinking, xiv, 44, 118, 122, 130, 135, 143–44

Feuerbach, Ludwig, 137
Fischer, Ernst Peter, 127
Flatland (Abbot), 14, 84
Francesca, Piero della, 98
Freud, Sigmund, 142

Galilei, Galileo, 25
game, 105–6, 111
geometry: experiment, 41–43, 58–59; four-dimensional, xiv, 11–13, 96; non-Euclidean, xii, xiv, 10–13, 31, 44, 57, 83–86, 89–91, 96–97, 112
Gleizes, Albert, 10, 90, 91, 109, 112, 113
Gold, Laurence Stephen, 90, 114
Gould, Stephen J., 33, 35
gravity, 36–37, 39, 129
Gris, Juan, 78, 80

Hamilton, George Heard, 68
Heisenberg, Werner, 127, 141
Helmholtz, Hermann von, 90
Henderson, Linda D., xv, 89, 91, 108, 111, 112, 113

Hopps, Walter, xi
Hugnet, Georges, 52, 66
humor, xvi, 41, 83, 90, 92–93, 110, 115, 118, 131
hyperspace, 14
hypophysics, 115

indetermination, 124
indifference, 129
individualism, xvi, 108, 133–35, 137–40
induction, principle of, 120–22
irony, xvi, 12, 44, 68, 92–93, 110; of indifference, 129; negative, 128

Janis, Harriet and Sidney, 68
Jarry, Alfred, xvi, 10, 43, 117, 118, 119, 120, 118, 129, 131, 133
Jouffret, Esprit-Pascal, 13, 83

Kandinsky, Wassily, 8
Kropotkin, Pjotr Alexejewitsch, 134
Kuh, Katherine, xi, 32, 56, 92
Kupka, Frank, 10

Lacaze-Duthiers, Gérard, 134, 135
L'Action d'art, xvi, 134–36
Laforgue, Jules, 129
Lavoisier, Antoine Laurent, 39
Léger, Fernand, 10, 112
Le Roy, Edouard, xv, 99, 100, 101, 105, 106, 109, 110 113, 114, 133
Lévy, Albert, 133
Lobachevsky, Nikolai Ivanovich, 12, 84

Lyotard, Jean-François, 142

Mallarmé, Stephane, 129
Man Ray, 132, 132
Marey, Etienne Jules, 58, 59, 60, 60
Marx, Karl, 137
Matisse, Paul, 40, 113
Matisse-Monnier, Jacqueline, xvi
Matta, Roberto, 40
Mayoux, Jehan, 105
meter, standard, 101–4
Metzinger, Jean, 10, 11, 90, 91, 112, 113
Milhaud, Gaston, 99, 107

Nayral, Jacques, 11
Newton, Isaac, 39, 99
Nicéron, Jean-Francois, 25
Nietzsche, Friedrich, 114, 122, 123, 124, 128, 133, 134, 136, 137, 138, 141
nominalism, 100, 105–9, 133, 137
nonsense, 92, 118

objectivity, 100–101, 143

painting: of chance, 51; pure, 7–8, 143; retinal, xii
Panofsky, Erwin, 16
Pascal, Blaise, 25
pataphysics, xvi, 115–19
Pauli, Wolfgang, 127
Paz, Octavio, 124, 129
perspectivalism, xiii, 31, 50, 80; linear perspective, xiii, 11, 15–18, 31–32; perspective machines, 23–25, 30
photography, 37, 46–47, 58–61, 64, 73

Picabia, Francis, 78, 127, 136
Picasso, Pablo, 31, 80
Plato, 141
Poincaré, Henri, xv, xvi, 13–14, 39, 41–44, 58, 84–89, 91, 97, 100–101, 104–11, 114, 117, 119–22, 133, 141
prime words, 48
Princet, Maurice, 10
probability, 121, 125, 131
Proudhon, Pierre-Joseph, 134
pseudoscience, 4, 66, 70, 92, 111, 113, 115
Puteaux, artists of, 10–11
Pyrrhon of Elis, 133
Pythagoras, 141

quantum mechanics, 127–28

Rabelais, François, 10, 118
rationalism, xv, 113–14
Redon, Odilon, 8
relativism, 107
relativity, 32, 43, 88, 101, 128
Rey, Abel, 99, 100, 110
Reynolds, Mary, 65, 66
Ribemont-Dessaignes, Georges, 10–12
Riemann, Bernhard, xii, 14, 83–84, 87–90, 119
Rorty, Richard, 142
Rougemont, Denis de, 105, 135
Roussel, Raymond, 76–78, 118, 125

Safranski, Rüdiger, 137

Schmidt, Johann Caspar. *See* Stirner, Max
Schwarz, Arturo, 70
"school of the thread," 43
science: meta-science, 92; philosophy of, 99–100, 144, 107–8; scientism, xv, 100; as word game, 105–6
Seurat, Georges, 12
Shearer, Ronda R., 33, 35
shop sign, 77–78
shop-window aesthetic, 78–82
singularity, 122
skepticism, 110, 114, 133
solipsism, 140
Stein, Gertrude, 11
Stirner, Max, xii, xvi, 83, 131, 133–34, 136–40
stopppage, 75–77

Tannery, Jules, 107
Titian (Tiziano Vecelli), 10
Tomkins, Calvin, 139
truth, 100, 104, 107, 122–23, 138, 141, 143
tychism, 133

Umbo (Otto Umbehr), *ii*
unique, 121–24, 127–28, 137–39

velum (grid), 29, 37
Villon, Jacques, 10, 112
visual ray, as thread, 23–29, 31, 50, 110

Wilde, Oscar, 136

Columbia Themes in Philosophy, Social Criticism, and the Arts

Lydia Goehr, Gregg M. Horowitz, and Noell Carroll, Editors

ADVISORY BOARD

J. M. Bernstein
T. J. Clark
Arthur C. Danto
Martin Donougho
David Frisby
Boris Gasparov
Eileen Gillooly
Thomas S. Grey
Miriam Bratu Hansen
Robert Hullot-Kentor
Michael Kelly
Richard Leppert
Janet Wolff

Columbia Themes in Philosophy, Social Criticism, and the Arts presents monographs, essay collections, and short books on philosophy and aesthetic theory. It aims to publish books that show the ability of the arts to stimulate critical reflection on modern and contemporary social, political, and cultural life. Art is not now, if it ever was, a realm of human activity independent of the complex realities of social organization and change, political authority and antagonism, cultural domination and resistance. The possibilities of critical thought embedded in the arts are most fruitfully expressed when addressed to readers across the various fields of social and humanistic inquiry. The idea of philosophy in the series title ought to be understood, therefore, to embrace forms of discussion that begin where mere academic expertise exhausts itself, where the rules of social, political, and cultural practice are both affirmed and challenged, and where new thinking takes place. The series does not privilege any particular art, nor does it ask for the arts to be mutually isolated. The series encourages writing from the many fields of thoughtful and critical inquiry.

Lydia Goehr and Daniel Herwitz, eds., *The Don Giovanni Moment: Essays on the Legacy of an Opera*
Robert Hullot-Kentor, *Things Beyond Resemblance: Collected Essays on Theodor W. Adorno*
Gianni Vattimo, *Art's Claim to Truth*, edited by Santiago Zabala, translated by Luca D'Isanto
John T. Hamilton, *Music, Madness, and the Unworking of Language*
Stefan Jonsson, *A Brief History of the Masses: Three Revolutions*
Richard Eldridge, *Life, Literature, and Modernity*
Janet Wolff, *The Aesthetics of Uncertainty*
Lydia Goehr, *Elective Affinities: Musical Essays on the History of Aesthetic Theory*
Christoph Menke, *Tragic Play: Irony and Theater from Sophocles to Beckett*, translated by James Phillips
György Lukács, *Soul and Form*, translated by Anna Bostock and edited by John T. Sanders and Katie Terezakis with an introduction by Judith Butler
Joseph Margolis, *The Cultural Space of the Arts: The Infelicities of Reductionism*